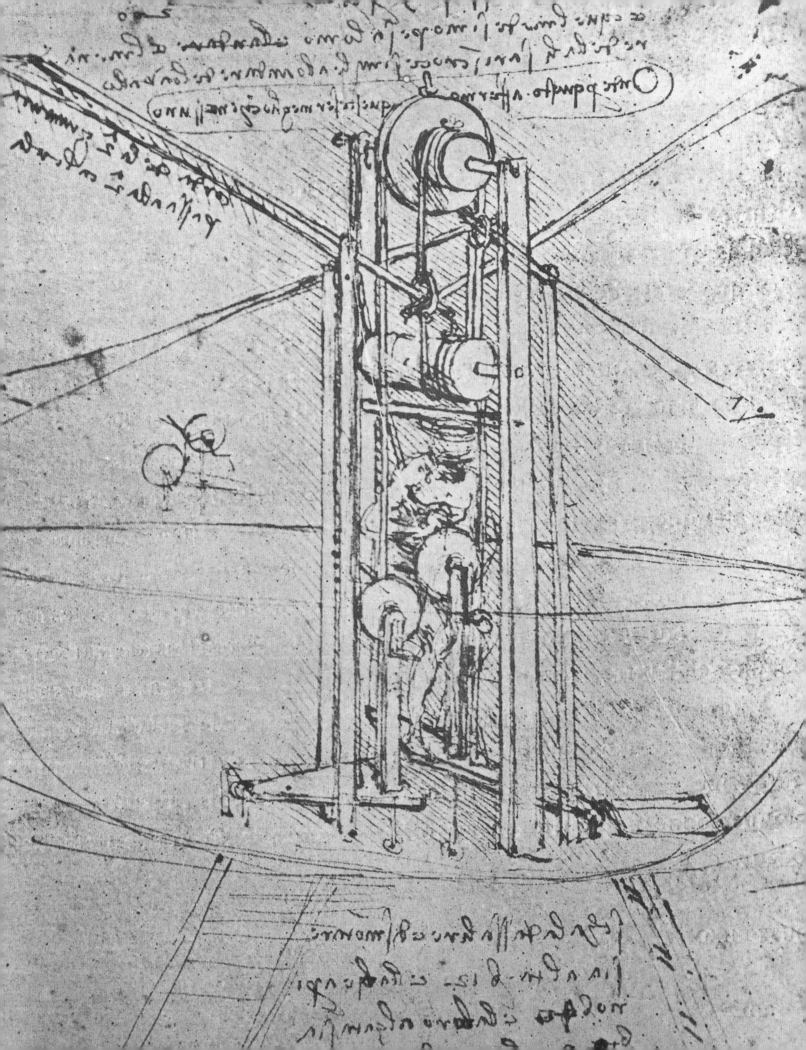

Blue Cross and Blue Shield of North Carolina presents

Defying
Gravity

CONTEMPORARY ART AND FLIGHT

Huston Paschal

Linda Johnson Dougherty

Co-Curators

With contributions by

Robert Wohl,

Anne Collins Goodyear,

and Laura M. André

North Carolina Museum of Art

Raleigh, North Carolina

2003

Published on the occasion of *Defying Gravity: Contemporary Art and Flight*, an exhibition celebrating the centennial of the Wright brothers' first powered flight at Kitty Hawk, North Carolina, organized by the North Carolina Museum of Art and on view November 2, 2003–March 7, 2004

The exhibition and this publication have been made possible by Blue Cross and Blue Shield of North Carolina. Additional funds have been provided by the National Endowment for the Arts, the North Carolina Department of Cultural Resources, and the North Carolina Museum of Art Foundation.

NATIONAL
ENDOWMENT
FOR THE ARTS

Printed and bound in Great Britain

Library of Congress Control Number: 2003102886
ISBN 3-7913-2926-X (hardcover)
 0-88259-989-5 (paperback)

Unless otherwise indicated in Photography Credits, works of art © the artists.
All photographs are copyrighted.

Front cover: Rosemary Laing, *flight research #5* (see pp. 142–43)
P. iii: Leonardo da Vinci, *Flying Machine with Man in Upright Position*, c. 1487. MS B, fol. 80 recto. Bibliothèque de l'Institut de France—Paris. © Scala/Art Resource, NY
Frontispiece: Mark Tansey, *Picasso and Braque* (see p. 197)
P. vii: Soo Kim, *North East*, large detail (see pp. 138–39)
Contents: Photograph of first flight, large detail (see p. 32)
Back cover: Marvin Jensen, *Give Me Wings* (see p. 130)

Copy editor: Fronia W. Simpson
Indexer: Frances Bowles
Design: Holland Macdonald and Heather Hensley
Typesetter: B. Williams & Associates
Printer: Butler and Tanner, Inc.

The North Carolina Museum of Art, Lawrence J. Wheeler, Director, is an agency of the North Carolina Department of Cultural Resources, Lisbeth C. Evans, Secretary. Operating support is provided through state appropriations and generous contributions from individuals, foundations, and businesses.

North Carolina Museum of Art
2110 Blue Ridge Road
Raleigh, NC USA
www.ncartmuseum.org

Prestel books are available worldwide. Visit our website at www.prestel.com or contact one of the following offices for further information:

Prestel Verlag
Koeniginstrasse 9
80539 Munich
Germany
Tel: 49 89 3817090, Fax: 49 89 38170935
E-mail: sales@prestel.de

Prestel Publishing Ltd.
4 Bloomsbury Place
London WC1A 2QA
United Kingdom
Tel: 44 20 7323 5004, Fax: 44 20 7636 8004
E-mail: sales@prestel-uk.co.uk

Prestel Publishing
175 Fifth Avenue, Suite 402
New York, NY 10010 USA
Tel: 212 995 2720, Fax: 212 995 2733
E-mail: sales@prestel-usa.com

Contents

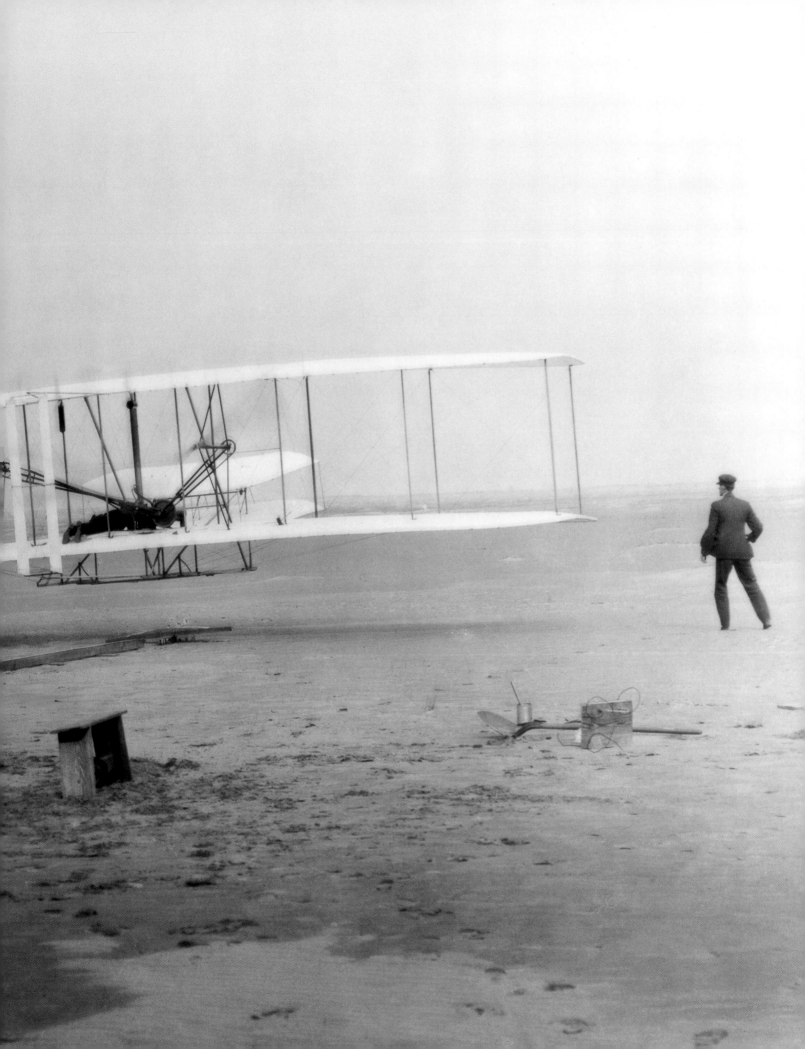

LENDERS
TO THE
EXHIBITION

Vija Celmins, *Strata*, detail (see p. 83)

SPONSOR'S STATEMENT

ROBERT J. GRECZYN JR.
PRESIDENT AND CHIEF EXECUTIVE OFFICER
BLUE CROSS AND BLUE SHIELD
OF NORTH CAROLINA

A stretch of sand, a windy day, and two bicycle-shop owners. At the time, these would have hardly seemed the components for a thrilling, inspiring story. But the Wright brothers' triumph a century ago endures today as a remarkable, pivotal moment in North Carolina history and in international history—a testament to man's imagination, innovation, and persistence.

This year we celebrate not only one hundred years of aviation but also the qualities intrinsic to that inventiveness. These are the qualities to which we still aspire in our communities, our businesses, and our individual lives—and in the arts, which at once offer insight into our humanity and challenge our perspectives on the world.

Blue Cross and Blue Shield of North Carolina is honored to commemorate the centennial of the Wright brothers' achievement by presenting this unique look at flight's diverse influences on our global society. And we are pleased to be associated with the North Carolina Museum of Art in this historic exhibition and to aid their continued contributions to the culture of this state and our nation.

Yvonne Jacquette, *Night Wing: Metropolitan Area Composite II*, detail (see p. 129)

DIRECTOR'S FOREWORD

LAWRENCE J. WHEELER

DIRECTOR

NORTH CAROLINA MUSEUM OF ART

Soaring at 40,000 feet somewhere above Colorado in a Boeing 737 going 620 mph on a five-hour flight between Raleigh and Los Angeles, I am attempting to absorb the sensations of this routine moment of flying as they relate to the meaning of an art exhibition on flight. Yes, flying through the air in a machine. I reflect on what a feat this is, imagined by civilizations over millennia and becoming possible only 100 years ago in America.

The drama of human ingenuity, persistence, and faith played out on the barrier islands of North Carolina in 1903 requires that each of us be a player still. The exaltation we feel but contain, the fear that is inherent but repressed, our individual human power which is temporarily bowed by the power of the aircraft are embedded in the roles required of my fellow passengers and me.

We marvel at the ability to see the landscape of five states all at once from this vantage above scattered clouds. It is now easy to comprehend how flight has changed dramatically behavior and events. It has been a force of good and evil. It has recast the scale of man in the world. Have we not come to expect that we are separated by only hours from any other human being on Earth? Have we not placed full faith in this technology to bring us safely to our destinations?

Perspective as an artist's tool arranges relationships and can alter our sense of the human condition. With the advent of flight, however, a powerful new arsenal of possibilities was made available to artists to create perspective on the issues of the twentieth and twenty-first centuries.

Defying Gravity, brilliantly conceived and executed by curators Huston Paschal and Linda Johnson Dougherty, brings together artists from around the world who, in our own time, find inspiration in a force unleashed in North Carolina 100 years ago. Whether making the fantastic object that flies or tries to, the photograph that captures the sensation of flight, or the installation that communicates the complexity of human issues altered by flight, *Defying Gravity* is grand opera for artistic possibilities. May its many expressions bring reflection, curiosity, inspiration, and a laugh or two.

Michael A. Salter, *lost baggage* from *situations unknown, landscape series*, detail (see p. 187)

PREFACE

HUSTON PASCHAL
ASSOCIATE CURATOR OF MODERN ART

LINDA JOHNSON DOUGHERTY
ADJUNCT ASSOCIATE CURATOR
OF CONTEMPORARY ART

NORTH CAROLINA MUSEUM OF ART

Doug Aitken, *Inflection*, still, detail (see p. 66)

When the architect Sir Norman Foster was asked to name his favorite building, he chose the Boeing 747. Aerodynamic design has indeed influenced Foster's field of practice. The choice suggests as well how the airplane has become almost a home away from home for many twenty-first-century travelers. What a leap, from the 1903 Wright Flyer cradling one brave soul to the jumbo jet, a self-sufficient village in the air. In the century since the Wright brothers made the first successful powered flight, their feat has precipitated change upon wrenching and awe-inspiring change.

Defying Gravity: Contemporary Art and Flight honors the Wright brothers' wild and heroic accomplishment by illuminating one aspect of its impact, its influence on the visual arts, specifically in the last twenty-five years. The airplane began appearing in paintings almost as soon as it showed up in the sky, and the protean image has preoccupied artists ever since. This exhibition, ninety-one works in all media from more than a dozen countries on five continents, concentrates on contemporary art derived from the creative interaction between the imagination and aviation. The show does not overlook the role of the airplane as catastrophic agent. Yet it is the gains, even when intangible, that are the chief focus of *Defying Gravity*—the enhanced visual perspective and the heightened perception of oneself and one's place on the planet.

With problem-solving mind-sets in common, the Wright brothers demonstrated that what some regard as bicycle-shop tinkering was in fact inspired experimentation. (Naturally enough, their trial-and-error methodology is reflected in many works in the exhibition.) These pragmatic visionaries stunned the world by fusing dream and reality. They proved that fantasies develop the self rather than confine it. Their example shapes this show's major premise: flight as a metaphor for self-fulfillment and transformation.

Long before the exhibition had a title and a focus, the NCMA curators spent many hours discussing possible approaches. John Coffey, Rebecca Martin Nagy (now director of the Samuel P. Harn Museum of Art, Gainesville, Florida), Mary Ellen Soles, David Steel, and Dennis P. Weller all share

credit in the final outcome. The advice of Coffey, in his role as chief curator, was, as always, perspicacious. Robert Wohl, professor of history at the University of California, Los Angeles, also has been involved from the early stages. Wohl has been indispensable in developing the concept of the exhibition. Among those knowledgeable about the interrelationship between modernism and flight, Wohl is recognized as the principal authority; and his highly regarded book, *A Passion for Wings: Aviation and the Western Imagination, 1908–1918*, exercises great influence. (The successor volume, *The Spectacle of Flight: Aviation and the Western Imagination, 1920–1956*, will be published by Yale University Press in 2004.) The Museum is fortunate to have had him serve as chief project adviser, and this publication is graced by his essay. His commitment has been exemplary.

The Museum also benefited from consultation with Barbara Bloemink, now Curatorial Director, Cooper-Hewitt National Design Museum, Smithsonian Institution; Anne Collins Goodyear, Assistant Curator of Prints and Drawings, National Portrait Gallery, Smithsonian Institution; Dominick A. Pisano, Curator, Aeronautics Division, National Air and Space Museum, Smithsonian Institution; and John Zukowsky, John H. Bryan Curator of Architecture, The Art Institute of Chicago. This advisory committee, though short-lived, was essential. Its members represented a breadth and depth of knowledge that contributed significantly to the show's planning at a crucial point in its evolution. Goodyear has continued her association with the project, offering useful suggestions as the exhibition came into being as well as contributing an essay and a chronology to this book.

Teresa Lee volunteered her services during her summer break from school, and graduate student Daire Roebuck made herself useful in any number of ways, particularly with background research, over a period of many months. Their time with the project was productive; their eagerness and insights were refreshing. Laura M. André, whose recently completed dissertation, "Lunar Nation: The Moon and American Visual Culture, 1957–1972," brought her to the co-curators' attention, agreed to write entries for this publication. A third voice, especially one so distinctive, is a welcome addition to the catalogue.

The exhibition has tested the resources of the Museum in every imaginable—and some unimaginable—ways. The NCMA staff, as well as that of the NCMA Foundation, has been resilient, cooperative, and patient. Dan Gottlieb, deputy director for planning and design; Doug Fisher, head of the design department; and Registrar Carrie Hastings Hedrick and her staff, especially Marcia Erickson, assistant registrar, rose to the occasion with wit as well as skill and ingenuity. Librarian Natalia Lonchyna and her assistant, Patricia Stack, fielded all manner of requests for help, always with good cheer. Over the many months of organizing the exhibition and preparing the catalogue, the photography department lent

itself to the project. Head Photographer Karen Malinofski and Assistant Photographer Christopher Ciccone obligingly expedited innumerable requests, and Photo Services Assistant William Holloman often—and characteristically—went beyond the call of duty. The smooth production of this publication can be credited to the expertise of Fronia W. Simpson, copy editor; Frances Bowles, indexer; Holland Macdonald, head of publications; and Heather Hensley, graphic designer. Stan Williams, director for public affairs and corporate development, and Emily Rosen, deputy director of marketing and operations, served as effective liaisons between the sponsor and the Museum. The director's spirited enthusiasm for this project, as is evident from his foreword, has heartened all involved. He has steadfastly championed the cause, recognizing the project's far-reaching implications for education and cultural enrichment as well as its art historical importance.

There is a story behind every credit line. The co-curators have relied heavily on the staffs of museums and commercial galleries in this country and abroad. Though space does not allow the listing of each and every name, readers can gain a good idea of who these valued colleagues are by consulting the list of lenders to the exhibition. Those who provided help but whose names do not appear on the lenders list include these curators: Nella Cassouto of Jerusalem; Carrie Przybilla of the High Museum of Art in Atlanta; Lisa Stone of the Roger Brown Study Collection at the School of the Art Institute of Chicago; and Jon Thompson, also an artist and critic, who lives in Brussels. It is a further pleasure to acknowledge here the assistance of Andrew Arnot and Emily Basner of Tibor de Nagy Gallery, New York; Stefania Bortolami and Bob Monk of Gagosian Gallery, New York; James Cohan of James Cohan Gallery, New York; Franziska von Hasselbach of Monika Sprüth Galerie, Cologne; and Peter Ryan of Joseph Helman Gallery, New York. Jessy and Ronny van de Velde of Gallery Ronny van de Velde, Antwerp, Belgium, and Jo Coucke of Deweer Art Gallery, Otegem, Belgium, provided critical assistance in securing loans.

Working with the artists is always a joy. This contact, an honor for curators, is reenergizing, and the openness of the artists is greatly appreciated. Lenders to this exhibition also merit special thanks. Their willingness to share these important works, many of which are unwieldy or fragile or both, is central to the success of the exhibition. The Museum's gratitude to them is substantial and ongoing.

Defying Gravity is dependent on the financial assistance of the NCMA Foundation and the National Endowment for the Arts. Blue Cross and Blue Shield of North Carolina, in accepting the director's invitation to serve as presenting sponsor, has made it possible for the Museum to realize its high hopes for this celebration. Those who have worked on the exhibition, most especially the co-curators, and those who come to see it offer that organization—and the Wright brothers—praise.

CHRONOLOGY OF AVIATION AND ART

Anne Collins Goodyear

Events in the history of flight are listed in black, while those in the field of art are in blue.

c. 1485–1515 Leonardo da Vinci studies the flight of birds and creates designs for several devices to enable human flight (see p. iii).

1894 In Germany Otto Lilienthal builds what he considers his most successful glider, a precursor to the powered airplane.

1896 AUGUST 10 Death of Otto Lilienthal, following a fall while gliding.

1903 MARCH 23 Orville and Wilbur Wright's first patent application for a flying machine is rejected.

1903 OCTOBER 7 In the United States Samuel P. Langley's Aerodome (a flying machine intended to remain aloft for a sustained period) falls apart when catapulted into the air. Pilot Charles Manley is not hurt. A second unsuccessful attempt follows on December 8.

1903 DECEMBER 17 At Kitty Hawk, North Carolina, Orville and Wilbur Wright achieve the world's first flight

Kara Hammond, *Lilienthal's Biplane Glider*, large detail (see p. 120)

with a powered, heavier-than-air machine. Each brother completes two flights that day, the longest lasting 59 seconds.

1904 SEPTEMBER 20 Wilbur Wright completes the first circle in an airplane.

1906 MAY 22 The Wright brothers receive their first patent for the airplane from the United States (Belgium, France, and Great Britain had already issued patents to the Wrights for their invention).

1906 NOVEMBER 12 Alberto Santos-Dumant, of Brazil, makes the first airplane flight in Europe.

1908 FEBRUARY The United States Army purchases one plane from the Wrights; it constitutes the country's first military aircraft.

1908 MAY 15 Mechanic Charlie Furnas becomes the first airplane passenger, on a flight with Wilbur Wright as pilot.

1908 AUGUST 8–13 Wilbur Wright flies for the first time in France at Les Hunaudières, awing crowds with his command of the airplane.

1908 AUGUST 8–1909 JANUARY 2 Wilbur Wright completes 129 flights in France, establishing 9 world records during this period, for height, distance, and duration.

1908 OCTOBER 7 Mrs. Hart Berg becomes the first woman to fly, riding as a passenger with Wilbur Wright.

1908 NOVEMBER 14 Louis Vauxcelles's review of the first cubist paintings of Georges Braque appears in *Gil Blas*, directly above an article announcing a new prize for altitude won by Wilbur Wright.

1908 DECEMBER In "Notes of a Painter" Henri Matisse compares artists who discover the "profound meaning" of "common truths" to "aviators," who, he believed, if "called to lay out their researches for us, to explain to us how they were able to leave the earth and launch themselves into space, . . . would give us simply the confirmation of some very elementary principles of physics that less fortunate inventors have neglected." (Henri Matisse, "Notes d'un peintre," *La Grande Revue* 52, no. 24 [December 25, 1908]: 731–45; trans. Jack D. Flam, ed., *Matisse on Art* [London and New York: Phaidon, 1973; New York: E. P. Dutton, 1978], 35–40; quoted in Kirk Varnedoe, *A Fine Disregard: What Makes Modern Art Modern* [New York: Harry N. Abrams, 1994], 273.)

1909 FEBRUARY 20 Filippo Tommaso Marinetti publishes the *Founding Mani-festo of Futurism* in *Le Figaro*, Paris, with a call to emulate, among other modern phenomena, "the gliding flight of aeroplanes." Yet despite the futur-ists' interest in the technology of speed, the bulk of pictorial responses to the airplane dates to the 1920s and 1930s. This aerial imagery is further stimulated by the 1929 "Manifesto of Futurist Aeropainting."

1909 APRIL 24 The first motion picture is shot from a flying plane by a Univer-sal newsreel cameraman flying with Wilbur Wright over Italy.

1909 JULY 25 Louis Blériot becomes the first person to cross the English Channel in a plane.

1909 AUGUST In Reims, France, the first airshow, and the Gordon Bennett, or Blue Ribbon, airplane race take place.

1910 SPRING In France the first licenses for airplane pilots are issued. Baroness Raymonde de la Roche becomes the first woman to earn one.

1910 Alfred Stieglitz makes the photograph *The Aeroplane* (National Gallery of Art, Washington, D.C.), one of the first works of art picturing an airplane.

1911 AUGUST 2 Harriet Quimby becomes the first American woman licensed pilot.

1912 SPRING Pablo Picasso completes three paintings incorporating the phrase "Our Future Is in the Air" (*Notre avenir est dans l'air*), borrowed from the cover of a contemporary pamphlet advocating military aviation (see p. 33).

1912 MAY 30 Wilbur Wright dies.

1912–13 Robert Delaunay features the new phenomenon of flight in his depiction of a rugby team at play with an airplane, a Ferris wheel, and the Eiffel Tower juxtaposed in the background. In each version of *The Cardiff Team* (*L'Equipe de Cardiff*), a reference to Astra, the company that produced Wright Flyers in France, is prominently placed. The paintings combine modern subject matter with the modern painting technique of "simultaneity," informed by Cubism. (For a detailed discussion of Delaunay's interest in flight, see Robert Wohl, *A Passion for Wings: Aviation and the Western Imagination, 1908–1918* [New Haven: Yale University Press, 1994], 178–99; on *The Cardiff Team*, see 188–92.)

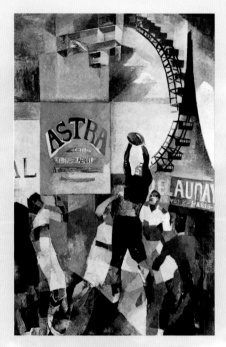

Robert Delaunay, *The Cardiff Team, Third Version* (*L'Equipe de Cardiff. Troisième Représentation*), 1912–13. Oil on canvas, 128⅜ x 81⅞ in. (326 x 208 cm). Musée d'Art Modern de la Ville de Paris

1913 Roger de la Fresnaye exhibits *The Conquest of the Air* (*La Conquête de l'air*) (The Museum of Modern Art, New York). Influenced by Delaunay's *The Cardiff Team*, this painting celebrates French contributions to aviation, notably the invention of the hot-air balloon by Joseph and Etienne Montgolfier in 1783.

Delaunay paints *Sun, Tower, Airplane* (*Soleil, tour, aéroplane*) (Albright-Knox Art Gallery, Buffalo, New York).

1913 SEPTEMBER 21 Adolphe Pégoud becomes the first pilot to achieve controlled, upside-down flight.

1914 Delaunay paints *Homage to Blériot* (*L'Hommage à Blériot*) (Öffentliche Kunstsammlung, Basel; see p. 21); his canvas honors Blériot as both a pilot and fabricator of flying machines.

Kazimir Malevich paints *The Aviator* (State Russian Museum, Moscow), symbolizing the spiritual and intellectual liberation he associated with flight. The artist would continue to respond to aviation, in increasingly abstract fashion. (For a detailed discussion of Malevich's interest in flight, see Robert Wohl, *A Passion for Wings: Aviation and the Western Imagination, 1908–1918* [New Haven: Yale University Press, 1994], 157–78.)

Carlo Carrà, an Italian futurist, creates the collage *Free-Word Painting (Patriotic Festival)* (*Dipinto Parolibero [Festa Patriottica]*) (Mattioli Collection, Milan), with scraps of text arranged to emulate a propeller.

Marsden Hartley paints *The Aero* (National Gallery of Art, Washington, D.C.). According to Hartley, this painting, influenced by Delaunay's *Homage to Blériot*, represents a plane's "soul state." A bold red burst in the foreground captures the flaming roar of its engines, while brightly colored shapes simulate an aerial perspective. (Gail Scott, *Marsden Hartley* [New York: Abbeville Press, 1988], 49; cited by Gerald Silk, in "'Our Future is in the Air': Aviation and American Art," in *The Airplane in American Culture*, ed. Dominick A. Pisano [Ann Arbor: University of Michigan Press, 2003].)

1914 AUGUST 3 The first bombing of World War I occurs when a German plane attacks Lunéville, France.

1915 Kazimir Malevich creates *Suprematist Composition: Airplane Flying* (The Museum of Modern Art, New York). This work distills the form and philosophic essence of flight. In a contemporary essay describing the goals of Suprematism, Malevich repeatedly alludes to the intellectual transformations produced

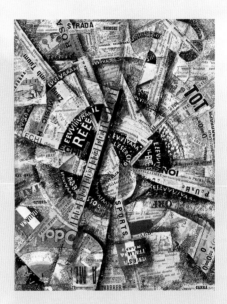

Carlo Carrà, *Free-Word Painting (Patriotic Festival)* (*Dipinto Parolibero [Festa Patriottica]*), 1914. Also known as *Manifestazione interventista (Interventionist Manifesto)*. Tempera and collage on cardboard, 15³/₈ x 12 in. (38.5 x 30 cm). Mattioli Collection, Milan

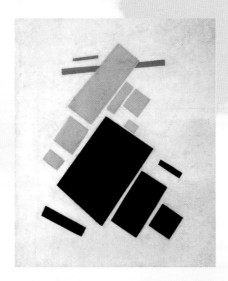

Kazimir Malevich, *Suprematist Composition: Airplane Flying*, 1915 (dated 1914). Oil on canvas, 22 7/8 x 19 in. (58.1 x 48.3 cm). The Museum of Modern Art, New York. Purchase. Acquisition confirmed in 1999 by agreement with the Estate of Kazimir Malevich and made possible with funds from the Mrs. John Hay Whitney Bequest (by exchange)

by the airplane, the epitome of modern technology: "If all artists could see the crossroads of these celestial paths, if they could comprehend these monstrous runways and the weaving of our bodies with the clouds in the sky, then they would not paint chrysanthemums." (Malevich, "From Cubism and Futurism to Suprematism: The New Realism in Painting," [1915, 1916], in *Art in Theory, 1900–1990*, ed. Charles Harrison and Paul Wood [Oxford: Blackwell Publishers, 1992], 170.)

1918 Fernand Léger paints *Propellers* (*Les Hélices*) (The Museum of Modern Art, New York). Léger relates: "Before the [First] World War[,] I went with Marcel Duchamp and Brancusi to an airplane exhibition. Marcel, who was a dry type with something inscrutable about him, walked around among the motors and propellers without saying a word. Suddenly he turned to Brancusi: 'Painting has come to an end. Who can do anything better than this propeller? Can you?' . . . I still remember the bearing of those great propellers. Good God, what a miracle." (Quoted in K. G. Pontus Hultén, *The Machine as Seen at the End of the Mechanical Age*, exh. cat. [New York: The Museum of Modern Art, 1968], 140.)

1918 MAY 15 The first regular airmail service begins in the United States.

1919 MAY 8–31 The first transatlantic flight is accomplished by A. C. Read and naval crew, flying from Newfoundland to Ireland.

1919 JUNE 14–15 John Alcock and Arthur Whitten Brown complete the first nonstop transatlantic flight, from Newfoundland to Ireland.

1920 Stanton Macdonald-Wright paints *Aeroplane: Synchromy in Yellow-Orange* (The Metropolitan Museum of Art, New York). The brightly colored composition alludes to "the counteracting interdependence of all physical and metaphysical things," which Macdonald-Wright felt could be expressed by the "reciprocal dynamic influence" of human pursuits so apparently diverse as art and aviation. (Macdonald-Wright, "Influence of Aviation on Art: The Accentuation of Individuality," *Ace: The Aviation Magazine of the West* 1, no. 2 [September 1919]: 11–12; quoted in Will South, *Color, Myth, and Music: Stanton Macdonald-Wright and Synchromism*, exh. cat. [Raleigh: North Carolina Museum of Art, 2001], 70.)

1924 SEPTEMBER 28 The United States Army team achieves the first global circumnavigation in an airplane.

1925 SPRING The 1903 Wright Flyer is sent by Orville Wright to the Science Museum of London, following a dispute with the Smithsonian Institution. The airplane would not return to the United States until 1948.

1927 MAY 20–21 Charles Lindbergh completes the first solo transatlantic flight, traveling from New York to Paris.

Describing the festive atmosphere following Lindbergh's touchdown, Alexander Calder recalled that "People wanted Lindbergh, so they cried, '*L'aviateur!*' I tried to cry '*L'aviateur!*' too, and drew quite a laugh. Finally Lindbergh appeared." Inspired by the event, Calder would fashion *The Spirit of St. Louis*, a wire sculpture, shortly thereafter. (On Calder's reaction to Lindbergh's landing, see Calder, *An Autobiography with Pictures* [New York: Pantheon Books, 1966], 83–84.)

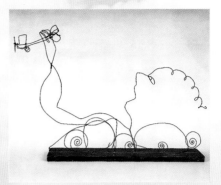

1927 Kazimir Malevich includes aerial photographs in his book *The Non-Objective World*. Associating the new perspectives of the airplane with a quintessentially modern vision, Malevich compared the development of pictorial abstraction to the experience of flying: "The ascent to the heights of non-objective art is arduous and painful . . . but it is nevertheless rewarding. The familiar recedes ever further and further into the background. . . . The contours of the objective world fade more and more and so it goes, step by step, until finally the world—'everything we loved and by which we have lived'—becomes lost to sight." (Malevich, *The Non-Objective World* [1927; Chicago: Paul Theobald, 1959], 68; quoted in Robert Wohl, *A Passion for Wings: Aviation and the Western Imagination, 1908–1918* [New Haven: Yale University Press, 1994], 175.)

Alexander Calder, *The Spirit of St. Louis*, c. 1927. Wire, 17 x 24 x 4 in. (43.2 x 60.7 x 10.2 cm). Private collection

Hugo Gellert, *Amelia Earhart*, c. 1932. Lithographic crayon on paper, image 8 1/4 x 8 1/8 in. (21 x 20.5 cm). National Portrait Gallery, Smithsonian Institution

1928 Elsie Driggs paints *Aeroplane* (private collection). The precisionist work, which responds to the classicism of Piero della Francesca, was inspired by Driggs's first flight, made the same year, in a Ford trimotor. (Gerald Silk, "'Our Future is in the Air': Aviation and American Art," in *The Airplane in American Culture*, ed. Dominick A. Pisano [Ann Arbor: University of Michigan Press, 2003].)

1929 SEPTEMBER 22 F. T. Marinetti and others publish a manifesto officially inaugurating *aeropittura* (air painting), a new branch of Futurism. Among other things, the artists declare that "the changing perspectives of flight constitute an absolutely new reality one that has nothing in common with the reality traditionally constituted by earthbound perspectives[.]" (F. T. Marinetti et al., "Manifesto of Aeropainting," in *Futurism in Flight*, ed. Bruno Mantura, Patrizia Rosazza-Ferraris, and Luivia Velani, exh. cat. [London: Accademia Italiana delle Arti e delle Arti Applicate; Rome: De Luca, 1990], 203.)

1930–31 Thomas Hart Benton creates the *America Today* mural series, originally housed at the New School for Social Research, New York. The work includes a tribute to "the new airplanes" and dirigibles.

1932 MAY 20–21 Amelia Earhart becomes the first woman to make a solo, nonstop transatlantic flight.

1932 Celebrating Earhart's pioneering solo flight across the Atlantic, Hugo Gellert accentuates her modernity and the speed associated with the airplane by portraying her in a futurist idiom (see p. 6).

Vladimir Tatlin completes *Letatlin—Ornithopter* (Moderna Museet, Stockholm). According to Kornelii Zelinsky, one of his students, Tatlin declared: "I want to give back to man the feeling of flight. . . . We have been robbed of this by the mechanical flight of the aeroplane. We cannot feel the movement of our bodies in the air." (Quoted in Angelica Zander Rudenstine, ed., *Collecting Art of the Avant-Garde by George Costakis* [New York: Harry N. Abrams, 1981], 482.)

Theodore Roszak creates *Airport Structure* (The Newark Museum, Newark, New Jersey). The artist's first metal sculpture, the work represents one of many constructivist pieces celebrating flight created by the artist prior to World War II.

1933 Diego Rivera completes the *Detroit Industry* murals for the Detroit Institute of Arts. It includes representations of Ford's Airplane Division and a mural entitled *Conquest of the Air*.

1937 Picasso paints *Guernica* (Reina Sofía, Madrid) in response to the horrific bombing of the Spanish town of that name by fascist forces in April. That

Vladimir Tatlin, *Letatlin—Ornithopter*, 1932. Wood, cork, Duralumin, silk cord, steel wire mesh, whalebone, and hide rope; wingspan 26 ft. 2½ in. (8 m), length 16 ft. 5 in. (5 m). Moderna Museet, Stockholm. © Estate of Vladimir Tatlin/Licensed by VAGA, New York, NY

Arshile Gorky, *Study for "Activities in the Field,"* mural for administration building, Newark Airport, New Jersey, 1935–36. Gouache on paper, 13⅝ x 29⅞ in. (34.6 x 75.9 cm). The Museum of Modern Art, New York; Extended loan from the United States WPA Art Program to The Museum of Modern Art, New York

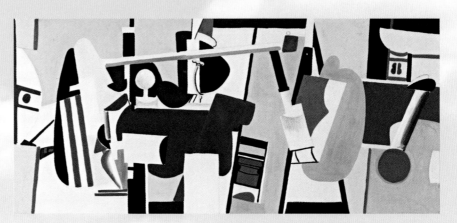

summer the canvas is hung in the Spanish Pavilion at the Paris International Exposition.

Painted under the auspices of the Work Progress Administration's Federal Art Project, Arshile Gorky's mural series for the Newark Airport, *Aviation: Evolution of Forms under Aerodynamic Limitations*, is completed and installed (see p. 7). Creating abstractions of the "elemental forms" of an airplane, including wing, rudder, and wheel, Gorky deliberately depicted them "in paralyzing disproportions in order to impress upon the spectator the miraculous new vision of our time." (Arshile Gorky, "My Murals for the Newark Airport, An Interpretation," in *Murals without Walls: Arshile Gorky's Aviation Murals Rediscovered*, exh. cat. [Newark: The Newark Museum, 1978], 13–14.)

1939 Charles Sheeler paints *Yankee Clipper* (Museum of Art, Rhode Island School of Design, Providence). Sheeler's painting depicts perhaps the best known of Pan American Airways' Clipper passenger planes. The "flying boats" greatly reduced transatlantic travel time and provided luxurious accommodations.

1939 SEPTEMBER 14 In the United States Igor I. Sikorsky conducts the first test flight of the prototype for the first helicopter to be mass-manufactured.

1939 AUGUST 27 The first flight by a jet plane takes place in Germany.

1940 JULY–OCTOBER In the Battle of Britain, the Germans rely on bombers to destroy the British Royal Air Force and clear the way for ground troops. Despite having more aircraft than the British, the Germans fail.

1940–41 Paul Nash paints *Totes Meer* (*Dead Sea*) (Tate Gallery, London). The British surrealist painter transformed a field of downed German planes into a "great inundating Sea" composed of the "hundreds and hundreds of flying creatures which invaded these shores." (Paul Nash, quoted in Robert Rosenblum, *Modern Painting and the Northern Romantic Tradition: Friedrich to Rothko* [New York: Harper and Row, 1975], 164; quoted in Joan French Seeman, "The Sculpture of Theodore Roszak: 1932–1952," Ph.D. diss., Stanford University, 1979, vol. 1, 202 n. 214.)

1941 Paul Nash records his vision of the Battle of Britain (see p. 9).

1941 DECEMBER 7 Japanese bombers stage a surprise attack on the United States naval base at Pearl Harbor, Hawaii.

Charles Sheeler, *Yankee Clipper*, 1939. Oil on canvas, 24 x 28 in. (61 x 71.1 cm). Museum of Art, Rhode Island School of Design

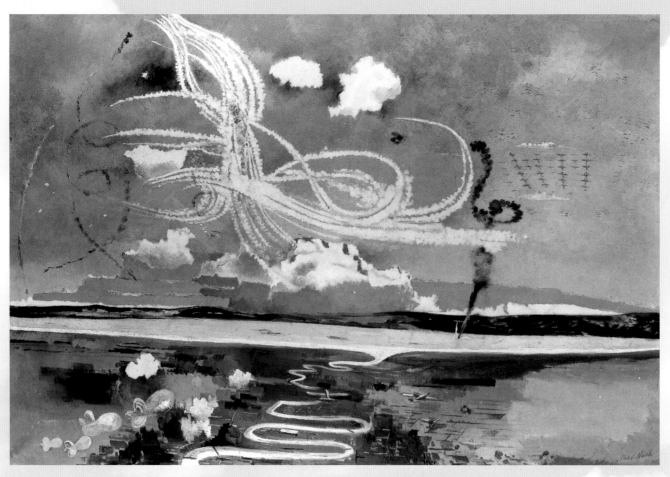

Paul Nash, *The Battle of Britain*, 1941. Oil on canvas, 48 x 72 in. (121.9 x 182.9 cm). The Imperial War Museum, London

1941 DECEMBER–1942 JANUARY Benton responds to the Japanese attack with a series of eight major paintings, entitled *The Year of Peril*. The works are widely reproduced.

1942 MARCH 7 The first African American military pilots earn their wings. They become known as the Tuskegee Airmen after their training in Tuskegee, Alabama.

1942 James Brooks completes the *Flight* mural, commissioned by the Work Progress Administration's Federal Art Project, for LaGuardia Airport's Marine Air Terminal. Painted over in 1955, the mural, which depicts the history of flight in a symbolic fashion intended to merge the achievements of modern abstraction and Renaissance figuration, was restored in 1980. (On the mural, see Greta Berman, "Does 'Flight' Have a Future?" *Art in America* 64

[September–October 1976]: 97–99; and quoted in Gerald Silk, "'Our Future is in the Air': Aviation and American Art," in *The Airplane in American Culture*, ed. Dominick A. Pisano [Ann Arbor: University of Michigan Press, 2003].)

1943 JULY–OCTOBER The Museum of Modern Art, New York, mounts the exhibition *Airways to Peace*. The show presents an overview of the history of flight and includes photographic installations illustrating World War II bombing campaigns. (Joan French Seeman, "The Sculpture of Theodore Roszak: 1932–1952," Ph.D. diss., Stanford University, 1979, vol. 1, 207 n. 237.)

1944 SEPTEMBER 8 Germany attacks Great Britain with V-2 missiles for the first time.

1945 AUGUST 6 The American bomber *Enola Gay* drops the world's first atomic bomb on Hiroshima, Japan. A second atomic bomb is dropped on August 9 over Nagasaki, Japan.

1946–47 Theodore Roszak makes *Spectre of Kitty Hawk* (The Museum of Modern Art, New York; see p. 34). The sculpture is accompanied by a number of related drawings.

1947 OCTOBER 14 In California Chuck Yeager becomes the first person to fly faster than sound.

1948 JANUARY 30 Orville Wright dies.

1948 JUNE–SEPTEMBER 1949 In the Berlin Airlift, Allied forces defeat a Soviet blockade of Berlin by flying supplies into the city.

1948 DECEMBER 17 The 1903 Wright Flyer goes on public view at the Smithsonian Institution, with full acknowledgment of the Wright brothers' priority in the invention of the first heavier-than-air powered aircraft.

1952 APRIL 21 The first jet airplane, the *Comet 1*, begins passenger service for British Overseas Airways.

1953 MAY 20 Jackie Cochran, an American, becomes the first woman to break the sound barrier.

1956 SEPTEMBER 7 Iven C. Kincheloe, an American Air Force test pilot, becomes known as the "First of the Spacemen" when he makes the first flight above 100,000 feet.

1957 OCTOBER 4 The Soviet Union launches *Sputnik*, the first artificial satellite to orbit the globe.

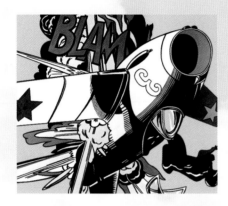

Roy Lichtenstein, *Blam*, 1962. Oil on canvas, 68 x 80 in. (172.7 x 203.2 cm). Yale University Art Gallery, Gift of Richard Brown Baker, B.A. 1935

1958 OCTOBER 1 The National Aeronautics and Space Administration (NASA) is officially established.

1958 OCTOBER 26 Pan American Airways begins the first American jet service.

1960 Yves Klein makes *Leap into the Void*. According to Klein: "Today the painter of space effectively has to go into space in order to paint, but he has to go there without tricks, without deceit, neither in airplanes, nor by parachute or rocket; he must go there by himself, with an autonomous individual force, in a word, he must be capable of levitating." (Klein, *Dimanche: Le Journal d'un seul jour*, November 27, 1960, 1; trans. in Stephen Petersen, "Space and the Space Age in Postwar European Art: Lucio Fontana, Yves Klein, and Their Contemporaries," Ph.D. diss., The University of Texas at Austin, 2001, 178.)

1961 APRIL 12 Soviet cosmonaut Yuri Gargarin becomes the first person to orbit the Earth.

1961 MAY 5 Astronaut Alan Shepard becomes the first American in space.

1962 FEBRUARY 20 John Glenn becomes the first American to orbit the Earth.

1962–64 Roy Lichtenstein creates a series of *War Comics* paintings, playful enlargements of comic strips frequently featuring the exploits of World War II–era flying aces. In parodying the cult of the war hero, Lichtenstein, who himself had flown as a pilot in the war, also poked fun at the heroic aspiration of artists.

1962 NASA creates an art program, commissioning contemporary artists to respond to space exploration. It continues to operate.

1963 Soviet cosmonaut Valentina V. Tereshkova becomes the first woman in space.

1963 Robert Rauschenberg dedicates his performance piece *Pelican* to the Wright brothers. (Mary Lynn Kotz, *Robert Rauschenberg/Art and Life* [New York: Harry N. Abrams, 1990], 123.)

1962–65 Gerhard Richter paints a series of paintings of American fighters and bombers. The monochromatic images speak, with dark humor, to the ongoing influence of American military power in postwar Europe. (On Richter's paintings of military aircraft, see Robert Storr, "Gerhard Richter: Forty Years of Painting" and "Interview with Gerhard Richter," in *Gerhard Richter: Forty Years of Painting*, exh. cat. [New York: The Museum of Modern Art, 2001], 41–43, 288–89.)

1964–68 Vija Celmins does several paintings depicting military aircraft, frequently in distress. Like Richter, Celmins draws attention to the physical and psychological legacy of bombing during World War II. (Judith Tannenbaum, "Vija Celmins: Holding On to the Surface," in *Vija Celmins*, exh. cat. [Philadelphia: Institute of Contemporary Art, University of Pennsylvania, 1992], 15.)

1965 FEBRUARY–OCTOBER 1968 The United States carries out Operation Rolling Thunder, a campaign of extensive bombing against North Vietnam, designed to bring about an end to the Vietnam War. It does not succeed.

1965 MARCH 18 Soviet cosmonaut Alexei Leonov becomes the first person to walk in space.

1965 Georgia O'Keeffe paints *Sky above Clouds IV* (The Art Institute of Chicago). The last of a series of four *Sky above Clouds* paintings, this canvas represented "at twenty-four feet wide by far the largest and most ambitious painting O'Keeffe had ever produced." (Charles C. Eldredge, *Georgia O'Keeffe* [New York: Harry N. Abrams, 1991], 150.)

In April, James Rosenquist's *F-111* opens at the Leo Castelli Gallery in New York City. At 86 feet long and 10 feet high, the painting wraps around all four walls of Castelli's main room. Denying that he was interested in "size for its own sake," Rosenquist turns the extravagant scale of *F-111* to political purpose, creating an overwhelming view of the U.S. military's "newest, latest fighter-bomber" that the viewer "couldn't shut . . . out." (G. R. Swenson, "The F-111: An Interview with James Rosenquist," *Partisan Review* 32, no. 4 [fall 1965]: 589–601, esp. 589, 595.)

Georgia O'Keeffe, *Sky above Clouds IV*, 1965. Oil on canvas, 8 x 24 ft. (2.5 x 7.3 m). The Art Institute of Chicago. Restricted gift of the Paul and Gabriella Rosenbaum Foundation; gift of Georgia O'Keeffe

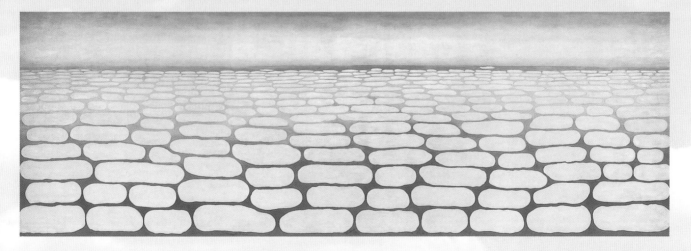

James Rosenquist, *F-111*, 1965. Oil on canvas with aluminum, 10 x 86 ft. (3 x 26.2 m). The Museum of Modern Art, New York; Gift of Mr. and Mrs. Alex L. Hillman and Lillie P. Bliss Bequest. © James Rosenquist/ Licensed by VAGA, New York, NY

Nancy Spero, *Search and Destroy*, 1967. Gouache and ink on paper, 24 x 36 in. (61 x 91.4 cm.).

1966–69 In *Bombs and Helicopters* (1966) and *War Series* (1966–69) Nancy Spero pictures helicopters as fierce antagonists in the Vietnam War, characterizing the works as "angry . . . manifestos against a senseless and obscene war." (Quoted in Gerald Silk, "'Our Future is in the Air': Aviation and American Art," in *The Airplane in American Culture*, ed. Dominick A. Pisano [Ann Arbor: University of Michigan Press, 2003].)

1967 The artist Robert Smithson is hired to work as a consultant to Tippetts-Abbett-McCarthy-Stratton, engineers and architects on plans for the Dallas–Fort Worth Airport.

Panamarenko creates *The Aircraft* (*Das Flugzeug*), the first of several flying machines.

1969 MARCH 2 The first supersonic airliner makes its first flight; the Concorde was developed by France and Britain.

1969 JULY 20 American Apollo 11 astronauts Neil Armstrong and Edwin "Buzz" Aldrin become the first people to land on the moon, while the third Apollo 11 astronaut, Michael Collins, orbits the moon in the command module Columbia.

1969–70 Robert Rauschenberg completes *Stoned Moon*, a series of 33 lithographs created in response to the launch of Apollo 11.

1972 Stuart M. Speiser commissions 22 photorealist painters to create works related to aviation, working in a style "consistent with their work in 1973," as Louis K. Meisel has explained. Among the artists are Audrey Flack, Malcolm Morley, Ben Schonzeit, and Richard Estes. The collection is donated to the National Air and Space Museum, Smithsonian Institution, Washington, D.C.

1974–75 Rauschenberg creates the lithographs *Kitty Hawk* (see p. 36) and *Killdevil Hill*, working with Universal Limited Art Editions, West Islip, New York.

1981 APRIL 12–14 American astronauts John W. Young and Robert L. Crippen complete the first space shuttle mission. The shuttle is the first reusable rocket and pioneers the use of winged spacecraft.

1983 JUNE 19 Sally K. Ride becomes the first American woman in space.

1983 Richard Serra creates his steel sculpture *Kitty Hawk* (Albright-Knox Art Gallery, Buffalo, New York; see p. 37).

1986 JANUARY 28 The Space Shuttle Challenger explodes shortly after take-off; among the seven lost crew members was Christa McAuliffe, the first teacher in space.

1986 DECEMBER 23 American pilots Jeana Yeager and Dick Rutan make the first flight around the world without refueling.

1989 The Berlin Wall falls. The important role played by flight-related imagery in Anselm Kiefer's work is apparent in the exhibition *The Angel of History: Poppy and Memory* at the Galerie Paul Maenz in Cologne (November 17, 1989–January 13, 1990). The exhibition features three lead airplanes modeled after bombers (for an illustration of one, see p. 38), two airplane wings, and eight flight-related paintings.

1990 APRIL 25 The Hubble Space Telescope is released into orbit.

1992 Mark Tansey paints *Picasso and Braque* (Los Angeles County Museum of Art; see p. 197).

1999 MARCH 20 Swiss pilot Bertrand Piccard and British co-pilot Brian Jones achieve the first balloon flight around the world.

1999 JULY 23 Eileen M. Collins becomes the first woman to command a Space Shuttle mission.

1999 Michael Richards completes *Tar Baby vs. St. Sebastian* (see p. 58). Created as a tribute to the Tuskegee Airmen, an elite group of African American military pilots, this sculpture features a cast of the artist's body dressed as a flying ace. His body is pierced by numerous model airplanes. Although Richards made several flight-related works during the course of his career, this one takes on special significance after the artist, who had a

Audrey Flack, *Spitfire*, 1973. Acrylic, oil, and glazes on canvas, 70 x 96 in. (177.8 x 243.8 cm). National Air and Space Museum, Smithsonian Institution, Gift of Stuart M. Speiser

studio at the World Trade Center, becomes one of the victims of the terrorist attacks two years later.

2001 SEPTEMBER 11 Four passenger airliners are hijacked. Two planes are flown into New York's World Trade Center, bringing down both towers, while a third flies into the Pentagon. The fourth plane crashes over Pennsylvania, after passengers overpower their assailants.

2003 FEBRUARY 1 The Space Shuttle Columbia breaks apart shortly before its scheduled landing in Florida. The international crew of seven, including the first Israeli astronaut, Ilan Ramon, perishes.

2003 SPRING Unmanned aerial vehicles (UAVs), such as the Predator and Global Hawk, play a critical role in the war in Iraq. UAVs were employed as early as the Civil War (in the form of hot-air balloons), and the first heavier-than-air prototypes appeared during World War I. They now gain increasing prominence due to recent technological advances. In addition to their military function, UAVs also hold promise for research, telecommunications, and even rescue missions.

British Airways and Air France announce the termination of Concorde service, thirty-four years after its inception.

2003 DECEMBER 17 The centennial of the Wright brothers' first powered flight is observed, with the construction of a faithful replica of the Wright Flyer and in myriad events, publications, and exhibitions.

The author wishes to acknowledge the valuable model and information provided for this chronology by Anne Millbrooke, "Aviation Firsts," in *Aviation History* (Englewood, Colo.: Jeppesen Sanderson, 1999), A1–A12. It has also benefited from overviews of the history of flight by Donald S. Lopez, *Aviation: A Smithsonian Guide* (New York: MacMillan, 1995), T. A. Heppenheimer, *A Brief History of Flight, from Balloons to Mach 3 and Beyond* (New York: John Wiley and Sons, 2001), and Tom Crouch, *The Bishop's Boys: A Life of Wilbur and Orville Wright* (New York: W. W. Norton and Company, 1989).

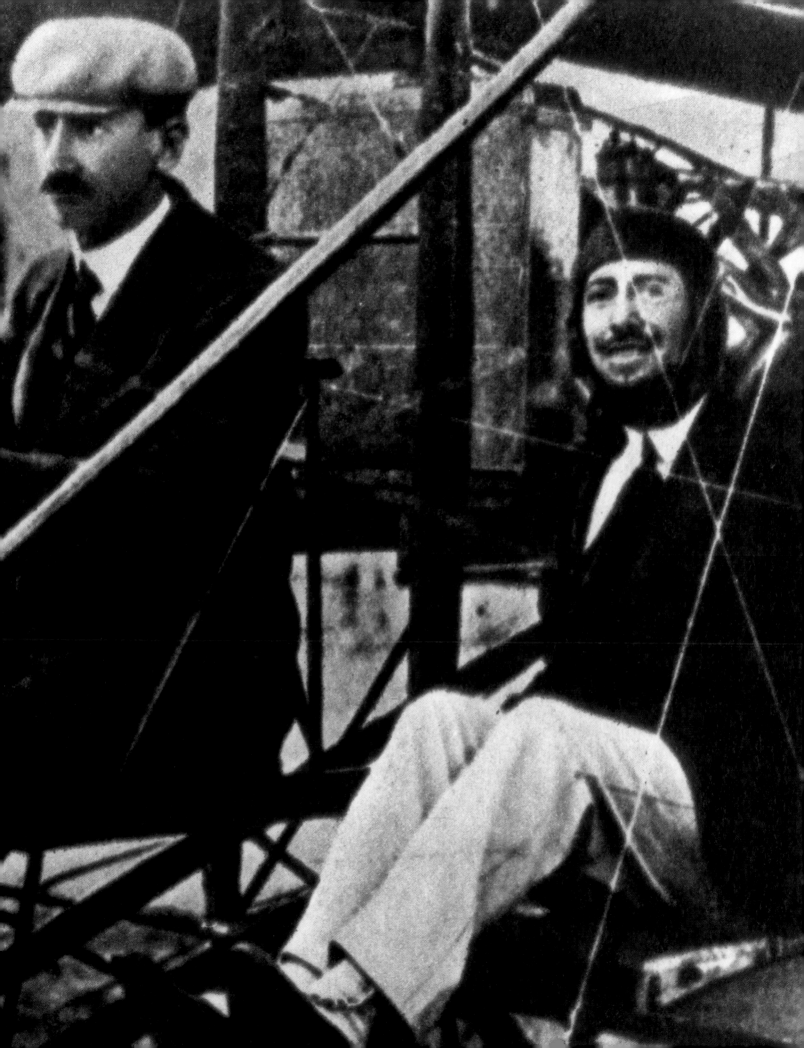

MESSENGERS OF A VASTER LIFE

Robert Wohl

The airplane, advance guard of the conquering armies of the New Age, the airplane arouses our energy and our faith.

—Le Corbusier, 1935

The world-transforming event whose centenary we celebrate in December 2003 slipped by almost unnoticed by the general public. The remoteness of Kitty Hawk, the secretiveness of the Wrights who feared that others would steal their invention, and the skepticism of a wary community of aeronautical experts combined to eclipse temporarily one of the greatest technological breakthroughs in history, the achievement of powered flight.

All this changed four and a half years later, in August 1908, when Wilbur and Orville agreed to demonstrate their Flyer to the French at a horseracing track near Le Mans (fig. 1) and to American military observers at Fort Myers, Virginia, just outside Washington, D.C. Their reasons for displaying the attributes of their flying machine to the outside world were not disinterested. At stake were lucrative contracts with the French and American governments, which were approved despite Orville's crash on September 17 and the

Gabriele D'Annunzio and Glenn Curtiss, September 1909, large detail of fig. 4 (see p. 19)

17

death of his passenger, Lieutenant Thomas Selfridge, the first victim of heavier-than-air flight.

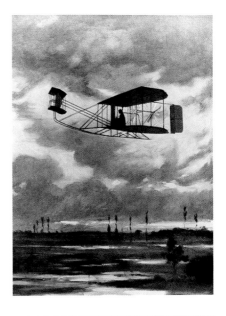

The year 1909 was the *annus mirabilis* of aviation. On the morning of July 25 Louis Blériot, in what now appears an extraordinary gamble, took flight from his base near Calais and headed across the fogbound waters of the English Channel (fig. 2). Thirty-six and a half minutes later, after a battle with adverse winds, down-drafts, and a motor prone to overheating, the exhausted pilot landed on a meadow near Dover Castle. He would receive a welcome in London and Paris worthy of a conquering prince, though one "without a scepter or a palace."[1] A month later half a million people made their way to Reims, the capital of the Champagne region, to attend a weeklong air show, where Blériot and other famous aviators astounded the spectators with their death-defying maneuvers (fig. 3). One even reached the aston-ishing height of 508 feet. Every record the Wrights had set during the previous year was broken. Where would it all end, one French journalist wondered, pondering the week's results? "Will our lives be better? Will we ourselves be better?"[2]

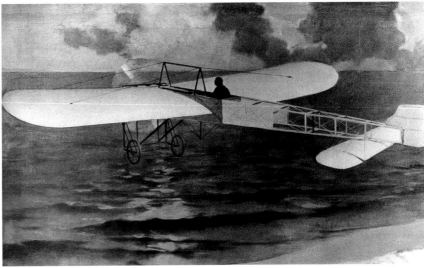

One renowned Italian writer had no doubt about the answer to this question. In an interview with the Parisian news-paper *Le Matin*, Gabriele D'Annunzio pro-claimed that aviation carried within it "the promise of a profound metamorphosis of civic life" that would have far-reaching consequences for aesthetics as well as for war and peace. High in the sky, above the clouds, customs barriers, property rights, and frontiers lost their meaning. Aviation would create a new civilization and a new form of life. New idols, new laws, and new rituals would appear. Rela-tions among nations would be trans-formed. The "Republic of the Air" would exile the wicked and the parasites and would open itself to "men of goodwill." The "elect" would abandon their "chrysalis of weight" and take flight. "A new civilization, a new life, new skies! Where is the poet who will be capable of singing this new epic?" (fig. 4).[3]

Fig. 1. Wilbur Wright flying at Auvours near Le Mans in the twilight on September 21, 1908

Fig. 2. Blériot sets forth across the Channel

In his novel *Perhaps Yes, Perhaps No* (*Forse che sì forse che no*), published shortly after this interview, D'Annunzio volunteered himself as the poet of the new air-minded civilization he had predicted. Its protagonist, Paolo Tarsis, like Blériot "a builder of wings" and a record-setting competitor in air meets, escapes from a

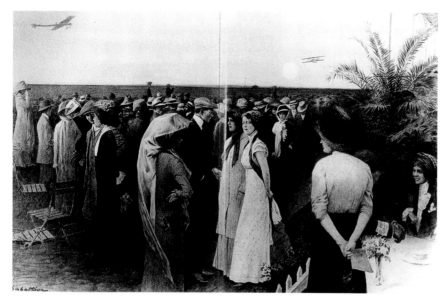

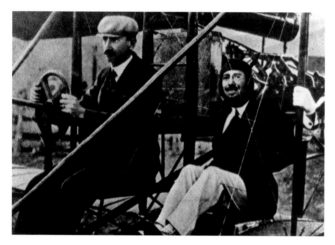

Fig. 3. Spectators at the Reims air show in August 1909

Fig. 4. D'Annunzio prepares to take his first flight with Glenn Curtiss during the Brescia air show, September 1909

destructive love affair and a psychologically twisted mistress by flying from the west coast of Italy to the island of Sardinia, where he is spiritually reborn. D'Annunzio intuited what would become the recurring refrain of aviation literature. For him, aviation was not a sport, still less a mode of transportation; it was a means of moral and spiritual transcendence that elevated man above his fate. This justified the sacrifice of lives that conquering the air would inevitably entail. By accepting the terrible risks of flight and challenging death, D'Annunzio believed, the new elect of pilots could create a religion of speed and escape from the limitations of everyday life. The aviator was "the messenger of a vaster life," a technological superman whose mission was to triumph over space and time. The earthbound would have to settle for the vicarious satisfaction they could feel for these "celestial helmsmen" who looked down on those below with a scornful smile.[4]

D'Annunzio was by no means alone among European writers in thinking that the achievement of flight had been, above all, an aesthetic and moral event. For his countryman, Filippo Tommaso Marinetti, the founder of Futurism, aviation was not just a topic for literature; it had *replaced* literature and rendered the romantic and sentimental sensibility of the nineteenth century obsolete. Men would merge with motors. Their will would become like steel. Their vital organs would become as interchangeable as a flying machine's spare parts. "We [futurists] believe in the possibility of an incalculable number of human transformations, and we say without smiling that wings sleep in the flesh of man."[5]

If wings slept in the flesh of man, why go on producing literature? Why not fly? One Russian futurist writer came to this conclusion. In 1910, soon after publishing his first novel, Vasily Kamensky abandoned literature to devote himself to aviation. He later wrote: "I wanted to participate in the great discovery not merely with words, but with deeds. What are poems and novels? The airplane—that is the truest achievement of our time. . . . If we are people of the motorized present, poets of

universal dynamism, newcomers and messengers of the future, masters of action and activity, enthusiastic builders of new forms of life—then we must be, we have no choice but to be flyers."[6]

Pre-1914 painters also responded to the miracle of flight. Henri Rousseau, known as *Le Douanier* because of his employment in a customhouse, was one of the first to seize on the flying machine as a symbol of modernity, placing his version of the Wright Flyer in the sky above lazy fishermen, a juxtaposition of the old and the new (fig. 5). The cubists Pablo Picasso and Georges Braque were so taken by the flights they witnessed at Issy-les-Moulineaux, a Parisian suburb with

Fig. 5. Henri Rousseau, *Anglers (Les Pêcheurs à la ligne)*, 1908–9. Oil on canvas, 21⅝ x 18⅛ in. (55 x 46 cm). Musée de l'Orangerie, Paris

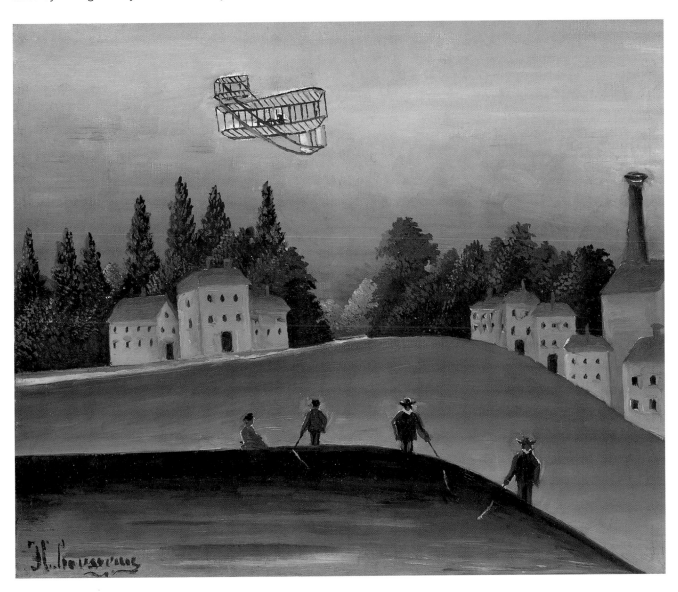

Fig. 6. Robert Delaunay, *Homage to Blériot (L'Hommage à Blériot)*, 1914. Tempera on canvas, 98½ x 99 in. (250.5 x 251.5 cm). Öffentliche Kunstsammlung Basel

an airfield, that they tried their hand at making model aircraft. In 1912 Picasso made several paintings titled *"Notre avenir est dans l'air"* (*"Our Future is in the Air"*), indicating his awareness of the extent to which French national security had become identified in the public mind with primacy in aviation. Inspired by his friend Rousseau, Robert Delaunay also began to insert images of aircraft into his paintings. *The Cardiff Team* (*L'Equipe de Cardiff*) combines a biplane, a Ferris wheel, and a rugby match in a powerful image of modernity (see p. 3). Then, in 1914, Delaunay created an even more ambitious work, *Homage to Blériot* (*L'Hommage à Blériot*), that sought to suggest through its manipulation of aviation symbols and its explosion of color the ascension of humanity toward a higher spiritual realm (fig. 6). To our twenty-first-century eyes, Delaunay's paintings stand as eloquent documents attesting to the innocent exhilaration with which the airplane was greeted during its first decade of life. To Delaunay and his artist-wife, Sonia, the form of the propeller would become a symbol of cosmic energy: "Solar power and power of the Earth."[7]

To be sure, not all Western poets and intellectuals greeted the coming of the flying machine with the unqualified enthusiasm of D'Annunzio, Marinetti, Kamensky, and Delaunay. Some, like the Viennese journalist and critic Karl Kraus, feared that their contemporaries were becoming the prisoners of their own inventions. They had been clever enough to create sophisticated machines, but they lacked the intelligence to use them properly. The British novelist John Galsworthy also deplored what he called "the prostitution of the conquest of the air to the ends of warfare." "If ever men presented a spectacle of sheer inanity it is now," he wrote in 1911, "when, having at long last triumphed in their struggle to subordinate to their welfare the unconquerable element, they have straightaway commenced to defile that element, so heroically mastered, by filling it with engines of destruction. If ever the gods were justified of their ironic smile—by the gods, it is now!"[8]

But Kraus and Galsworthy were exceptions. Even writers who deplored the building up of nationalist tensions and the cult of violence in pre-1914 Europe could not suppress their enthusiasm for aviation. The passion for flight and the willingness of young aviators to risk their lives, they felt, were signs of vitality and a demonstration that, contrary to what many claimed, the Western peoples were not in decline. Ancient virtues that many feared had been eroded by urban civilization had reappeared. Heroism had been reborn. The "huddled masses" had been forced to raise their faces away from the dirty city pavements toward the purity of the sky (fig. 7). Or, as Edmond Rostand, celebrated author of *Cyrano de Bergerac*, put it in the long poem, "Hymn of the Wing," which he devoted to the new technology and its apprentices:

Higher! Ever higher, pilot! And glory to men
Of great will!
Glory to those stealers of the flame that we are!
Glory to humanity![9]

Looking at pre-1918 Western culture, one cannot help but be struck by the variety of contexts in which aviation metaphors appeared. Flight could signify the act of imagination and artistic creation, escape from the constraints of a dreary bourgeois world, triumph over the limitations placed on human beings by nature, ascension toward a new system of perception, or sometimes union with the angels and God. The airplane, in the hands of a painter like the Russian Kazimir Malevich, became a symbol for liberation from the limitations of gravity and earthly space. (Malevich's *Suprematist Composition: Airplane Flying* is illustrated on p. 5). The connection between avant-garde art and aviation was so natural and so accepted that when the young photographer Jacques-Henri Lartigue attended the ballet *Rite of Spring* in June 1913, what he liked about Igor Stravinsky's music was that its throbbing rhythms—*vroum, vroum, vroum*—reminded him of the roar of airplane engines taking off at Issy-les-Moulineaux.[10]

One might guess that the trauma of World War I would have had the effect of inspiring second thoughts about the conquest of the air. This was not the case. True, the inhabitants of Paris and London got a preview of aircraft, as H. G. Wells had described them in his 1908 novel *War in the Air*, "dripping death" from the sky. Watching a zeppelin raid over London, D. H. Lawrence had visions of apocalypse and the birth of a new cosmos symbolized by the German airship "calm and drifting

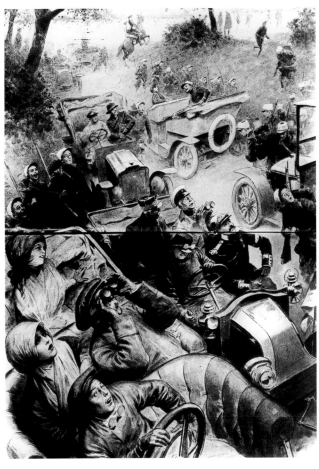

Fig. 7. Awed spectators observe French aviators during the army maneuvers of 1910. Drawing by Louis Sabattier

in a glow of light like a new moon, with its light bursting in flashes on the ground." "So it is the end," he wrote in a letter to Lady Ottoline Morrell. "Our world is gone, and we are like dust in the air."[11]

But the dominant image of the aviator that emerged from the war was not that of the merciless bombadier who threatened an end to civilization but rather that of the flying ace, a knight of the air who jousted with blazing machine guns in chivalrous combat above the stalemated and entrenched armies of the ground. Heroes larger than life were driven to seek combat in the clouds—in W. B. Yeats's stirring phrase—not by law or duty nor by cheering crowds but by "a lonely impulse of delight."[12]

Charles Lindbergh was only one of thousands of young boys who decided to become an aviator after reading an account of the adventures of a World War I ace. After a brief apprenticeship as a barnstormer, wing-walker, Army Air Force cadet, and airmail pilot, he went on to become the most famous airman in history. Even today, it is difficult to explain his extraordinary and persisting celebrity. Contrary to what many people believe, he was not the first person to fly the Atlantic. A long train of aviators before him (beginning with the American pilot A. C. Read and his crew in 1919) had made spectacular overseas flights that had captured the imagination of the public and the headlines of newspapers throughout the world. But no one before Lindbergh had made the flight across the Atlantic alone, and no one before him had ever so charismatically incarnated the promise of the airplane to change the world, a mission he invoked when he entitled his 1927 autobiography *"We,"* suggesting the fusion that Marinetti had earlier predicted between human beings and their machines.

To be sure, when Lindbergh made his prizewinning flight from New York to Paris in May 1927, the groundwork had already been laid for the explosion of aviation culture that would occur over the next decade. In Italy, for example, Benito Mussolini had understood that aviation could be used for ideological purposes to identify the new fascist regime with speed, audacity, and modernity. Aviators figured prominently in Mussolini's entourage when he came to power in October 1922, and one of his first actions as premier was to create a Ministry of Aviation whose portfolio he personally assumed. His goal was not just to develop a powerful air force—indispensable to Italy's future imperial expansion—but to cultivate an aviation consciousness among the Italian people. As he explained to a gathering of aviators in 1923, not everyone could learn to fly. Not everyone should learn to fly. Flying would remain the privilege of an aristocracy. But everyone should long to fly and regard aviators with envy. "All devoted citizens must follow with profound feeling the development of Italian wings."[13]

To implement this program, Mussolini sponsored highly publicized record-

breaking flights by Italian aviators, staged spectacular air shows for the public, and built a monumental Air Ministry in the center of Rome whose lavish murals suggested the dominance of Italian air power. His minister of aviation, Italo Balbo, led flotillas of Italian seaplanes across the South and North Atlantic, reaching in 1933 as far as Chicago, whose city council erected a monument to Balbo along Lake Michigan and named one of the city's streets after him. Italian artists were commissioned to create works inspired by aeronautical feats, postage stamps were issued to commemorate Italian aerial triumphs, and Mussolini, who had himself learned how to fly, was often photographed at the controls of Italian military airplanes. Stimulated by this environment and spurred by their leader Marinetti, Italian futurist painters created an impressive body of work called *aeropittura* (air painting), the most sustained effort made in the 1930s to apply new visual perspectives gained from flight to transform the way we represent the world (figs. 8, 9).

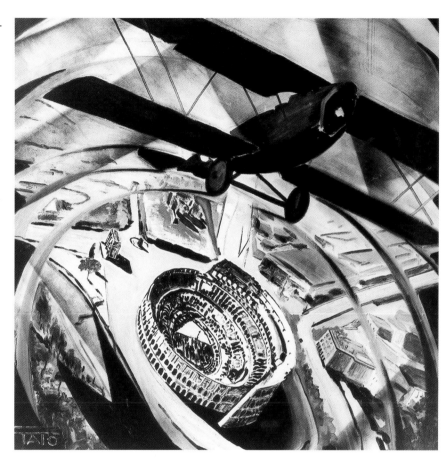

Fig. 8. Tato, *Spiralling in Flight over the Colosseum (Sarvolando in spirale il Colosseo)*, 1931. Oil on canvas, 31¹/₂ x 31¹/₂ in. (80 x 80 cm). Private collection

In France aviation also became a major source of cultural inspiration. Ever since Wilbur Wright had made his first flights near Le Mans in August 1908, French writers had been inclined to identify aviators with poets and airplanes with objets d'art. Marcel Proust found the metaphor of flight so compelling that he used it in his novel *In Search of Lost Time* (*A la recherche du temps perdu*) to express his ascension toward "the silent heights of memory."[14] Jean Cocteau wrote elegant verses celebrating the exploits of his friend, the famous aviator Rolland Garros, and identifying himself as an "aviator of ink." Several best-selling books dealt with the adventures of French aviators during the Great War, the most influential being Henry Bordeaux's biography of the ace Georges Guynemer. In 1924 Louise Faure-Favier, author of the first novel devoted to commercial aviation pilots, called on French writers to "go up in planes."[15]

But it was not until the publication in 1931 of *Night Flight* (*Vol de nuit*) by Antoine

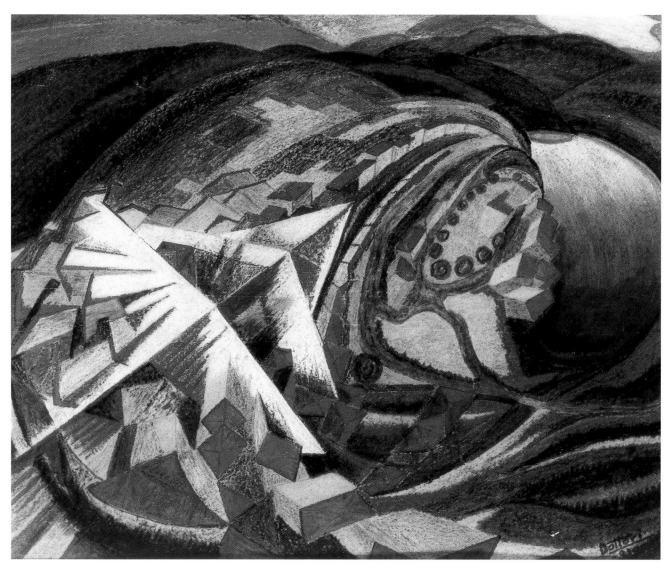

Fig. 9. Gerardo Dottori, *Flying over the Town at a Speed of 300 Km (A 300 km sulla città)*, 1930. Mixed media on pasteboard, 18 7/8 x 25 3/8 in. (48 x 60 cm). Private collection

de Saint-Exupéry that the aviation novel was consecrated by the French literary establishment. Drawing on his own experiences as an airmail pilot and those of his friends, Saint-Exupéry created a portrait of a group of men whose dedication to their craft as aviators was such that it bore no relationship to the cargo that they carried. Flying, for them, was a means of spiritual transcendence that raised them above themselves and allowed them to achieve nobility, even if doing so required their death. Their monklike leader, Rivière, lived by a code so austere that he never considered putting the safety of the individual above the common mission. The mail must go through, no matter what the cost. In a preface to the novel that drew as

much attention as the novel itself, André Gide, the reigning pope of the French literary establishment, expressed his gratitude to Saint-Exupéry for having elucidated a paradoxical truth that the French badly needed to understand: namely, "that man's happiness is not to be found in liberty, but in the acceptance of a duty."[16]

One of the features of aviation culture from the beginning was the ease with which themes and images traversed the intellectual distance separating modernist and avant-garde art forms from the culture of the masses. Holly-wood discovered aviation in the early 1920s and quickly learned how to adapt the airplane aesthetic to its own commercial ends. The translation of the culture of flight to film was all the smoother because many of the directors, actors, and writers who participated in the making of Hollywood aviation films were themselves pilots, some of whom had flown during World War I.

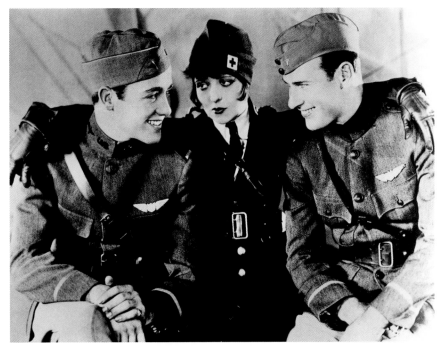

Fig. 10. The stars of *Wings*, Clara Bow as a volunteer between the pilots played by Charles "Buddy" Rogers (left) and Richard Arlen (right)

In view of this and the flourishing cult of aces in popular magazines and books, it is not surprising that the aviation topic for which Hollywood showed the most enthusiasm during the late 1920s and 1930s was combat in the skies of France. William Wellman's *Wings* (fig. 10)—winner of the first Academy Award in 1928 and dedicated to Charles Lindbergh, whose flight preceded by only a few months the release of the film—portrayed in unforgettable images the mechanical ballet of scout planes making deadly passes in the air. *Wings* managed to give the impression that the actors had become one with their machines, an uncanny realization of Marinetti's prewar futurist fantasies, but one, unlike his, that reached an audience of millions. Determined to go *Wings* one better, the millionaire aviator Howard Hughes invested four million dollars of his own money—a fortune in those days—to produce *Hell's Angels*, an epic of the air war, which received a spectacular premiere at Graumann's Chinese Theatre in May 1930. As late as 1938, in the direct aftermath of the Munich agreements, Hollywood was busy remaking Howard Hawks's *Dawn Patrol*, a bitter yet exhilarating look back at the life (and death) of British fighter pilots during World War I.

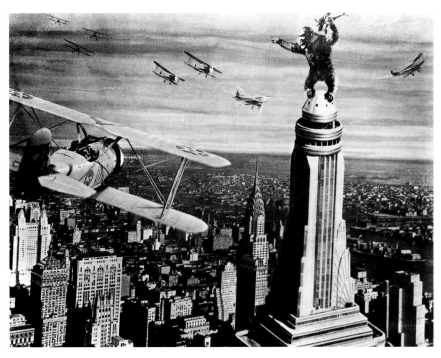

Fig. 11. Biplanes attack King Kong atop the Empire State Building

But Hollywood's passion for aviation was evident also in other classic films of the 1930s, such as Merian C. Cooper's *King Kong* (fig. 11), Frank Capra's *Lost Horizon*, and RKO's 1933 musical *Flying down to Rio*, which introduced Fred Astaire to screen audiences and paired him for the first time with Ginger Rogers. *Flying down to Rio* was in many ways Hollywood's most astonishing and exuberant display of aviation madness. Rising above an inconsequential plot based on a triangle involving a sultry Brazilian beauty played by Dolores del Rio, her rich Brazilian fiancé, and an American aviator-bandleader, the film throbs with Latin rhythms, the roar of aircraft engines, and the excitement of exotic settings. The genius of this vibrantly air-minded movie lies in the realization by its makers that flight had become a form of spectacle. Deprived of the use of the nightclub in which they had been appearing, the dancers take to the sky and, strapped to the wings of airplanes, perform their act above the city. Afterward, in a surprising twist, del Rio's fiancé arranges for her to be married to the American bandleader by the captain of the airplane, then parachutes out over the city, leaving the couple to fly away on their honeymoon. The entire film is full of aviation motifs, designed by Carroll Clark and Van Nest Polglass, and leaves an impression of irrepressible aeronautical enthusiasm and the limitless possibilities of love and international communication opened up by the new technology.

From such romantic and idealistic heights, the cult of aviation was bound to fall. When *Flying down to Rio* was released, Adolf Hitler had been in power for eleven months. With every year thereafter, the prospect of war seemed more threatening, and many believed that if war came, it would be decided in the air. The bombing of the Basque town of Guernica in 1937 during the Spanish Civil War provided a brutal example of what lay in store for civilian populations. And in the years that followed, for millions of people in Europe and Asia the droning sound of aircraft engines and the sight of airplane wings became identified, not with godlike heroes, but with air raid sirens, death-dealing explosives raining from the sky, gutted buildings, shrieking children, and crowded shelters in which families huddled

together as the ground above them shook. The incineration of entire cities, such as Coventry, Hamburg, Dresden, and Tokyo, was a cruel reminder that, far from bringing an end to war as many before 1914 had claimed or hoped it would, the airplane had instead made it impossible to maintain a distinction between combatants and civilians. After Hiroshima and Nagasaki, the world would live with the knowledge that the age of aviation might culminate in the end of civilization and the destruction of the human race. Even aviation's most eloquent apostle, Charles Lindbergh, wondered why he should devote his life to flight "if aircraft are to ruin the nations which produce them? Why work for the idol of science when it demands the sacrifice of cities full of children; when it makes robots out of men and blinds their eyes to God?"[17]

For all his misgivings, Lindbergh reluctantly acknowledged that Western man could not live without science and technology. And indeed the great expansion and democratization of commercial aviation began precisely at the time when Lindbergh wrote these lines, in 1948. More and more people began to travel by air; airports were expanded into self-contained cities; and airline pilots began to acquire the reputation for sober reliability and safety that they have today, high-tech bus drivers distinguished by the fact that their highways are thousands of feet above the ground and their salaries correspondingly lofty. As airspace is more and more controlled, as airports become increasingly congested, as security concerns constrict the air traveler and undermine the equation of airplanes with speed, the idea of flight as liberation seems remote, the utopia of a distant past.

And yet, as this exhibition so amply demonstrates, even in its post–World War II forms, flight retains its ability to stimulate artists. Though aviation may no longer be regarded as "the advance guard of the conquering armies of the New Age," as the architect and city planner Le Corbusier believed, it remains an inevitable and overwhelming presence in our everyday life: a source of frustration, irritation, discomfort, fear—and ultimately, wonder. Wonder that those hulking, metallic, unwelcoming machines to which we reluctantly entrust our lives can actually leave the earth and safely return to land, defying gravity. For being the first to show that heavier-than-air machines could fly, we owe the Wrights, those two dour sons of Ohio, an eternal, if grudging, debt of gratitude.

NOTES

Epigraph: Le Corbusier [Charles Jeanneret-Gris], *Aircraft* (1935; New York: Universe, 1985), 6.

1. A line chanted by wandering singers on the streets of Paris on the occasion of Blériot's triumphant return from England, according to *Le Petit Parisien*, July 29, 1909.

2. H. Desgrange, in *L'Auto*, August 30, 1909.

3. In an interview with *Le Matin*, quoted by Ricciotto Canudo, "Gabriele D'Annunzio et la vie moderne," *Mercure de France*, July 1, 1910, 53. D'Annunzio had attended the air show at Brescia in September 1909, one of the many important aeronautical events that took place during the last six months of that year. For an entertaining and well-informed account of this event in its larger context, see Peter Demetz, *The Air Show at Brescia, 1909* (New York: Farrar, Straus and Giroux, 2002).

4. Gabriele D'Annunzio, *Forse che sì forse che no* (Milan: Treves, 1910), 230, 78–79.

5. Quoted by Renzo de Felici in his essay "L'avanguardia futurista," in F. T. Marinetti, *Taccuini, 1915–1922*, ed. Alberto Bertoni (Bologna: Il Mulino, 1987), xiii. For the replacement of literature by technology, see Giovanni Lista, "Sur un vol de Beaumont ou 'Le Monoplan du pape,'" *Europe*, January–March 1975, 60.

6. Vasily Kamensky, *Put' entusiasta* (The path of an enthusiast) (New York: Orpheus, 1986), 106–7.

7. Robert Delaunay, *Du Cubisme à l'art abstrait*, ed. Pierre Francastel (Paris: S.E.V.P.E.N., 1957), 63–64. For examples of Sonia Delaunay's continuing fascination with circular forms, see *Sonia Delaunay. La Moderne*, exh. cat. by Jan Castro (Tokyo: The Japan Association of Art Museums, 2002).

8. In a letter to the *Times* of London, April 7, 1911.

9. Edmond Rostand, *Le Cantique de l'aile* (Paris: Eugène Faquelle, 1922), 16.

10. Jacques-Henri Lartigue, *Mémoires sans mémoire* (Paris: Editions Robert Laffont), 150.

11. D. H. Lawrence to Ottoline Morrell, September 9, 1915, from D. H. Lawrence, *Letters*, vol. 2, ed. G. J. Zytaruk and J. T. Boulton (Cambridge: Cambridge University Press, 1981), 389–90.

12. From "An Irish Airman Foresees His Death," in *Men Who March Away: Poems of the First World War*, ed. I. M. Parsons (New York: Viking, 1965), 47.

13. Quoted by Guido Mattioli in *Mussolini aviatore*, 3d ed. (Rome: L'Aviazione, 1938), 133.

14. Marcel Proust, *A la recherche du temps perdu* (Paris: Gallimard, 1954), vol. 3, 838.

15. *Les Nouvelles Littéraires*, August 16, 1924, 1.

16. André Gide, introduction to Antoine de Saint-Exupéry, *Vol de nuit* (Paris: Gallimard, 1951), 13–15.

17. Charles A. Lindbergh, *Of Flight and Life* (New York: Scribners, 1948), 51.

THE LEGACY OF KITTY HAWK:
A CENTURY OF FLIGHT IN ART

Anne Collins Goodyear

On December 17, 1903, at 10:35 A.M., the shutter of a camera opened and closed, capturing what would become, as the historian Tom Crouch reports, "perhaps the most reproduced photograph of all time" (fig. 1).[1] A horizontal structure levitates above the ground, bearing the weight of a single man, whose dark figure lies prone against it. Another figure, striking in his verticality, appears to stand beside the hovering white structure. In the foreground we spot a small wooden prop, shovel, a can with tools, and a coil box, capable of creating electrical sparks to start an engine.[2] The process of developing this exposure, which records the first successful powered flight by a heavier-than-air craft, and others like it, would be, Wilbur Wright later explained, "as thrilling as any [time] in the field, when the image begins to appear on the plate and it is yet an open question whether we have a patch of flying machine, or merely a patch of open sky."[3]

The excitement experienced by Wilbur as photographic images of the world's first flying machines appeared before his eyes has an analogue in the work of artists who, during the

Anselm Kiefer, *Angel of History*, large detail (see p. 38)

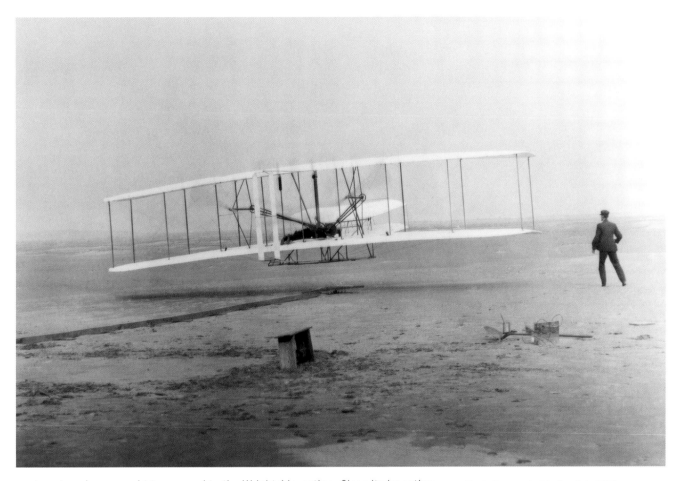

Fig. 1. Photograph of the first flight, 1903

past century, have sought to respond to the Wrights' invention. Since its inception, the airplane has not merely provided a new object for artists to picture but has fundamentally altered accepted patterns of human perception, providing unprecedented visual and physical experiences.[4] Aerial perspective both compressed space and created a new mode of interpreting the Earth from the sky, while the sensation of flight stimulated a new consciousness of gravity. The machine capable of bringing about such transformations became itself an object of reverence, and the inventors became a symbol of possibility. As a means of exploring this rich legacy, this essay juxtaposes a series of interpretations of the Wrights' accomplishment at Kitty Hawk created over the course of the twentieth century. Each work, while focusing on a common theme, provides a unique vantage point from which to survey the wide range of implications flight has had for artists.

Mark Tansey's 1992 painting *Picasso and Braque* (see p. 197), through both its virtually monochromatic palette and its subject matter, pays tribute to the photo-

graphic tradition that has been associated with flight since the time of its inception. Merging the Wrights' famous photograph of the first flight with an earlier picture of A. M. Herring piloting a glider designed by Octave Chanute, Tansey casts Pablo Picasso and Georges Braque as Orville and Wilbur Wright, respectively.[5] This historical compression, or "airplane view of time," as the Bauhaus artist László Moholy-Nagy would later describe this phenomenon, calls attention to the relationship of the invention of flight to the development of modern art, particularly pictorial abstraction, in the opening years of the twentieth century.[6]

Tansey's reference to parallels between the historical construction of the Wright brothers' success and that of Picasso and Braque in "pioneering cubism" reflects scholarship that has linked the artists' own view of their formal innovations and the feats of the American inventors.[7] As William Rubin and other art historians have noted, correspondence between the painters and their dealer, Daniel-Henri Kahnweiler, indicates that by the summer of 1912 Braque had adopted the nickname "Wilbur Braque."[8] This association may have been stimulated initially by the juxtaposition of a 1908 review of Braque's earliest cubist paintings with an announcement of a new record for height set by Wilbur Wright.[9] However, the appearance of the nickname in the summer of 1912 may also reflect Picasso's comparison of paper sculptures recently crafted by Braque to the biplanes flown by the Wrights.[10] The year would represent a breakthrough period for the artists akin to that experienced by the Wrights at Kitty Hawk. With the construction of their first cubist sculptures and collages, the artists undertook an intense investigation of the relationship of two- to three-dimensional form. That spring Picasso created a series of three still lifes, clearly influenced by the invention of collage, that incorporated portions of the cover of a contemporary pamphlet advocating military aviation, declaring "Our Future Is in the Air" (fig. 2). The paintings indicated the artist's allegiance to the new invention, which offered human beings an unprecedented opportunity "to navigate in three dimensions simultaneously"—an experience Picasso and Braque sought to conquer through a radical approach to shaping form.[11]

Fig. 2. Pablo Picasso, *"Notre Avenir est dans l'air" (The Scallop Shell)*, 1912. Oil on canvas, 15 x 21³/₄ in. (38.1 x 55.2 cm). Private collection

While the cubists were by no means the only members of the avant-garde to respond to the airplane, the association of this influential modern style with aviation became so strong that by the 1930s, many passengers and pilots would quite

literally "see" flight through cubist lenses, another idea conveyed by Tansey's painting.[12] Gertrude Stein's 1938 biography of Picasso equates his artistic achievements with his seeming anticipation of aerial views. "[I]t is very interesting knowing that Picasso had never seen the earth from an airplane," writes Stein, "that being twentieth century he inevitably knew that the earth is not the same as in the nineteenth century, he knew it, he made it, inevitably he made it different and what he made was a thing now that the world can see."[13] Alfred Noyes's poem "Cubism," published the same year, with its playful conflation of mechanical and pictorial "planes," similarly reinforces the link between aerial perspective and this movement. Describing the view from an airplane as "Blue cubes, yellow cubes, crimson cubes and / brown," Noyes continues his comparison to avant-garde painting, noting "Planes of Anglo-Saxon art, planes of modern mirth, / From an aeroplane above—or below—the earth."[14]

Among the young modernists to be fascinated by flight during the 1930s was Theodore Roszak, a constructivist who aspired to forge a relationship between artistic vision and industrial production. Intrigued by the futuristic visions of the city of such designers as Norman Bel Geddes, Roszak created sculptural and graphic representations of a wide variety of aircraft and related structures, such as airports and observatories.[15] Roszak's enthusiasm for flight was so great that he put his skills to work for the aircraft industry during World War II, designing and building bombers to advance the Allied cause. Ironically, Roszak's patriotic service would help bring about, in his own words, "an almost complete reversal of ideas and feelings."[16] Horrified by the devastation caused by the war, and particularly the atomic bombing of Hiroshima and Nagasaki, Roszak lamented the appropriation of aviation for what he viewed as gratuitous destruction.

Spectre of Kitty Hawk, 1946–47 (fig. 3), marked a major shift in the artist's career, just as the period itself represented a watershed in the history of American art.[17] With its large scale, biomorphic form, and expressive lines, Roszak's sculpture and drawings related to it demonstrate a link to the emergence of Abstract Expressionism, the "modern" techniques and forms which Jackson Pollock attributed in 1950 to "this age, the airplane, the atom bomb, the radio."[18] The importance of *Spectre* for Roszak is suggested by the great number of highly charged preparatory studies and finished drawings that relate to it. A drawing from 1946 in the collection of the Hirshhorn Museum and Sculpture Garden, for example, shows a monstrous creature ready to burst out of the paper that contains it. Its energy is conveyed through spatters of wash below it, to its left, and to its right. The power of an explosion seems to emanate from its side. Roszak was quite clear about what this imagery represented, explaining:

Fig. 3. Theodore Roszak, *Spectre of Kitty Hawk*, 1946–47. Welded and hammered steel brazed with bronze and brass, 40¼ x 18 x 15 in. (102.2 x 45.7 x 38.1 cm). The Museum of Modern Art, New York; Purchase. © Estate of Theodore Roszak/Licensed by VAGA, New York, NY

It has to do with the large concept of flight and the way in which it affected the whole legend that has now become part of the American scene, regarding the Wright brothers' trial at Kitty Hawk. . . . The whole idea here is that the aircraft has been used in a very destructive way and it recalled the superior dominance of the pterodactyl that at one time was also the scourge of the air and the earth and is a kind of reincarnation of its evil intent, so therefore its visitation at Kitty Hawk was the embodiment again of the aircraft assuming the role of the pterodactyl . . . this visitation of force back to the same origin of flight, excepting that this was in terms of man-made possibilities rather than the natural evolution of the species.[19]

The metamorphosis of the airplane into an instrument of destruction crushed the artist's youthful association of flight with utopian communities of the future and seemed to him to represent a perversion of the inventor's wishes. "I think it is interesting and relevant that Orville Wright in the last of his life mused about his brain child with apprehension and misgivings," wrote Roszak in an undated statement. "He died a disillusioned man, and the Myth of Icarus completes another circle, tangent to pragmatic America."[20] If Roszak's perspective on Orville's reaction to aerial bombings reveals more about the artist's own misgivings than those of the inventor, the artist nevertheless captures the transformation of the myth of Kitty Hawk, from symbol of optimism to an awareness of the unforeseen consequences of new technologies.[21]

For the artist Robert Rauschenberg, the legacy of Kitty Hawk took on a new significance in the 1960s. In 1971 he completed his *Cardbird* series, a group of eight cardboard collages "that suggest, despite their primitive quality of animation, the spirit of flight," as the curator Ruth Fine has noted.[22] Rauschenberg offered this account of his activities in the period leading up to the *Cardbird* series:

For over five years I have deliberately used every opportunity with my work to create a focus on world problems, local atrocities and in some rare instances celebrate men's accomplishments. I have strained in collecting influences to bring about a more realistic relationship between artist, science, and business, in a world that is risking annihilation for the sake of a buck. It is impossible to have progress without conscience.[23]

It is appropriate to include Rauschenberg's remark in the context of a body of work linked to the concept of flight. Among the "men's accomplishments" he had recently celebrated, as he would continue to do, were those of the Wright brothers and the National Aeronautics and Space Administration (NASA). The year 1971 marked not only the completion of Rauschenberg's *Cardbirds* but also the

conclusion of an ambitious series of thirty-three lithographs entitled *Stoned Moon*, created in honor of the launch of Apollo 11.[24] One of the works in the series, *Trust Zone*, executed in 1969, incorporates a photograph of the first flight. Layering a map he used to navigate Cape Kennedy (as Cape Canaveral was known from 1963 to 1973) while attending the launch of Apollo 11, a diagram of an astronaut's suit, and the famous photograph from Kitty Hawk, Rauschenberg relates the origins of heavier-than-air flight to the space age.[25] The reversed orientation of the photograph creates a visual parallel between Wilbur and the astronaut pictured in the diagram. At the same time, Rauschenberg's placement of this image in the lower register of the work communicates that the Wright brothers' achievement represents the foundation for space flight. The astronaut's lunar boot, clearly labeled, rests squarely on the sands of Kitty Hawk. Its importance is highlighted by a circled X, a symbol Rauschenberg used to mark a critical area at Kennedy Space Center on his map.

The great number of works composing the *Stoned Moon* series and the large physical size of these lithographs testify to the new scale assumed by flight with the advent of the space age. In 1974 and 1975 Rauschenberg created two more lithographs honoring the achievements of the Wright brothers. These works, *Kitty Hawk* (1974; fig. 4) and *Killdevil Hill* (1974–75), boasting extraordinarily long vertical and horizontal orientations respectively, evoke the lift and soaring of objects in flight.[26] Incorporating pictures of a bicycle that Rauschenberg found in Paris, the works allude to the background of the brothers—bicycle makers—who achieved some of their greatest successes in France.[27] The free-floating bicycle in *Kitty Hawk*, which appears repeatedly upside down, suggests the freedom from gravity represented by the Wright brothers' invention. At the same time, the presence of the bike in a work about flight creates a discourse about different modes of travel, one that is heightened by the subtle inclusion of a picture of a donkey-drawn cart embedded in the lower right bicycle tire.[28] In the center of the work, Rauschenberg has incorporated the wording found on a crumpled bag: "[Sh]op Rite's Brand is the Answer"—a playful pun referring to the inventors of the airplane who discovered the "answer" to the age-old problem of human flight.[29] The same logo appears at left in *Killdevil Hill*, balancing a bicycle at right, whose forward tire rises into the air. In a final gesture to the history of aeronautics, Rauschenberg signed *Killdevil Hill* in reverse, evoking the legacy of Leonardo da Vinci, the Renaissance master whose broad interests extended to the design of flying machines.[30]

The technical achievements and heterogeneous materials associated with Rauschenberg's printmaking point to a broadening interest on the part of many artists during the 1960s in new technologies and new media. As traditional bound-

Fig. 4. Robert Rauschenberg. *Kitty Hawk*, 1974. Multicolor lithograph on brown Kraft wrapping paper, 79 x 40 in. (200.7 x 101.6 cm). National Gallery of Art, Washington. © Robert Rauschenberg/Licensed by VAGA, New York, NY

aries between artistic categories such as painting, sculpture, and theater dissolved, several artists explored the creation of flying sculpture that, like the airplane, took to the skies.[31] Charles Frazier's *Second Kittyhawk* project, which he intended to launch at Kitty Hawk to "stage an appropriate celebration for the ascent of the first flying sculpture," was to incorporate a wide range of flying machines, including helicopters, balloons, blimps, jets, and rockets, as well as airborne events such as an "air dance of Orville and Wilbur Wright." Partially realized as a 1966 Happening entitled *Gas*, staged with Allan Kaprow, the mere conception of *Second Kittyhawk* led Frazier to articulate what flight could mean for avant-garde art in the 1960s:

> *Self-propelled forms that move over the ground, through the air and under water will allow the sculptor to physically extend his work where he is no longer burdened by gravity. Somewhere between technology and art is another world. . . . [Flying sculpture] is the next logical step [in Western art], of releasing sculpture from the earth, off the ground into the air, out of the galleries and museums and into the world.[32]*

At the same time that Frazier was devising airborne flying sculptures, the Belgian artist Panamarenko, also intrigued by new materials and the merger of art and technology, was similarly experimenting with the creation of innovative flying machines, much as the Wright brothers had. Indeed, the artist's first one, *The Aircraft* (*Das Flugzeug*) of 1967, with an intricate system of treadles and drums, suggests an imaginative reinterpretation of the heritage of bicycle design that led to the first flight.

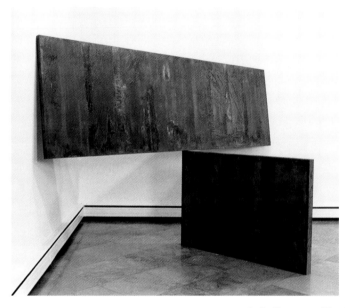

Fig. 5. Richard Serra, *Kitty Hawk*, 1983. Cor-ten steel, 2 pieces: 4 ft. x 14 ft. x 2 1/2 in. (1.2 m x 4.3 m x 6.4 cm), 4 ft. x 6 ft. x 4 in. (1.2 m x 1.8 m x 10.2 cm). Albright-Knox Art Gallery, Buffalo, New York; Mildred Bork Connors, Edmund Hayes, George B. and Jenny R. Mathews, and General Purchase Funds

Writing in 1967, the earth artist Robert Smithson, who consulted with the architectural and engineering firm Tippetts-Abbett-McCarthy-Stratton on the design of the Dallas–Fort Worth Airport, remarked: "As the aircraft ascends into higher and higher altitudes and flies at faster speeds, its meaning as an object changes—one could even say, reverses."[33] Directed at the development of new technologies of air flight, Smithson's prediction has been borne out by the response of contemporary sculpture to the significance of flight. Richard Serra's sculpture *Kitty Hawk* (fig. 5), of 1983, indeed "reverses" the significance of the aircraft its form emulates.[34] At five tons, Serra's sculpture, composed of two Cor-ten steel slabs, is more than fourteen times the weight of the seven-hundred-pound Wright Flyer. *Kitty Hawk* literalizes the metaphoric "weightiness" of the Wright brothers' accomplishment.[35]

Yet despite the work's heft, as the viewer walks around it, the steel structure achieves a visual dematerialization akin to the release from gravity provided by flight itself. Looking at the work straight on, the lower slab is suddenly reduced from a wide plank to a slender vertical prop above which the upper beam seems to hover. The effect is intensified when further investigation reveals that this upper steel member, longer than its lower partner, is pushed so far forward that only a portion of its width rests on the support below. Through precise and delicate engineering, as Serra's art demonstrates, even steel can float.[36] The magnitude of the surprise produced by the first flight is recapitulated through this experience of sculpture that appears to defy physical laws, precisely by harnessing them so ingeniously.

Like Serra, the German artist Anselm Kiefer has responded in recent years to the legacy of powered flight by creating sculptures of airplanes with materials that clearly render the objects incapable of flight. In Kiefer's hands, the construction of such inherently "flawed" flying machines becomes an instrument for exploring the metaphoric implications of flight. Born in the immediate aftermath of World War II, Kiefer has persistently treated themes of destruction and regeneration in his work. Since the late 1980s the airplane has assumed a vital role in Kiefer's iconography, both for its political and spiritual symbolism, as Kiefer's poignant sculpture of 1989, *Angel of History* (fig. 6), reveals.[37]

Created after the Berlin Wall fell, Kiefer's sculpture, whose title refers to a passage from Walter Benjamin's "Theses on the Philosophy of History," demands reflection on the role that the invention of the airplane has played for more than a century in shaping history and human sensibilities.[38] At approximately two thousand pounds, the lead sculpture, with a form designed for flight and a material composition that prohibits it, is a study in contradictions. Kiefer's *Angel of History* is a B-52 bomber that carries a cargo of poppy seeds. The white oxidation and brownish red rust apparent on its skin carry allusions to the alchemical transformation of base metals into silver and gold.[39] The dilapidated form, weighed down with leaden tomes and covered with dried poppies, captures an object in a state of transition, a dynamic occasioned by art and also by creative engineering—as with the metamorphosis, a century ago, of an earthbound craft into one that could fly.

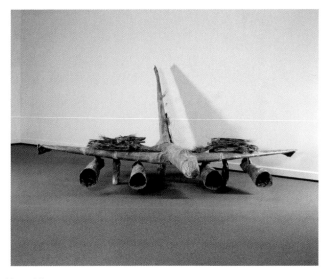

Fig. 6. Anselm Kiefer, *Angel of History*, 1989. Lead, glass, and poppies, 157½ x 197 x 78¾ in. (400 x 500 x 200 cm). National Gallery of Art, Washington; Eugene L. and Marie-Louise Garbáty Fund

"[The average person] is apt to forget, or perhaps he never knew, the centuries of effort which have finally enabled man to be a bird, centuries of patient desiring, which reach back at least as far as the Greek world of Icarus," writes Anne Morrow

Lindbergh. "For Icarus, trying to scale the skies with his waxen wings, was merely an expression of man's desire to fly. How long before him the unexpressed wish wrestled in the mind of men, no one can tell."[40] At Kitty Hawk, human beings finally flew. That accomplishment would provide a foundation for all future aeronautical adventures, from transportation, to experimental airships, to bombers, to space travel. It represented a fulfillment of ancient dreams, but also an achievement whose implications could not be controlled. While no brief overview of the impact of the airplane on art can hope to be comprehensive, this survey of artists' responses to the moment of the invention of heavier-than-air flight aims to demonstrate how the legacy of Kitty Hawk has endured and developed, inspiring art, time and time again, to attempt the impossible.

NOTES

This essay and the accompanying chronology benefited greatly from a meeting with John Coffey, Huston Paschal, David Steel, Barbara Bloemink, Dominick Pisano, Robert Wohl, and John Zukowsky in April 2001 at the North Carolina Museum of Art, where we were able to discuss broadly the impact of aviation on art and culture of the twentieth century. I am also indebted to Tom Crouch for his invaluable assistance with research pertaining to the Wright brothers and Kitty Hawk and to Frank H. Goodyear III for his careful reading of drafts of this essay.

1. Tom Crouch, *The Bishop's Boys: A Life of Orville and Wilbur Wright* (New York: W. W. Norton and Company, 1989), 268.

2. Marvin W. McFarland, ed., *The Papers of Wilbur and Orville Wright* (New York: McGraw Hill, 1953), description of plate 70, the first flight.

3. Quoted in Russell Freedman, *The Wright Brothers: How They Invented the Airplane* (New York: Holiday House, 1991), 120, and in Gerald Silk, "'Our Future is in the Air': Aviation and American Art," in *The Airplane in American Culture*, ed. Dominick A. Pisano (Ann Arbor: The University of Michigan Press, 2003), note 37.

4. On the relationship between flight and twentieth-century art, see Silk, "Our Future is in the Air"; Robert Wohl, *A Passion for Wings: Aviation and the Western Imagination, 1908–1918* (New Haven: Yale University Press, 1994), esp. 157–201; Kirk Varnedoe, *A Fine Disregard: What Makes Modern Art Modern* (New York: Harry N. Abrams, 1994), 216–77; Julie H. Wosk, "The Aeroplane in Art," *Art and Artists*, no. 219 (December 1984): 23–28; and Anne Collins Goodyear, "The Impact of Flight on Art in the Twentieth Century," in *Reconsidering a Century of Flight*, ed. Roger D. Launius and Janet R. Daly Bednarek (Chapel Hill: University of North Carolina Press, 2003).

5. I thank Tom Crouch for pointing out this conflation to me; personal communication, November 20, 2001. For another discussion of this painting, see Goodyear, "The Impact of Flight on Art in the Twentieth Century."

6. László Moholy-Nagy, *The New Vision* (New York: W. W. Norton and Company, 1938), 40–41.

7. Tansey was specifically responding to the attention focused on this relationship by the Museum of Modern Art's 1989 exhibition *Picasso and Braque: Pioneering Cubism*. Judi Freeman, "Metaphor and Inquiry in Mark Tansey's 'Chain of Solutions,'" in *Mark Tansey*, exh. cat. (Los Angeles: Los Angeles County Museum of Art, 1993), 61. See William Rubin, "Picasso and Braque: An Introduction," in *Picasso and Braque: Pioneering Cubism*, exh. cat. (New York: The Museum of Modern Art, 1989), 33–34. For more on this relationship, see Silk, "Our Future is in the Air," 14–15; John Richardson, *A Life of Picasso*, vol. 2, 1907–1917 (New York: Random House, 1996), 226–28; Wohl, *A Passion for Wings*, 272; Francis Frascina, "Realism and Ideology: An Introduction to Semiotics and Cubism," in Charles Harrison, Francis Frascina, and Gil Perry, *Primitivism, Cubism, Abstraction* (New Haven: Yale University Press, 1993), 155–57; Jeffrey S. Weiss, "Picasso, Collage, and the Music Hall," in *Modern Art and Popular Culture: Readings in High and Low*, ed. Kirk Varnedoe and Adam Gopnik (New York: The Museum of Modern Art and Harry N. Abrams, 1990), 96; and Varnedoe, *A Fine Disregard*, 270–73.

8. Rubin, "Picasso and Braque: An Introduction," 32–33.

9. This suggestive juxtaposition was preserved by a clipping in the album of Daniel-Henri Kahnweiler. Ibid., 33.

10. Ibid.

11. Varnedoe, *A Fine Disregard*, 271.

12. For more information about how the early-twentieth-century avant-garde was influenced by aviation, see Silk, "Our Future is in the Air"; Wohl, *A Passion for Wings*, esp. 157–201; and Varnedoe, *A Fine Disregard*, 216–77.

13. Gertrude Stein, *Picasso* (London: B. T. Batsford, 1938), 49–50, quoted in Stephen Kern, *The Culture of Time and Space* (Cambridge, Mass.: Harvard University Press, 1983), 245; and Silk, "Our Future is in the Air."

14. Alfred Noyes, "Cubism," in *Icarus: An Anthology of the Poetry of Flight*, ed. R. de la Bère et al. (London: MacMillan and Co., 1938), 157–58. A 1944 pictorial essay entitled "Conquest of the Air" made the same point, juxtaposing an aerial photograph with Picasso's 1910 painting *Dressing Table* and noting that the two "present striking analogies." "Conquest of the Air," *Art News* 42, no. 18 (February 1–14, 1944): 16.

15. Roszak purchased Norman Bel Geddes's book *Horizons* (whose very title betrays the designer's interest in the impact of flight on modern life) immediately after it was published in 1932 and worked with Bel Geddes on the Futurama exhibit at the 1939 New York World's Fair. Even late in life, the artist expressed his admiration for the designer. Joan Marter, *Theodore Roszak: The Drawings*, exh. cat. (Madison: Elvehjem Museum of Art, University of Wisconsin; New York: The Drawing Society, in association with the University of Washington Press, Seattle, 1992), 14. Bel Geddes devotes an entire chapter of *Horizons* to the implications of air travel, in addition to discussions of flight in other areas of his book. See Bel Geddes, *Horizons* (Boston: Little, Brown, and Company, 1932), 79–121 and passim.

16. Quoted in Wayne Andersen, *American Sculpture in Process: 1930/1970* (Boston: New York Graphic Society, 1975), 65.

17. For a detailed discussion of this sculpture, see Joan French Seeman, "The Sculpture of Theodore Roszak: 1932–1952," Ph.D. diss., Stanford University, 1979, 96–101. On the relationship of the sculpture to the drawings, see Douglas S. Dreishpoon, "Theodore Roszak (1907–1981): Painting and Sculpture," Ph.D. diss., The City University of New York, 1993, 81–83.

18. Jackson Pollock, "Interview with William Wright" (1950), in *Art in Theory, 1900–1990*, ed. Charles Harrison and Paul Wood (Oxford: Blackwell, 1992), 575.

19. Quoted in Marter, *Theodore Roszak*, 21. As Marter and Seeman point out, World War II bombers were often painted to resemble fearsome flying creatures. Seeman, "The Sculpture of Theodore Roszak," 91; and Marter, 21.

20. Theodore Roszak, "The Spectre," undated statement, Theodore Roszak Papers, Archives of American Art, Smithsonian Institution, reel 69-81.

21. Although Orville Wright was distressed about aerial warfare, he regarded it as a necessary evil. "I feel about the airplane much as I do in regard to fire," Orville Wright explained at the height of World War II. "That is, I regret all of the terrible damage caused by fire. But I think it is good for the human race that someone discovered how to start fires and that we have learned to put fire to thousands of important uses." Fred Kelly, "Orville Wright Looks Back on Forty Years since First Flight," *St. Louis Post Dispatch*, November 7, 1943, 1D, 4D. I thank Tom Crouch for bringing this statement to my attention; personal communication, November 19, 2002.

22. Ruth Fine's description of the *Cardbirds* is from Fine, "Writing on Rock, Rubbing on Silk, Layering on Paper," in *Robert Rauschenberg: A Retrospective*, curated by Walter Hopps and Susan Davidson, exh. cat. (New York: Solomon R. Guggenheim Museum, 1998), 386.

23. Rauschenberg, quoted in Ruth E. Fine, *Gemini G.E.L.: Art and Collaboration*, exh. cat. (Washington, D.C.: National Gallery of Art; New York: Abbeville Press, 1984), 109.

24. On Rauschenberg's space-related artwork, see Anne Frances Collins, "Robert Rauschenberg's Space Age Allegory, 1959–1970," in *1998 National Aerospace Conference, Conference Proceedings* (Dayton: Wright State University, 1999), 82–91. The *Stoned Moon* series is reproduced in its entirety in Edward A. Foster, *Robert Rauschenberg: Prints, 1948–1970*, exh. cat. (Minneapolis: The Minneapolis Institute of Arts, 1970), figs. 72–104.

25. I thank James Dean for alerting me to the significance of this map for Rauschenberg; personal communication, November 19, 1998.

26. The technical feat represented by Rauschenberg's large-scale lithographs is analogous to the technical accomplishment of flight itself. In 1969, as part of the *Stoned Moon* series, Rauschenberg similarly associated the technical finesse demanded by lithography with that of the space program, creating the two largest hand-pulled

lithographs ever made, *Waves* and *Sky Garden*. On the conceptual parallels between the printing shop and NASA, see Collins, "Rauschenberg's Space Age Allegory," 85–86.

27. Esther Sparks, *Universal Limited Art Editions: A History and Catalogue of the First Twenty-five Years* (Chicago: The Art Institute of Chicago; New York: Harry N. Abrams, 1989), fig. 51.

28. Ruth Fine has noted Rauschenberg's interest in "less exotic modes of transportation." See Fine, "Writing on Rocks, Rubbing on Silk, Layering on Paper," 383.

29. The work's tan background evokes a series of *Cardbird* multiples the artist created at Gemini G.E.L. in the early 1970s. Sparks points out that imagery for *Kitty Hawk* and *Killdevil Hill* was drawn from the *Cardbirds* series. The brown Kraft wrapping paper used for *Kitty Hawk* creates an additional connection with this series. See Sparks, *Universal Limited Art Editions*, figs. 50, 51. Note too that during 1974 Rauschenberg also completed a group of prints entitled *Airport Series*. See Fine, "Writing on Rocks, Rubbing on Silk, Layering on Paper," 384.

30. This was not the artist's first allusion to Leonardo. Rauschenberg's 1963 performance, *Pelican*, dedicated to the Wright brothers, featured the artist on roller skates wearing a parachute, originally conceived of by Leonardo (though his design was not known until the nineteenth century) and visually evokes Leonardo's design for a winged ornithopter. On the dedication of *Pelican* to the Wright brothers, see Mary Lynn Kotz, *Rauschenberg: Art and Life* (New York: Harry N. Abrams, 1990), 123. On Leonardo's interest in flying machines. see Charles H. Gibbs-Smith, *Leonardo da Vinci's Aeronautics* (London: Her Majesty's Stationery Office, 1967).

31. On the development of air-bound art, see Barbara Rose, "Shall We Have a Renaissance?" *Art in America* 55, no. 2 (March–April 1967): 30; Steve Poleskie, "Art and Flight: Historical Origins to Contemporary Works," *Leonardo* 18, no. 2 (1985): 69–80; and Otto Piene with Robert Russett, "Sky, Scale and Technology in Art," *Leonardo* 19, no. 3 (1986): 193–200.

32. Charles Frazier, "Excerpts from a Work Journal on Flying Sculpture," c. 1966, Barbara Rose Papers, Archives of American Art, Smithsonian Institution. Charles Frazier, personal communication with author, April 15, 2003.

33. Robert Smithson, "Towards the Development of an Air Terminal Site," originally published in *Artforum*, June 1967; reprinted in *Robert Smithson: The Collected Writings*, ed. Jack Flam (Berkeley: University of California Press, 1996), 52.

34. For a more detailed discussion of this work, see Goodyear, "The Impact of Flight on Art in the Twentieth Century."

35. Serra himself has commented on the relationship between the "weight" of history and his own approach to making sculpture: "It is the distinction between the prefabricated weight of history and direct experience which evokes in me the need to make things that have not been made before. I continually attempt to confront the contradictions of memory and to wipe the slate clean, to rely on my own experience and my own materials even if faced with a situation which is beyond hope of achievement." Richard Serra, *Richard Serra: Sculpture*, exh. cat. (New York: The Pace Gallery, 1989), n.p.

36. Serra traces his interest in balance and gravity to the experience of accompanying his father to the launching of a steel tanker on his fourth birthday. Serra, *Richard Serra: Sculpture*, n.p.

37. Kiefer's sculpture was originally entitled *Poppies and Memories* in honor of the German Jewish poet Paul Celan, who lost his parents in the Holocaust and who later took his own life. The work was renamed in 1994. Melissa Geisler, note of March 30, 1994, for curatorial file, Anselm Kiefer, *Angel of History*, National Gallery of Art, Washington, D.C. It should be noted that Kiefer created two versions of *Poppies and Memories* with slightly different structures. According to Ida Panicelli, the other iteration resembles a B-1 bomber. Panicelli, "Theory of Flight," *Artforum* 28, no. 5 (January 1990): 132.

38. For a more detailed discussion of this work, see Goodyear, "The Impact of Flight on Art in the Twentieth Century."

39. On Kiefer's interest in alchemy, see Mark Rosenthal, *Anselm Kiefer*, exh. cat. (Chicago: The Art Institute of Chicago, 1987), 115. On Kiefer's use of "aging" to evoke alchemical associations, see James Hyman, "Anselm Kiefer as Printmaker—II: Alchemy and Woodcut, 1993–1999," *Print Quarterly* 17, no. 1 (2000): 38.

40. Anne Morrow Lindbergh, *North to the Orient* (New York: Harcourt, Brace and Company, 1935), 23.

FACTORY

ALLERY, LONDON
OSED BY FABRICATOR
(studio S)

FLIES TO 6

ASCENT

Rubber Band Wound → PLANE **LAUNCHED!** ONE EVERY MINUTE!

8 hours a day = 480 airplanes each day × 6 mo

= 86,400 A

DESCENT

PROPELER
&
WIRE LANDING
GEAR

↗ RUBBER BAND

PROPELLER FREE

THE POSSIBILITY OF IMPOSSIBILITY

Huston Paschal

As at home in the air as a bird, a man rides the drafts up near the ceiling of the Museum's three-story atrium. "*I Dreamed I Could Fly*": the title of Jonathan Borofsky's work serves as caption for his airborne figure (fig. 1). Without wings, without supernatural power, this regular guy drifts slowly along through the Museum's aerosphere, deriving the maximum from his advantaged observation point. Dreamy, at ease in the upper altitude, he personifies the poetry of flight, its lasting grip on the imagination—a reminder that flight's value resides as much in the spiritual as in the aeronautical. Borofsky explains in his artist's statement, "These flying figures [on view is one of six] are free and able to rise up and look down upon the whole planet. They are able to see and feel that human beings are all connected together and that we are all one—no divisions and no walls."[1] His humanitarian sentiment, perceiving the world's people harmoniously linked under a shared sky, recalls Georgia O'Keeffe's ringing endorsement of air travel: "What one sees from the air is so simple and so beautiful I cannot help feeling that it would do something wonderful for the human race—rid it of much smallness and pettishness if more people flew."[2]

Chris Burden, *Airplane Factory Drawings*, Drawing #5 of 5, detail (see p. 79)

The urge to fly has transfixed the imagination with a steady, irresistible charm for millennia. On December 17, 1903, at Kitty Hawk, North Carolina, Orville and Wilbur Wright, with that charm—and chance—on their side, realized this dream with the first powered flight. It lasted twelve seconds and covered forty yards. Humans now fly, all the time, everywhere. And yet, renewed and amplified by the Wrights' daring feat, the dream lives on. Visionaries and entrepreneurs—and provocateurs—have seen to it that the experience of flying has changed dramatically since that 1903 takeoff. And, culturally speaking, the impact of powered flight has been seismic. Flight has perplexed progress, threading its effect through politics and finance, diplomacy and war, society and the arts; and it has radically revised visual and metaphoric perceptions of the world. Recognizing these ramifications, *Defying Gravity: Contemporary Art and Flight* celebrates the Wrights' achievement and the vitality of this eternal dream in ninety-one works created during the last quarter century.

Borofsky's flying Everyman as well as O'Keeffe's conjecture pay implied tribute to the Wright brothers. Artists showed explicit interest in them as soon as news of their outlandish success spread worldwide, and their accomplishment has held artists in thrall ever since. Mark Tansey's painting *Picasso and Braque*,* done nearly nine decades after Kitty Hawk, cunningly puts this idea into play. Doctoring the familiar image of the 1903 Flyer, Tansey translates it into a daft cubist contraption with Picasso at the controls as Orville and Braque running alongside as Wilbur—or Wilbourg, as Picasso sometimes called him.[3] The painting teaches a cultural lesson: the parallel breakthroughs, Cubism and powered flight, invigorated the development of modernism.

Aviation has had a pronounced effect on the evolution of modern art—and it exerts continued sway. Not only are flight-related themes conspicuous in contemporary art, but planes also function as critical artistic accessories. Think of land art—Robert Smithson's *Spiral Jetty*, for instance—the very nature of which depends on flight for the work to be adequately seen and documented. And airplanes, thanks to their indifference to geographic borders, literally and figuratively bridge cultural divides. The Chilean artist Eugenio Dittborn began using airmail in the mid-1980s to circumvent the censorship imposed by the Pinochet dictatorship and the related international boycott of the country. His *Airmail Paintings* emigrate by plane, folded in envelopes; unfolded, they are exhibited on the walls of museums all over the world.

Beyond such tangible connections between the airplane and the art object lies a more subjective one. The aerial view that flight makes possible has so thoroughly infiltrated thinking that artists who make paintings with aviation-free content and who are not active Wright worshipers still acknowledge the plane as a factor, if a

Fig. 1. Jonathan Borofsky, *I Dreamed I Could Fly* (see p. 70)

*Works in *Defying Gravity* are illustrated in the Catalogue of the Exhibition, which begins on p. 63.

subconscious one. For instance, Wayne Thiebaud's *Reservoir and Orchard* (fig. 2) does not draw on a specific image from an airplane trip, though it may look as if it does. Instead, the *idea* of flight—more precisely, the angle of vision flight allows—feeds the composition. Works of art like the Thiebaud—demonstrating that this superior view has embedded itself in a common cultural mind-set—support the premise of the exhibition as forcefully as the literal representations of airplanes do. The plane's-eye perspective has implanted itself and unfurled in the imagination of even those who have never flown. The meager but measurable distance the first flight left between the plane and the Earth, that sliver of emptiness with a twelve-second life, ballooned into a space of immeasurable promise and consequence. The enduring obsession with flight, the fantasy and fun it stimulates—and the fear it engenders—these leitmotifs course through aviation's pervasive influence. Most important, flight privileges a new point of view. This exalted perspective has overturned the status quo, adjusting sense of scale, enhancing perception, empowering dreams.

Fig. 2. Wayne Thiebaud, *Reservoir and Orchard* (see p. 198). © Wayne Thiebaud/Licensed by VAGA, New York, NY

Consider the visual evidence of this influence. Artists long associated with airplane imagery come readily to mind. James Rosenquist's investigation of aviation and technology did not stop with the sardonic *F-111* of 1965 (see p. 13). New works, in which he adapts the formal sleekness and metallic colors of aircraft, pack the same punch, with more elegance and less narrative. Malcolm Morley, a model builder as a child and as an adult, adds his handmade biplanes to the lavishly painted surfaces of his canvases. In other, tightly finished, and slightly goofy paintings, Morley depicts model-plane kits for these World War I single-seaters, patterns laid out, directions spelled out. Taking a look at a more recent air force, Alighiero Boetti lightheartedly, almost mischievously, recounts the 1970s chapter of the aviation story in his *Skies at High Altitudes* triptych—a jovial hullaballoo of a rubescent airscape through which about 150 airplanes zip and zoom (fig. 3). Chris Burden—who has reengineered both a kayak and a steamroller into credible flying objects and *incredibly* (in *C.B.T.V. to Einstein*) flown a balsa-wood-and-tissue-paper model plane faster than a supersonic jet[4]—conceptualizes designs for an airplane factory. Based on Burden's scheme (a detail of which opens this essay), one stick-and-tissue plane, a fragile toy that requires hours of manual labor to assemble, can be produced and launched every two minutes.

No artist may better exemplify the élan vital of *Defying Gravity* than Panamarenko. This Belgian artist and engineer, poet and inventor, rechristened himself

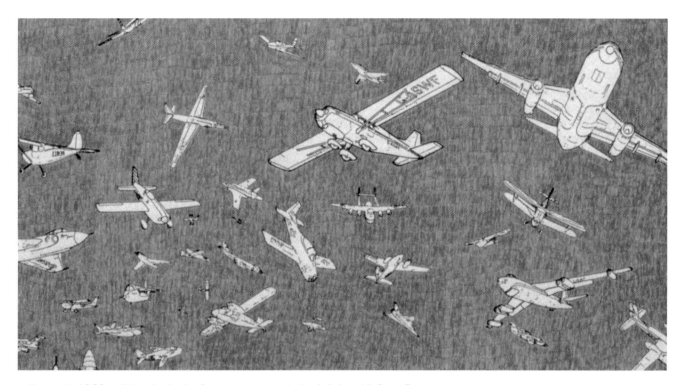

Fig. 3. Alighiero Boetti, *Skies at High Altitudes*, detail of central panel (see p. 69)

in the early 1960s with a rhythmic, fun-to-say name derived, it is said, from Pan American Airways (then in its glory years, now defunct). Admirers often refer to this boffin as a modern-day Leonardo da Vinci. These two Renaissance men, kindred spirits of the Wright brothers, share an astonishing range of skills and interests, including a fascination with flight. Panamarenko constructs flying machines scaled—and intended—for human use. *Raven's Variable Matrix*, with its seventeen-foot wingspan (making it slightly less than half the size of the 1903 Flyer) resting on bicycle wheels, poises for takeoff with a larky "might just be done" attitude—a gay and fitting salute to Orville and Wilbur and their legacy.

Shifting focus to the very beginning of flight, Panamarenko re-creates one of the planet's earliest flying creatures in his *Archaeopterix IV*, a 15¾-inch-long skeleton of a prehistoric winged creature brought back to precarious life. Panamarenko's version of this reptilelike bird has been technologically modernized, if not in the process immobilized. The featherless wings of *Archaeopterix IV* are layered (and thus weighed down) with light-sensitive cells, whose presence calls to mind a legendary being also modified for flying. Whereas the *Archaeopterix IV* (if it ever leaves the ground) gains strength the closer it approaches the sun, that same source of power returned Icarus to the fateful pull of gravity. Behind many a Wright brothers' homage is a respectful tribute to the cautionary tale of Icarus.

Icarus and birdlike flight weave in and out of the story of the Wright brothers

and contemporary art. (The Wrights were both helped and misled by the study of avian flight.[5] Leonardo as well, like all early students of aeronautics, assumed man would fly as birds do, with flappable wings. In today's world of fixed-wing aircraft, the errant association lives on, in the word "aviation.") The Icarus story absorbs Morley and Panamarenko; so too, Albert Chong invokes Daedalus's son in kinetic, winged self-portraits. Enthralled by natural and mechanical flight, myth and reality, Chong appraises the ability to fly as a tricky power, capable of providing—or denying—rescue and salvation. Robert and Shana ParkeHarrison enlist birds in their quest for human flight, comically implausible efforts recorded with mock reverence in elegant photogravures. And Simone Aaberg Kærn documents her self-powered aerial voyage in video. Employing a questionable but valiant method of arm waving and leg kicking, the madcap Dane churns over Greenland, above ice floes and polar bears.

Brent Cole turns a Museum visit into a fantasy flight. His flight simulator, whose wingspan of similar width makes it a cousin of Panamarenko's *Raven*, takes viewers on a ride that roves through the galleries, out the front entrance, and around the Museum preserve. Cole's clunky aesthetic—he makes do with whatever lowly items he finds at hand and transforms them into something ascendant—echoes the Wright brothers' improvising methodology. Jeffrey W. Goll also finds a way to use found objects. Among the hundred centennial planes Goll has pieced and patched together for *Defying Gravity*, visitors will find one on the Museum grounds whose almost anthropomorphic cockpit hood once served as the sight for a World War II German tank. Goll's endearingly ramshackle planes banter in polyglot lingo with the clean-lined, high-flying models of Boetti's triptych.

Another habitué of the salvage yards is the sculptor Donald Lipski. Selecting from deconstructed planes (to which Grumman Aero-space Corporation granted him access), Lipski has reconstructed their parts into transmogrified carriers with baffling missions. (Might *Baby Z* be an ejection capsule?) Artists ingeniously stretch, reconfigure, and transpose aircraft components. Working in two dimensions, Susan Rankaitis diffracts plane imagery in lush, darkly romantic photographic monoprints. She integrates landing gear, nose cones, and wings into her shattered and fused compositions. The designer Mark Newson adapts airplane materials into futuristic (or retro?) furniture. From the aluminum and rivets that typify a fuselage, Newson has extrapolated the ne plus ultra of airport lounge chairs—unlikely to be found by any passenger searching for a place to sit down in the average terminal seating area.

The airport terminal itself surfaces as a subject in contemporary art. A non-place takes a place as content—telling commentary on the twenty-first-century's dislocated nomads and the way station where they spend so much time. An inhospitable

atmosphere taints it unmistakably. And the din of an airport's relentless traffic makes it an unwelcome neighbor. Roger Brown's painting conveys, with mordant humor, the liabilities of living near one. More neutrally, the collaborators Peter Fischli and David Weiss photograph on-the-ground activity at airports in large color images taken from inside terminals. John Schabel works stealthily from the tarmac. Using a telephoto lens, he captures seated passengers, each framed by a plane's porthole window, waiting to take off. In grainy black-and-white, these intimate portraits evoke the traveler's disorientation. Vera Lutter's oversize photographic negatives, suffused with mystery, also contemplate this opalescent domain, where apprehension and anticipation together reign. Her work trains attention on the unsettling feelings flying breeds, the claustrophobia and vulnerability at battle with the exhilarating sense of freedom and speed. A disquieting bargain.

Lutter, like Chong, does not lose sight of the fact that travelers must place their trust in something that they have reason —or reasons (mechanical or human failure, sabotage)—to fear. Those at home have grounds for concern as well. The airplane overhead, whatever its mission, casts a dark shadow below. Lawrence Gipe's pseudo–history paintings, for instance, analyze Western hegemony, using the powerful, gleaming airliner as a scornful reference to capitalist might. To cite another example, even surveillance aircraft can intimidate (a point Roman Signer makes into something of a joke in his *Bed* video). Artists have not shrunk from confronting flying's inherent vice.

And this vice has been inherent from the very beginning. For within a few scant years of the 1903 flight, the airplane found itself in use as a terrifyingly potent World War I weapon. Stirred by more recent wars, contemporary artists have incorporated flight as a source of anxiety into their work. The Vietnam War, reported by another mixed blessing of modern technology, the television, factors into the paintings of Phuong Nguyen. Sophie Ristelhueber's *FAIT* includes a number of photographs she took from military aircraft immediately following the 1991 Persian Gulf War. Ristelhueber employs the prints, which document the bomb-ravaged countryside, to make an artistic statement about scars. *Planes*, a beautiful but bleak painting by Margot Gran, derives from turmoil in that same part of the world. Inspired by the ongoing Palestinian-Israeli conflict, *Planes* telegraphs the distant thrum of warplanes which, whether originating from protector or attacker, send ominous

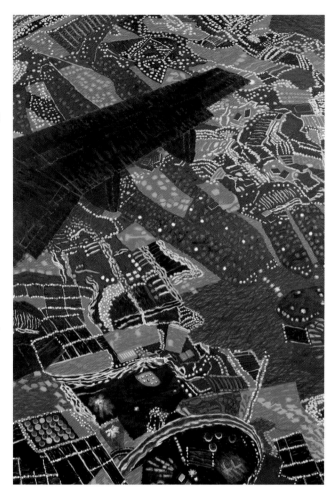

Fig. 4. Yvonne Jacquette, *Night Wing: Metropolitan Area Composite II* (see p. 129)

reverberations through every facet of Middle Eastern life. The hopeful assessment of how flight might ameliorate social behavior offered by Georgia O'Keeffe (quoted in the opening paragraph) was immediately qualified by her. And certainly the serene optimism of Antoine de Saint-Exupéry's 1939 *Wind, Sand, and Stars* is no longer sustainable. After the 2001 terrorist attacks it is unthinkable.

Flying, a questionable bargain, to be sure. But no one doubts that on balance the gain has been positive. A clear benefit: vantage points have multiplied. The traditional earthbound view, looking up, is supplemented by a plane's-eye view, looking down—or out and across. Yvonne Jacquette (unlike Thiebaud) bases some of her work on what she sees at night, far below, from her airplane window seat. Her elevated perspective abstracts a metropolis's mean streets into glittering traceries rivering through a softened blackness (fig. 4). This elegant aerotherapeutics demonstrates how distance can order and purify a city's material decay and social ills. In contrast, Kara Hammond immerses herself in the particular. She looks straight out the porthole, surveying the daytime cloudscape horizontally—and renders in realistic detail a cross section of atmospheric nature. Her panoramic *30,000 feet*, could be called *Inside the Sky*, the title of William Langewiesche's engaging book of 1998 about his days—and thoughts—as a pilot. (And Hammond's inside-the-sky frame of reference recalls the cloud paintings O'Keeffe did in the 1960s, one of which is illustrated on p. 12.) As Hammond's seatmates, viewers are drawn into a composition where the spaces—both physical and psychic—seem to stretch to infinity.

The airplane magnifies awareness of the ocean of sky embracing the world. Born the same year (1871) as Orville Wright, Marcel Proust recognized this gift to perception. In *Time Regained*, his narrator regards the planes flying overhead at night and comments, "And perhaps the greatest impression of beauty that these human shooting stars made us feel came simply from their forcing us to look at the sky, towards which normally we so seldom raise our eyes."[6] Without including the "human" variety, Vija Celmins arrests attention with her quiet, intense renderings of the limitless, star-studded, jet black sky. Her work calls to mind the reflections of another French author, a generation younger than Proust. Saint-Exupéry lyrically described how piloting his small craft made him feel that he "alone was in the confidence of the stars."[7] Celmins's skyscapes encourage a private exchange between viewer and firmament; they elicit musings on humankind and the cosmos, on chaos and harmony.

Conjoining the terrestrial and celestial, flying brings the flyer back to earth, with a heightened understanding of reality. Gravity enforces boundaries. Overcoming gravity, refusing to be pulled toward a center, undoes them. This centrifugal force finds a metaphoric equivalent in flight's ability to liberate the imagination.

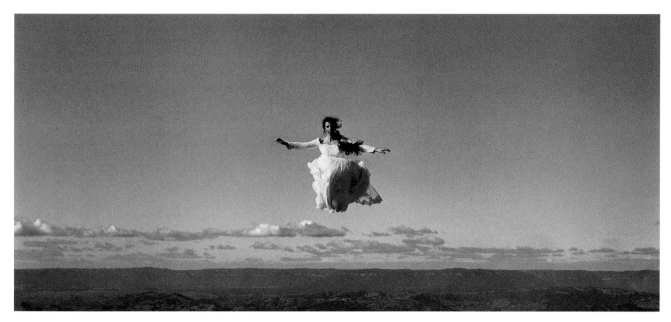

Words bear a history, and the words involved in this story can tell it with poetic simplicity—and license. The Latinate "plane" in airplane relates to the geometric plane familiar from high school algebra; an airplane is basically a plane placed in the air for aeronautical experiments. By adding one letter, and an airplane-shaped one at that, "plane" becomes "planet," though the longer word comes from a different source. "Planet" derives from the Greek for "lead astray or wander" (emphasizing a contrast with the stationary stars). When a plane becomes an air-plane, its reach extends planet-wide. Planes have enabled people to roam the planet, mimicking their home's etymology.

The airplane, a hybrid species introduced to the biosphere by humans, shadows their daily life with its capacity to lead the world murderously, cataclysmically astray. Pondering the other root meaning of the word "planet" illuminates more fruitful implications. Flight's virtue, for airborne or armchair traveler, can be found in the wandering and wandering's gift for inducing—or becoming—wonder. A long-distance perspective can refresh understanding of the strange mysteries close at hand. An exquisite example of one of those riddles within reach is used by Ralph Helmick and Stuart Schechter as the building block of their airplane, suspended above the Museum's galleries. From the natural world, they chose the Lepidoptera. Nearly 1,400 Mylar butterflies, wings fluttering, define the shape of a brand-new fixed-wing aircraft at the super scale of Panamarenko's grounded *Raven* and Cole's simulator. The butterfly, age-old symbol of transformation, transformed into an airplane—this vital concept goes to the very heart of *Defying Gravity*.

Transporting travelers through a darkness even to the edge of doom, then on

Fig. 5. Rosemary Laing, *flight research #5* (see pp. 142–43)

to realms of gold in a once unimaginable beyond, the airplane—as machine or metaphor—enlivens seeing, intoxicates thinking. Flight intrigues one to look in a direction never looked before, to think of Earth and self in a new sense—thus conjuring a world where reason and fantasy function in tandem. Jonathan Borofsky inhabits this world. The lifelike—like *his* life—figures in *I Dreamed I Could Fly* are based on his own body and come from his dream notebooks. The Wright brothers, on wings and wheels, traveled in such a world, erasing distinctions between discovery and invention, elevating observation into revelation—much as Leonardo united the aesthetic and the analytical. *Defying Gravity* at its core exults in this blended, synthesizing, quickened creativity. Rosemary Laing's sky-high flight researcher (fig. 5) makes Borofsky's dream a dream materialized. The skydiver jubilantly spins, whirls, swandives through a vast airscape straight out of the horizontal perspective of artists like Hammond and O'Keeffe. Flight moved O'Keeffe to observe—or, put another way, to imagine: "When you fly . . . you see such marvelous things, such incredible colors that you actually begin to believe in your dreams."[8] The art of flying rejuvenates; it puts the wayfarer in a frame of mind attuned to the possibility of something transcendent. Its thrust: creation is the ultimate defiance.

NOTES

The title of this essay is taken from "Icarus," a poem by John Updike, published in his *Americana and Other Poems* (New York: Alfred A. Knopf, 2001), 15.

1. Jonathan Borofsky, artist's statement, curatorial file, Museum of Fine Arts, Boston.

2. Georgia O'Keeffe to Maria Chabot, 1941, in Jack Cowart and Juan Hamilton, *Georgia O'Keeffe: Art and Letters*, letters selected and annotated by Sarah Greenough, exh. cat. (Washington, D.C.: National Gallery of Art, 1987), 231.

3. William Rubin, *Picasso and Braque: Pioneering Cubism*, exh. cat. (New York: The Museum of Modern Art, 1989), 33.

4. The artist's statement accompanying the 1977 *Relic from "C.B.T.V. to Einstein"* reads: "While aboard the Concorde at Mach 2.05 and 60,000 feet, I flew a small stick and tissue, rubberband-powered model airplane from the rear of the airplane toward the front. In accordance with Einstein's theories, the velocity of my model airplane as seen from earth, is the sum of the velocity of the Concorde (approx. 1400 miles per hour) plus the velocity of my model airplane (approx. 10 miles per hour). My model airplane thus traveled faster than the supersonic Concorde." Quoted in Anne Ayres and Paul Schimmel, *Chris Burden: A Twenty-Year Survey*, exh. cat. (Newport Beach, Calif.: Newport Harbor Art Museum, 1988), 80.

5. For elucidation on this point, see Steven Vogel, *Cats' Paws and Catapults: Mechanical Worlds of Nature and People* (New York: W. W. Norton & Company, 1998), 257–61, 270–75.

6. Marcel Proust, *Time Regained*, vol. 6 of *In Search of Lost Time*, trans. C. K. Scott Moncrieff and Terence Kilmartin, rev. D. J. Enright (New York: Modern Library, 1992), 161.

7. Antoine de Saint-Exupéry, *Wind, Sand, and Stars*, trans. Lewis Galantière (New York: Reynal & Hitchcock), 18.

8. O'Keeffe, quoted in Katharine Kuh, *The Artist's Voice: Talks with Seventeen Artists* (New York: Harper & Row, 1962), 202.

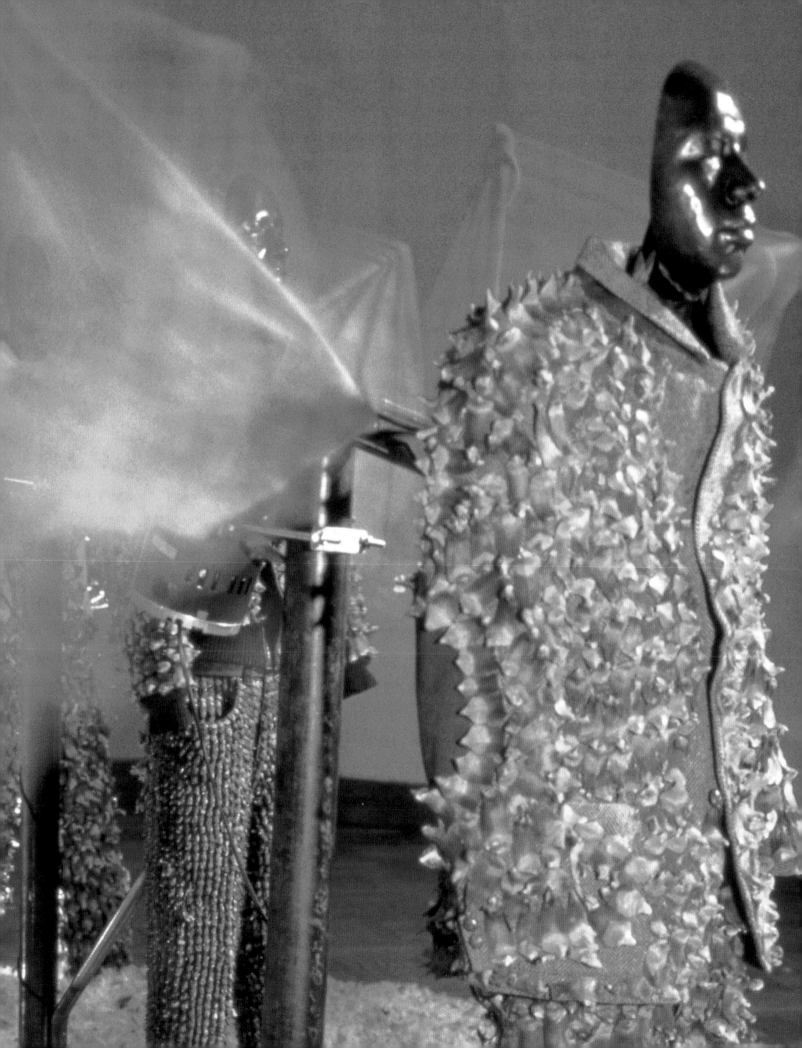

DEFYING GRAVITY

Linda Johnson Dougherty

Flight is but momentary escape from the eternal custody of earth.

<div align="right">

—Beryl Markham, *West with the Night*, 1942

</div>

Like flying, contemporary art is often a leap of faith—defying expectations, defying the odds, defying convention, pushing boundaries, expanding the realm of what is possible, transforming one's view of the world and one's perception of oneself in relation to others and to the rest of the world. In this exhibition, one can see how the interaction between aviation and artists' imaginations has expanded both the borders of the art world and the human perspective of the world.

Flight is an all-pervasive element in contemporary society. Not only does humankind's age-old desire to fly persist into the twenty-first century, but mechanical flight is also an inescapable part of everyday life. Airplanes are the reason one can have strawberries in January, mail can be delivered overnight, and one can arrive in Paris three and a half hours after leaving New York. The invention of flight has aided the cross-fertilization of cultures, creating a global world culture instead of isolated individual cultures unique to one place and

Albert Chong, *Winged Evocations*, detail (see pp. 84–85)

time. Looking back, one can see that during the course of the last century, the invention of flight has changed the world dramatically.

One hundred years after the Wright brothers' first flight, people have continued to look for new ways to be personally airborne, including hang gliding, kite sailing, and skydiving. Many of the works of art in *Defying Gravity* simulate the act of flying, exploring this timeless human obsession with flight, either with mechanical assistance or imaginary personal powers. Artists including Panamarenko, Simone Aaberg Kærn, Robert and Shana ParkeHarrison, Albert Chong, and Brent Cole envision how one might transform oneself into a bird, a flying machine, or a modern-day Icarus merely by flapping one's arms and legs, jumping off high places, or strapping on wings (fig. 1).

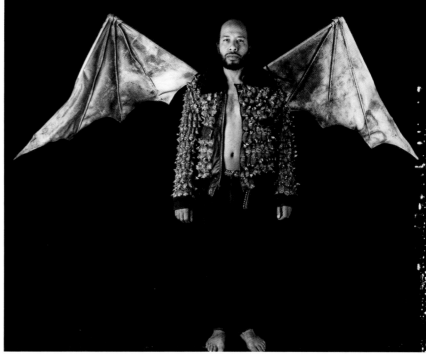

Fig. 1. Albert Chong, *Winged Self-Portrait (wearing pinecone bomber jacket)*, 1998. Gelatin-silver print, dimensions variable

Rosemary Laing's flying bride, Jonathan Borofsky's flying man, and Kærn in a black wetsuit* all achieve levitation unfettered, either with invisible means of support or their own superhuman powers. One knows that most of the fantastic flying machines on view in the exhibition, such as Panamarenko's *Raven's Variable Matrix*, a hybrid of a bicycle, bird, and plane that references the Wright brothers' early bicycle business, Cole's flight simulator, or Jeffrey W. Goll's one hundred airplanes, will never leave the ground, but they capture one's imagination and one's secret desire to fly, even if only in one's dreams.

In several of these artists' works, flight becomes a metaphor for journeys, both real and imagined, and flying machines become the vehicles to take one to dreamworlds or places that could otherwise not be reached by the earthbound. Cole's work, *Flight,* turns the viewer into a pilot, zooming through the galleries of the Museum, zipping out the front door, and soaring around the grounds and up into the sky. Other works in the show examine the spiritual aspect of flight and the idea that the ability to fly will allow one to reach a higher realm, perhaps one closer to heaven. This view of flight as a means of spiritual transport is explored by Chong in his installation of birdlike figures, *Winged Evocations*, who stand sentinel on a cloud of feathers and appear either to have just landed and shed their feathers or are preparing to take off, perhaps heavenbound.

*Works in *Defying Gravity* are illustrated in the Catalogue of the Exhibition, which begins on p. 63.

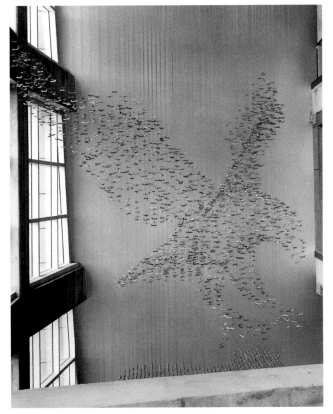

Numerous artists in the show look at the differences between man-made and natural flight and/or create hybrid creatures that combine mechanical flight with the innate flying abilities of birds, bats, butterflies, and insects. Many of the first gliders, including those of Otto Lilienthal, the pioneering German engineer and glider expert, resembled giant insects, and several early attempts at flight were based on studies of birds.

Even the Wright brothers were observed studying, and imitating, birds in flight, as described by people living near Kitty Hawk at the turn of the century: "[a] lot of folks thought the Wrights were a little touched, you know. I think it was because they would imitate the ways birds flew . . . turn their arms like wings and run through the dunes while watching the gulls."[1] In fact, the Wright brothers' successful biplane was based on Wilbur's observations of flying pigeons when he realized that

a bird's lateral balance depends on the coordinated movements of its wing tips. Slightly increasing the exposure to the air of the underside of one wing (tilting it upward) increases air pressure beneath the wing and makes it rise. Simultaneous exposure of the topside of the other wing (a downward tilt) increases the pressure above it and causes it to drop, the bird's direction altering to whatever degree it desires. Wilbur realized that what was needed was a machine that could make those adjustments.[2]

One of Robert and Shana ParkeHarrison's elaborately staged photogravures, *Flying Lesson*, takes the lessons of avian flight one step further and simply uses birds as a means for man to fly. The work depicts a man preparing for takeoff with two flocks of birds tethered to his wrists by long strings. Other artists refer to the mythical flying skills of Icarus and Daedalus, as can be seen in Hoss Haley's sculpture of a man from the chest up, part tribute to Daedalus, part flying contraption. His wings float over his head, powered by a crank on his back.

Several collaborative works by Ralph Helmick and Stuart Schechter investigate and meld innate flight and fabricated flight (figs. 2, 3). *Double Vision*, 2000, is a monumental two-part sculpture depicting a DC-3 airplane and an eagle. Composed of thousands of suspended cast metal elements, the sculptures realize in three dimensions a transformation from avian flight to man-made flight. The giant plane consists of more than two thousand birds, while the immense bird is made up of hundreds of small airplanes. *Rara Avis*, 2001, located at Midway Airport in Chicago,

Fig. 2. Ralph Helmick and Stuart Schechter, *Double Vision* (eagle), 2000. Cast metal and stainless steel, 28 x 13 x 12 ft. (8.5 x 4 x 3.7 m). American Airlines Arena, Miami, Florida, commissioned by Metro-Dade Art in Public Places and the Miami Heat (see also pp. 126–27)

Fig. 3. *Double Vision*, detail

is a cardinal formed of a multitude of small bright red aircraft, covering the history of aviation, from Leonardo-inspired designs for flying machines and nineteenth-century balloons to classic passenger airliners and twenty-first-century spacecraft. Their most recent flight-related work, *Rabble*, commissioned for this exhibition, transforms a diaphanous, fluttering rabble of rainbow-hued butterflies into an exuberantly buoyant twenty-first-century airplane that floats above the Museum's galleries.

Like Helmick and Schechter, many of the artists in this exhibition present the magic of making something heavier-than-air stay up in the air—even today one has to suspend disbelief when one goes up in a plane—in works that float, hover, and soar through space. Laing's flying bride in her series of photographs, *flight research*; Kara Hammond's monumental painting of a cloud-filled sky, *30,000 feet*; and Lawrence Gipe's depiction of a tiny plane in a vast skyscape, *Insignificance*, all depict the transcendent feeling of flight, of rising above the earth, and the experience of being in the clouds, airborne, and no longer earthbound.

In Chris Drury's *Cloud Chambers*, the sky is captured and brought inside sculptural shelters that operate as oversized pinhole cameras to project an image of the sky, upside down and backward, onto the floors of the chambers. As Drury has described his work,

People who have never experienced being inside cloud chambers sometimes question the difference between looking up at clouds—and seeing the image inside a chamber. In fact, these experiences are quite distinct.—. . . it is an altered image, slightly blurred, dim, like a scene from an old movie or a dream. One woman said it disturbed her, that she couldn't quite believe it was the same view, it was more like a memory from her childhood—a "soul-catcher."[3]

Fig. 4. Vera Lutter, *Frankfurt Airport, V: April 19, 2001* (see p. 147)

Vera Lutter's immense black-and-white photographs, such as *Frankfurt Airport, V: April 19, 2001* (fig. 4), have a similar ghostly quality and are, in fact, images also taken with giant camera obscuras. Lutter makes her pinhole cameras of traveling trunks and room-sized containers. The exposures are taken over several hours and sometimes days, creating multilayered, luminous, negative images of airports and airplanes, caught in a netherworld or dream state of slow motion, where objects seem to glow with an incandescent inner light.

Once one manages to get airborne, either by one's personal powers or assisted

Fig. 5. Vija Celmins, *Holding onto the Surface*
(see p. 82)

by an airplane, one can view the world from an entirely new perspective. Many of the works of art in *Defying Gravity* replicate or document a previously unimagined view of the earth— the ability to look down from above; of being in the sky versus always looking up at the heavens from an earthbound vantage point. In a wide range of works by artists including Wayne Thiebaud, Ed Ruscha, Andreas Gursky, Doug Aitken, Yvonne Jacquette, and many others, one can see how aerial perspective has informed and transformed contemporary art. As William Langewiesche has written,

The aerial view is something entirely new. We need to admit that it flattens the world and mutes it in a rush of air and engines, and that it suppresses beauty. But it also strips the facades from our constructions, and by raising us above the constraints of the treeline and the highway it imposes a brutal honesty on our perceptions. It lets us see ourselves in context. . . .[4]

Vija Celmin's series of *Night Sky* and *Galaxy* paintings, drawings, and prints (fig. 5) portray an earthbound vantage point of the nighttime sky, a view of a vast and boundless heaven filled with a countless number of stars and planets. As a counterpoint to Celmins, and in some cases, almost a mirror image, many of Jacquette's paintings present a dazzling nocturnal view of the world below. Her paintings, such as *Night Wing: Metropolitan Area Composite II*, depict the experience of flying at night and looking down at the Earth from above. In an urban landscape filled with millions of sparkling, twinkling pinpoints of light, it looks as if the stars have fallen out of the sky and formed a new constellation, a latticed network of man-made stars.

The downside of aerial perspective is that it can dehumanize the world one sees below, because when seen from 30,000 to 50,000 feet above, people down on Earth disappear from view, houses turn into toy blocks, and the landscape becomes an abstract pattern of crosshatched lines. As Graham Coster has written, "For those on the ground, the plane is the unreachable, anonymous speck up in the clouds. For the aviator, the earth below is a diminished, detached, Lilliputian ant-kingdom."[5]

Sophie Ristelhueber's series of seventy-one photographs, *FAIT*, primarily aerial views taken by the artist from a military aircraft in Kuwait seven months after the war had ended, depicts a war-torn desert landscape destroyed by the bombings of the Persian Gulf War of 1991. The gridlike installation of the photographs mimics

the linear patterns and networks, the crisscrossing of man-made demarcations and desecrations of the earth below when seen from an aerial perspective. She documents a scarred and horrific landscape in images where scale and perspective are almost impossible to determine.

After the tragedy of September 11, 2001, there is a new sense of unease about flying. For many passengers, the joy and excitement associated with takeoff and landing, that exhila-rating moment of suddenly lifting from the ground and being airborne, has been replaced with trepidation and worry about what might happen next. Anxiety has always been a part of air travel—it is hard to believe that an 875,000-pound metal ma-chine can go up in the air and stay there without just falling out of the sky—but recent events have made most people realize or remember that there is also a dark side to flight. With the advent of the Wright brothers' first successful flight in 1903, modern warfare took a dramatic turn by gaining the use of airplanes for surveillance and for bombing, and now the plane itself has become a formidable weapon and means of mass destruction. The B-52 bomber plane, designed by Boeing in 1948 for aerial warfare and still in use today, "can carry 70,000 pounds of various bombs, mines, and missiles, in-cluding nuclear-armed cruise missiles."[6]

Graham Coster has described the unbelievable speed with which advances in aviation technology have been applied to warfare:

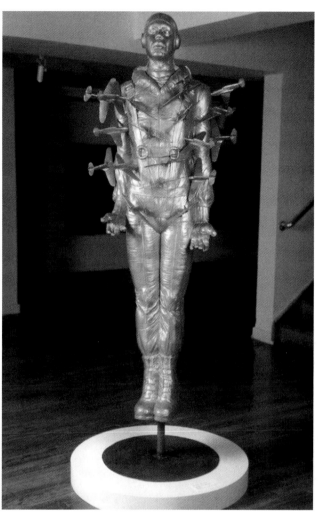

Fig. 6. Michael Richards, *Tar Baby vs. St. Sebastian*, 1999. Resin and steel, 81 x 30 x 19 in. (205.7 x 76.2 x 48.2 cm). Installation view, *Passages: Contemporary Art in Transition*, The Studio Museum of Harlem, New York, 1999–2000

[O]nly a decade after the Wright brothers managed a few precious yards off the ground, Fokker Triplanes and SE5As were fighting air battles above the Western Front. Thirty years later, and the first jet aircraft were already flying. And then, within two years of a world war fought mostly at air speeds of around 300 m.p.h., a man flew faster than the speed of sound. Where, as recently as the seventies, aerial bombardment meant a B-52 excreting dozens of bombs to waste a whole Vietnamese landscape, a mere twenty years' advance sees the next major conflict, the Gulf War, redefining bombing as a stealth fighter, invisible to radar, creeping in low for the precise laser-guided elimination of a television mast.[7]

The military now routinely employs unmanned spy planes—to shoot missiles and take photographs—flown by remote control by pilots on the ground.

One's experiences unavoidably color one's perceptions of what one sees, and

before September 2001 viewers would most likely have had different reactions to and associations with several of the works of art in the exhibition than they will have now. Earlier on, one might have admired the physics of Heide Fasnacht's *Exploding Plane*, seeing its dematerialized form, the energy frozen in time and space, and the almost whimsical, lighthearted side of the work with its tiny flying suitcases. One might have recognized its references to the artificial nature and stylized violence of the special effects of exploding planes in action and suspense movies. Now it is almost impossible to see the work without thinking of how planes were used as giant weapons whose explosions triggered the implosion and demolition of seemingly indestructible buildings, resulting in the loss of thousands of lives, making visual memories that will forever be imprinted on all those who saw the attack on the World Trade Center.

An artist, Michael Richards, was one of the many who died in the World Trade Center. He had been working the previous night in his studio on the ninety-second floor and was still there in the morning when the planes hit the buildings. One of his

sculptures, *Tar Baby vs. St. Sebastian*, can be seen as an unsettling foretelling of his own death (fig. 6). The work depicts an airman whose body is pierced by a flurry of small airplanes. The last sculpture he was known to have been working on was of an airman riding a burning meteor falling toward Earth. Richards described his ongoing series of works about the Tuskegee Airmen, the African American pilots of World War II, "as only being free, really free, when they were in the air.—They serve as symbols of failed transcendence and loss of faith, escaping the pull of gravity, but always forced back to the ground. Lost navigators always seeking home."[8]

Employing a nonlinear narrative and a sense of dislocated time, several of the artists in the show create works that examine how flight has transformed perception in general and how flight can turn visual perception upside down. Doug Aitken's dizzying and disorienting video, *Inflection*, taken from a camera attached to a model rocket shot into the sky, and Susan Rankaitis's complex, confusing, and enigmatic monoprints of fractured airplanes moving through time and space both capture the unsettling sensation of flying blind in the clouds or in a dense black night. Without sight and with only controls to guide one, one's sense of up from down can easily be confused when one can no longer distinguish above from below, the location of the Earth versus the sky.

Rosemary Laing takes the viewer on a vertiginous and mesmerizing ride in her continuous-loop video installation *spin* (fig. 7), which she created by going up in a

biplane with an open cockpit with a stunt pilot. Once airborne, the pilot cut the engine and let the plane stall out and spin through the air while Laing videotaped their corkscrewing descent, hurtling toward Earth at a rapid rate. The viewer is pulled into this death-defying stunt and enveloped in the disorienting state of being turned upside down and spinning around and around, as the plane dives toward Earth. In describing this work, Laing has said, "the metaphor of a pending crisis represented in the work—an aircraft crash—is never actualized. The passenger on this journey is denied final impact—there is none." Instead, one is trapped in a never-ending cycle of disorientation and "the terror-thrill experience of the ever increasing acceleration of the ride."[9]

Other artists in the exhibition who focus on similar flight-related elements of speed and movement through time and space include James Rosenquist and Bill and Mary Buchen. Rosenquist's 1999–2001 series of monumentally scaled paintings, *Speed of Light,* combine kaleidoscopic compositions and swirling vortexes of color and light to evoke a rushing sense of motion, seemingly faster than the eye can actually see in real life (fig. 8). The Buchens' *Flight Wind Reeds* depict

Fig. 8. James Rosenquist, *Voyager—Speed of Light* (see pp. 176–77). © James Rosenquist/Licensed by VAGA, New York, NY

speed and motion in three-dimensional form in kinetic sculptures composed of abstracted airplane forms that move in response to the speed of the wind.

When one flies, one finally realizes the vastness of the world. From a plane, one can begin to realize the shape of the globe and actually sense the curvature of the Earth. Instead of the shortened, flattened, earthbound view where one can only see what is right in front of one, in flight one is presented with an expansive, boundless view of the landscape and a horizon that seems to stretch forever. David Solow's ephemeral installation, on view for one night only, depicts an imaginary runway made up of hundreds of candles, flickering luminaries that lead the way to an endless horizon. As Solow has described it, "the runway is a place of departure, from which our imagination can soar. . . ."[10] As all the artists in this exhibition show, the ability to fly, as well as the dream of flight, has proven to be a fertile ground for the artistic imagination and a timeless metaphor for growth, transformation, and transcendence.

NOTES

Epigraph: Beryl Markham, quoted in Graham Coster, ed., *The Wild Blue Yonder* (London: Picador, 1997), 36.

1. This and many other comments made by people living in the Outer Banks at the time of the Wright brothers' first experimental flights can be found in Thomas C. Parramore, *Triumph at Kitty Hawk: The Wright Brothers and Powered Flight* (Raleigh: North Carolina Department of Cultural Resources, Division of Archives and History, 1993), 74.

2. Ibid., 20.

3. Chris Drury, quoted in *Chris Drury: Silent Spaces* (London: Thames and Hudson, 1998), 108.

4. William Langewiesche, *Inside the Sky: A Meditation on Flight* (New York: Pantheon Books, 1998), 4.

5. Coster, introduction to *The Wild Blue Yonder*, xi.

6. Laurence Zuckerman, "The B-52's Psychological Punch," *The New York Times*, December 8, 2001, A15.

7. Coster, *The Wild Blue Yonder*, x.

8. Michael Richards, quoted in "In Memoriam: Michael Richards (1963–2001)," *ArtsLink* (newsletter for Americans for the Arts in Washington, D.C.), October 2001, 1.

9. All quotations by Rosemary Laing are from her unpublished studio notes, 1997–99.

10. From David Solow's written description of his proposed project, *runway*, October 9, 2002.

CATALOGUE OF THE EXHIBITION

The catalogue is arranged
alphabetically by artist.
Dimensions are given in inches
followed by centimeters unless
otherwise indicated; height
precedes width precedes depth.

Entries by
Laura M. André (LMA)
Linda Johnson Dougherty (LJD)
Huston Paschal (HP)

Kara Hammond, *30,000 feet*, detail (see pp. 122–23)

Vito Acconci

AMERICAN, BORN 1940; LIVES BROOKLYN, NEW YORK

For more than thirty years, the visceral experiences of the human body have been central to Vito Acconci's compelling performance-based works of art. Acconci's installations and videos frequently subject viewers to unexpected sights, sounds, and other disquieting spatial stimuli to challenge and expand the thresholds of the sensate body.

Two Wings for One Wall and Person exemplifies how Acconci's work interacts with the viewer's body both to open up and foreclose the space in between. The empty wall separating the two halves of the work invites viewers to imagine their own body as a fuselage, arms outstretched as if attached to the great wings on either side. The airy pink etchings suggest the delicate, ultralight wings of an insect or tissue-paper model plane, even as they structurally echo the lifting devices on a full-fledged aircraft. At one with Acconci's wings only in the imagination, the viewer's body briefly becomes part of the unforgiving wall, leading to the uncomfortable sensation that one is crucified or pinned, like a specimen, against the immobile surface. Standing at a distance, in the space of the gallery, the viewer becomes aware of the tragic stillness of Acconci's wings, of his or her own static body, and dreams of a way to release them.

LMA

Two Wings for One Wall and Person, 1979–81
Photoetching on 12 sheets of paper, printed in pink
Each sheet 16½ x 41 (41.9 x 104.1); overall 53 x
268 (1.3 x 6.8 m)
Published by Crown Point Press, edition 10
Crown Point Press

Doug Aitken

AMERICAN, BORN 1968; LIVES LOS ANGELES AND NEW YORK

Doug Aitken's video installations are multisensory travelogues, documenting transformative journeys through landscapes all over the world. Describing himself as a nomad, Aitken sweeps his camera across the landscape, turning the everyday into something strange and unknown. In his work, the world often slows to an immeasurable pace, where time and movement seem to take on physical dimensions.

Inflection was created by attaching a surveillance camera to a model rocket and launching it into the sky over a suburban California landscape. Shooting straight up, the rocket presents a bird's-eye view of the world below. At first, one sees the rocket itself as it is launched skyward; then the view shifts to the landscape below, which slowly reveals itself as the forms of cars, houses, and parking lots begin to emerge from what first appears as a grainy, blurred, indiscernible pattern. Played in very slow motion, the film creates a contradictory experience for

Inflection, 1992
Video, 13-min. loop
Collection of the artist,
courtesy 303 Gallery, New York

the viewer. One knows that the rocket was moving extremely fast when it was launched, but Aitken forces time almost to stop, reversing its normal speed. Halfway through the film, it speeds up and the images start to spin in a dizzying, mesmerizing motion. As the rocket begins its descent back to Earth, the film slows down again, and the camera floats back and forth, hovering over the landscape until it finally drops to the ground. Swinging between accelerating and decelerating time, *Inflection* takes one on a hypnotic journey, shooting up into the sky and back down again.

LJD

ABOVE AND OPPOSITE stills from *Inflection*

Alighiero Boetti ITALIAN, 1940–1994; LIVED ROME

The veritable constellation of airplanes arrayed across an enormous, startling red sky vividly conveys Alighiero Boetti's conceptual drawing, *Skies at High Altitudes* (*Cieli ad alta Quota*). Gathered together is a collection of every conceivable type of airplane, including graceful sailplanes, supersonic airliners, lumbering cargo transports, nimble stunt planes, and military jet-fighters. Soaring through the skies at alarmingly diverse altitudes, headings, and speeds, Boetti's densely packed fleet of airplanes at first looks like an air traffic controller's nightmare. The image, however, resists such a literal reading; it instead encourages viewers, through its cartoonish sky and impossible juxtapositions of scale, to see it as an imaginative and fantastic "portrait" of aviation history.

Drawn precisely with a ballpoint pen, Boetti's contour-line images echo the diagrammatic representations used in definitive reference books like *Jane's Aircraft Recognition Guide*. Yet they also suggest a boyish tendency to collect and replicate rudimentary drawings of airplanes from magazines, models, films, and other sources. Zooming in front of the viewer like a frenzied flock of birds or a swarm of flying insects, these airplanes overwhelm the viewer with a playful, yet awe-inspiring glimpse of the wide-ranging and truly amazing achievement of manned flight. LMA

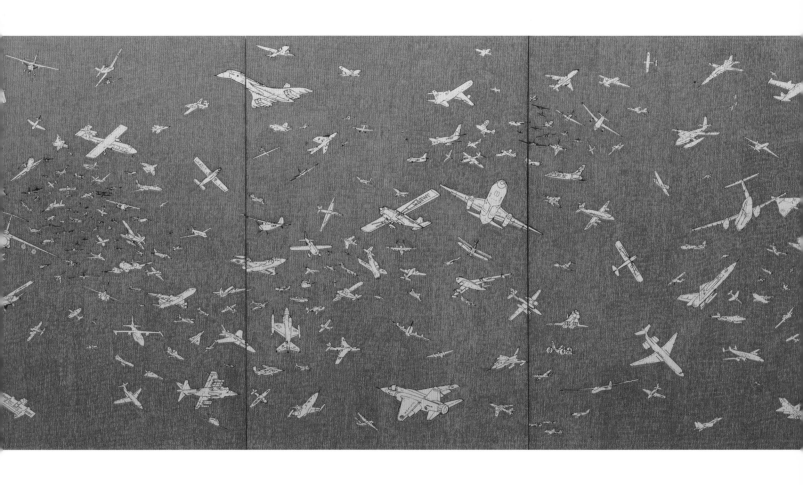

Skies at High Altitudes (Cieli ad alta Quota), 1982
Ballpoint pen on paper on canvas
3 panels, each 39 x 27 (100 x 68.5); overall 39 x 81
(100 x 205.5)
Courtesy Gagosian Gallery, New York

Jonathan Borofsky AMERICAN, BORN 1942; LIVES OGUNQUIT, MAINE

I Dreamed I Could Fly is a group of six figures intended to be suspended from the ceiling, so that the viewer looks up at them from below. (Only one of these figures is on view here.) Made slightly smaller than life-size, so that they appear to be flying even higher than they actually are, the figures are dressed in everyday clothes as they float and dive through the air. Jonathan Borofsky's work explores an archetypal dream of being able to fly, unassisted, through the air and look down upon the world below.

The figures have an almost cartoonish, superhero quality with their styl-ized features and simple clothing. Borofsky is known for his larger-than-life chattering, running, hammering stick-figure men, but these flying figures have a quieter, more contemplative aura, and they seem to exist in a slow-motion dreamworld. Flying figures have appeared intermittently in Borofsky's work since the late 1970s; and in his 1984 retrospective exhibition catalogue, the artist described the airborne figures as "looking down on the planet, sort of surveying. I don't feel like I'm trying to escape the world, as much as trying to get above it for an overview of the larger issues—to try to see it as a whole—the tensions and the beauty, the touch of God. I want to see both together, to understand the workings of the planet."[1]

LJD

I Dreamed I Could Fly, 2000
1 figure suspended from ceiling, from group of 6
Painted Fiberglas, 62 x 36 x 18 (157.5 x 91.4 x 45.7)
Museum of Fine Arts, Boston; Museum purchase with funds donated by Hank and Lois Foster

[1] Jonathan Borofsky, quoted in Mark Rosenthal and Richard Marshall, *Jonathan Borofsky*, exh. cat. (Philadelphia: Philadelphia Museum of Art in association with the Whitney Museum of Art, 1984), 161.

Roger Brown AMERICAN, 1941–1997; LIVED CHICAGO

Many viewers will no doubt respond to Roger Brown's *Living near the Airport* with a chuckle of self-recognition, or at least a sympathetic twinge, as they contemplate the incongruous—but all too common—juxtaposition of airport and suburban neighborhood. As the looming airliner roars over the street, exasperated residents are visible inside their brightly lit, but tightly spaced, identical houses, holding their ears, watching helplessly, and trying to carry on conversations amid the noise and vibrations of the jet.

The compressed spatial depth, exaggerated scale, limited palette, and signlike graphic clarity of Brown's work largely derive from images found in comic books, animated films, and the work of so-called outsider artists. As part of the informal group known as the Chicago Imagists, Brown based his work in popular culture but did not literally appropriate its imagery. Instead, he created a simpler, more lucid visual language that humorously and irreverently commented on personal and social issues. (Notably, Brown painted a number of works related in some way to aviation, including one with an unsettling relevance to today—*Gulf War*, a 1991 diptych showing a concerned George H.W. Bush beside a smiling Saddam Hussein, with a quartet of helicopters circling overhead in each panel.) *Living near the Airport* is not merely a visual joke about the apparent undesirable consequences of living in proximity to a major airport; like the 1997 Australian film *The Castle* (directed by Rob Sitch), Brown's work reminds viewers how issues of class, "desirable" real estate, and "convenience" are interrelated and relative.

LMA

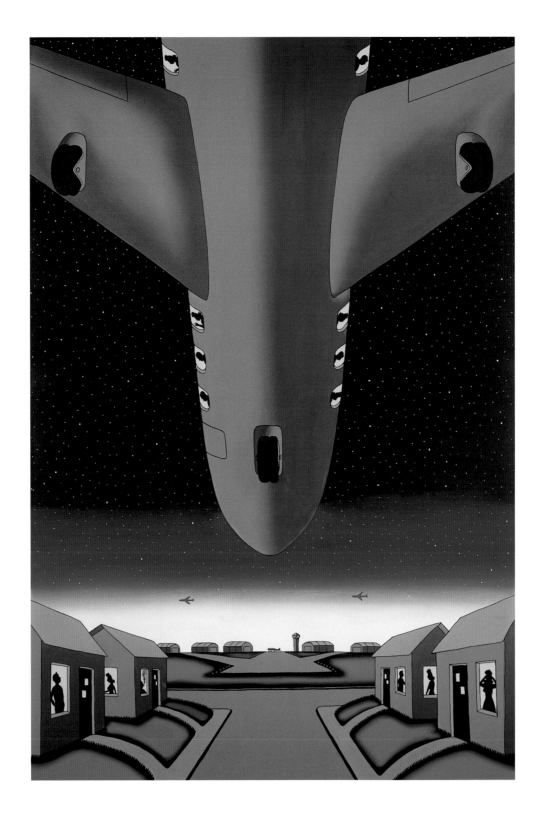

Living near the Airport, 1990
Oil on canvas, 72 x 48 (183 x 122)
Private collection

Bill and Mary Buchen AMERICAN, BORN 1949 AND 1948; LIVE NEW YORK

Bill and Mary Buchen create "sonic architecture": kinetic and sound sculptures powered by the wind. Their interactive works of art combine an exploration of environmental, acoustic, and visual phenomena with music, art, and architecture. Their studio is filled with drums and bells acquired during their extensive trips to India and Southeast Asia, and their works of art are infused with a musician's sensibility. Recent works of art based on aviation themes include a series of wind reeds and a playground in Santa Monica with

an observation tower, a runway, and benches shaped like airplane wings.

Their new work, *Flight Wind Reeds*, commissioned for the exhibition, consists of five elements, each twenty-five feet high, composed of stainless steel and aluminum poles topped with brass bells and steel fins that reference elements of flight and the abstracted parts of an airplane. The works turn, pivot, and spin, making music as the bells on each reed are activated by the wind. *Flight Wind Reeds* is the second in a series of kinetic sculptures by the Buchens inspired by television images of Russian fighter pilots performing aerial stunts. The pilots fly their planes at seven hundred miles per hour and then suddenly cut the engines off, causing the planes to flip up and backward. The sleek, aerodynamic forms

of the sculptural elements of the reeds look as if they are designed for speed, and they perform a similar stunt in response to wind force, spinning and then flipping up. *Flight Wind Reeds* activate and render visible the invisible— the motion, speed, sound, and physical energy of the wind.

LJD

Flight Wind Reeds, 2003
5 aluminum and stainless steel elements with brass
bells, on Museum grounds, each approximately 25 x
25 ft. (7.6 x 7.6 m)
North Carolina Museum of Art; Commissioned with
funds from the North Carolina Art Society (Robert F.
Phifer Bequest)

Chris Burden AMERICAN, BORN 1946; LIVES TOPANGA, CALIFORNIA

Chris Burden's work resonates powerfully with viewers because it reminds them, often through deceptively simple but ingenious means, that conceptual art is not an escape from reality but rather its mirror. Dismayed that technology has left many people with little understanding of how machines work or how everyday objects are made, Burden began producing art that playfully and brilliantly illustrates complex principles of physics, engineering, industry, and commerce. A classic model airplane, constructed of balsa wood, plastic, wire, glue, and tissue paper, with a rubber band to drive the pro-

peller, appears in a number of his works beginning in the late 1970s.

The *Airplane Factory Drawings* in this exhibition represent the conceptual stages of Burden's ambitious project *When Robots Rule: The Two-Minute Airplane Factory* (1999). Installed in London's Tate Gallery, the "factory" was a twenty-foot-long automated assembly line that would build and launch more than eighty thousand airplanes to spiral into the lofty gallery space. Burden's notes reveal his delight that gallery attendants would collect the little planes and sell them as souvenirs to the public, "who then litter the streets

of London with crashed and stuck airplanes." While the project revealed a simplified manufacturing process, it also provided a model of capitalistic industrial production, since constraints of time and money forced Burden to make significant concessions. Due to computer glitches, mechanical problems, and administrative disputes, the "factory" was never fully operational. However, even in its perpetually broken-down state, it managed to offer a critique of the uncomfortable relationship between art, industry, and commerce.

LMA

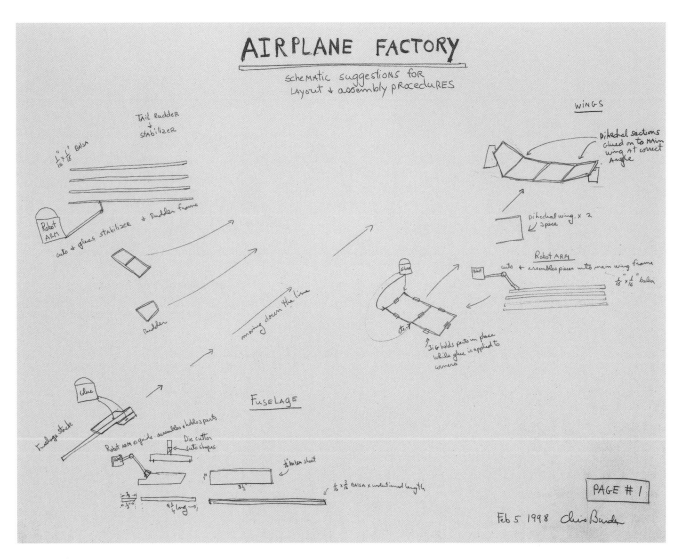

AIRPLANE FACTORY

schematic suggestions for
Layout & assembly pROceduRES

WINGS

Dihedral sections
glued on to main
wing At correct
Angle

TAIL RUDDER
+
STABILIZER

1/16" x 1/16" BALSA

Robot
ARM

cuts & glues stabilizer & Rudder Frame

Dihedral wing, x 2
1 space

Robot ARM

cuts & assembles pieces into main wing frame

1/8" x 1/16" balsa

moving down the line

Rudder

GLUE

PAINT

Jig holds parts in place
while glue is applied to
corners

FuseLage

GLUE

Fuselage stock

Robot ARM in guide. assembles & holds parts

Die cutter
cuts shapes

1/16" balsa sheet

1"

3 1/2"

1/16" x 1/2" BALSA x undetermined length

3/8"
1/2"

9 1/4 long

PAGE #1

Feb 5 1998 Chris Burden

Drawing #1 of 5

Airplane Factory Drawings, 1998

Drawings #1–4 of 5
Each graphite on paper, 19 x 24 (48.2 x 61)
Collection of the artist

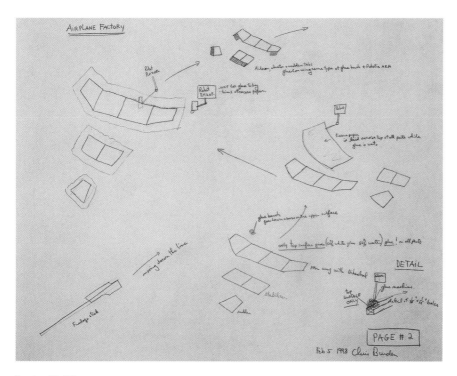

Drawing #2 of 5

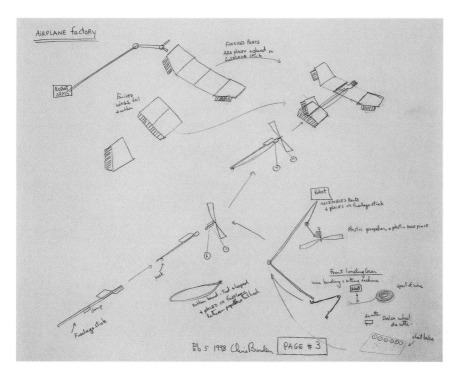

Drawing #3 of 5

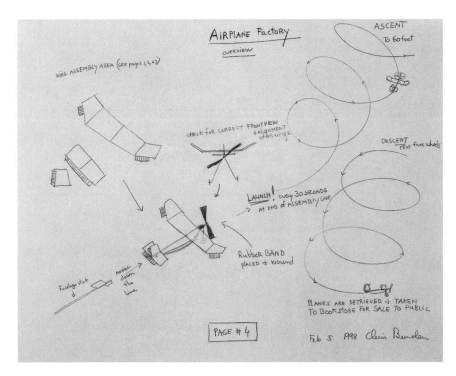

Drawing #4 of 5

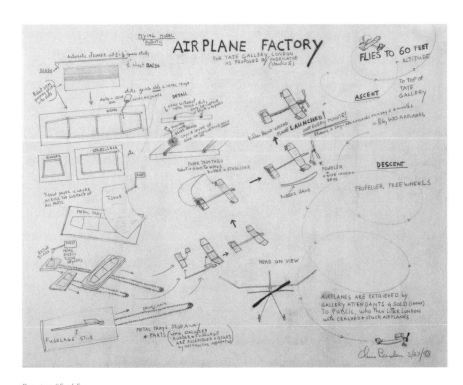

Drawing #5 of 5
Graphite on paper, 18 ¾ x 24 (47.6 x 61)
Gilbert and Lila Silverman, Detroit

Vija Celmins AMERICAN, BORN LATVIA, 1938; LIVES NEW YORK

Vija Celmins's art speaks quietly, and with riveting forcefulness. Her subjects often come from the world of nature—rippling oceans, night skies, desert landscapes, spiderwebs—but nature as seen through reproduction. Celmins works from clippings and black-and-white photographs, and not necessarily recent ones. A perfectionist unafraid of time-consuming projects, she makes paintings in built-up and sanded-down layers and prints in the labor-intensive technique of mezzotint.

Though in the mid-1960s Celmins painted pictures of airplanes—airborne World War II bombers (a reminder that she experienced the war at first-hand)—the work by her included in *Defying Gravity* looks farther out into space. Three works on paper from Celmins's *Night Sky* series draw viewers in for an intimate study of the vast blanket of stars overhead. The above-and-beyond eternally invites contemplation; humans puzzled over and found meaning in the stars even before they felt the urge to fly.

Celmins's own profound and poetic interpretation—the hushed mood, the slight chill thrown off by the intergalactic remoteness, and the pinpricks of light—also mesmerizes. Viewers admiringly scrutinize the painstaking craftsmanship that goes into Celmins's drawings and prints and paintings, and they read these hypnotic, hermetic surfaces as metaphor and metaphysics (despite the artist's insistence that her art is message-free). People often find in the *Night Sky* series a paradox (not unlike the positive and negative results of technological progress); the series instills a certain contented peacefulness and at the same time communicates a melancholic acceptance of uncontrollable fate.

Celmins's work links the insignificant here on Earth to nature in its inherent splendor, to infinity. Even though Celmins elevates technique and process, her art has a way of focusing attention on universals. "Truth . . . is what lives in the stars."[1]

HP

[1] Antoine de Saint-Exupéry, *Wind, Sand, and Stars*, trans. Lewis Galantière (New York: Reynal & Hitchcock, 1939), 227.

22/35 V. Celmins

Concentric Bearings B, 1984
2-color aquatint, drypoint, and mezzotint on Rives BFK paper
Left plate 5 x 4⅜ (12.7 x 11.1);
right plate 4¹¹⁄₁₆ x 3¹¹⁄₁₆ (11.9 x 9.4)
Sheet 17⅜ x 14½ (44.1 x 36.8)
Mount Holyoke College Art Museum, South Hadley, Massachusetts;
Gift of Renée Conforte McKee (Class of 1962)

Strata, 1983
1-color mezzotint from 25 individual copperplates
mounted on single aluminum plate on Arches Cover
paper
Plate 23½ x 29¼ (59.7 x 74.3)
Sheet 29½ x 35¼ (74.9 x 89.5)
Collection of the Orlando Museum of Art;
Gift of Council of 101

Albert Chong

AMERICAN, BORN JAMAICA, WEST INDIES, 1958;

LIVES BOULDER, COLORADO

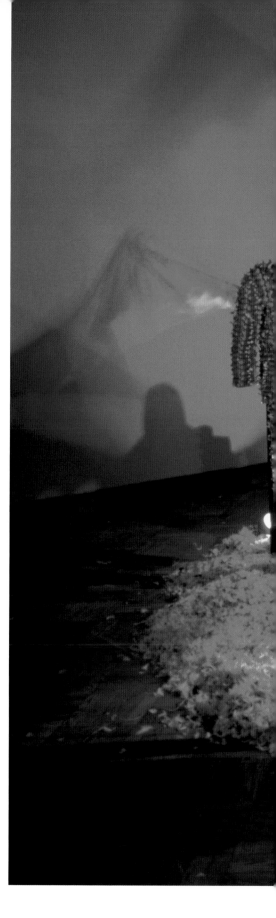

Albert Chong's kinetic installation *Winged Evocations* consists of a group of winged figures standing on a carpet of feathers. The life-size, half-human–half-animal creatures have mechanized rawhide wings that evoke associations with bats and prehistoric birds. Triggered by a motion detector, they slowly flap or beat their wings when a viewer walks by. Their cast-bronze faces are self-portraits of the artist, and they wear pinecone-covered suits, a strange hybrid covering of the natural and man-made that serves as an armored shell to protect the momentarily grounded figures. The feathers shed on the floor around the figures suggest a flight that has failed.

These enigmatic figures are rich with associations and references, reflecting Chong's personal journeys of immigration and transformation, as well as more universal experiences and dreams of flight, escape, magic, and spirituality. As Chong wrote in a 1998 exhibition catalogue for Oberlin College, "With *Winged Evocations* I hope to continue the exploration I started almost twenty years ago, that very human fantasy, soaring unfettered through the heavens: a new divinity, innocent of the misery and desires of the terrestrial world. Like Icarus and Daedalus, like Mercury, the god with winged feet, like harpies, griffins and the winged steed Pegasus, we are all earthbound creatures longing for flight, craving for a glimpse, if not experience, of heaven."[1]

LJD

[1] Albert Chong, "Winged Evocations," in *Winged Evocations: A Kinetic Sculptural Installation and a Meditation on Flight and Its Association with Divinity*, exh. cat. (Oberlin, Ohio: Allen Memorial Art Museum, Oberlin College, 1998), 9.

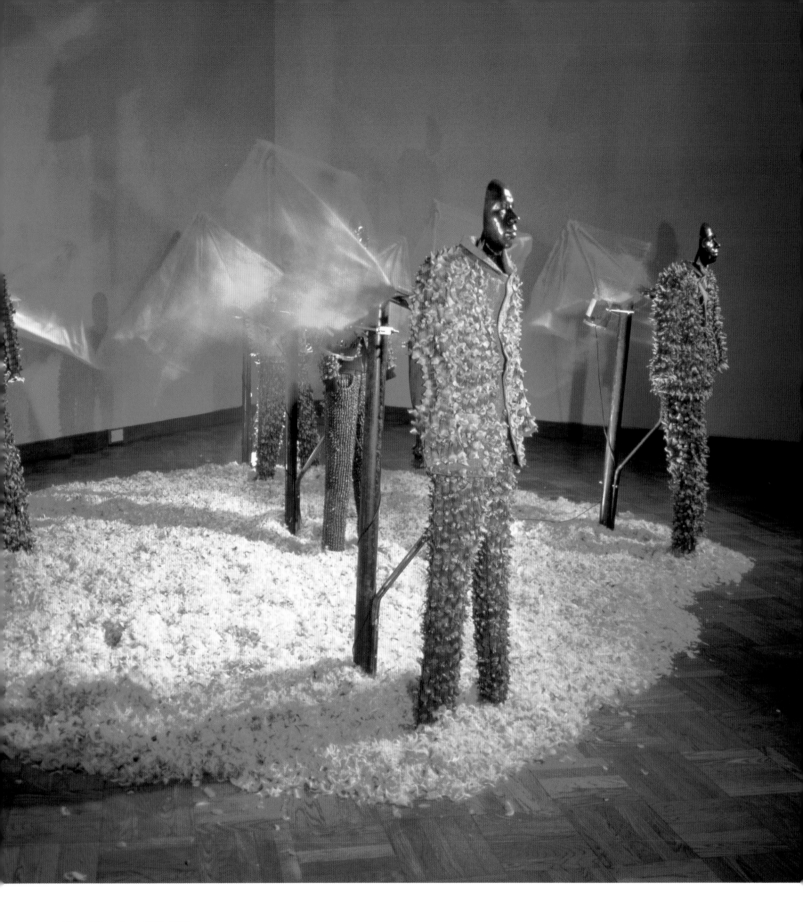

Winged Evocations, 1998–2003
Kinetic installation activated by motion sensor and
composed of mechanized rawhide wings, cast-bronze
faces, pinecone-covered suits, and duck feathers,
approximately 25 x 25 ft. (7.6 x 7.6 m)
Collection of the artist

Brent Cole AMERICAN, BORN 1968; LIVES BURNSVILLE, NORTH CAROLINA

Brent Cole's mixed-media installation tricks the viewer twice by simulating a simulator, a simulacrum times two. *Flight* is a makeshift, clunky, flying apparatus made of found objects and recycled materials. Set on a wheeled platform, it consists of two giant wings and a harness or cradle to hold the pilot in a prone position, so that when in place, one's body would in effect become the body of the plane. The winged contraption faces a curved, transparent screen mounted over two industrial fans and a flight manual. Powered by a motor and set off by a motion detector, the wings slowly flap whenever a viewer walks by.

The artist re-creates the video shown on the screen each time the work is installed in a new place, making the video specifically fit the site.

For this simulated journey, filmed from the pilot's point of view, the video takes the viewer on a wild flight through the galleries, whirring and zipping by objects, out the front door, soaring up into the sky, and around the grounds of the Museum. The flying apparatus has an anthropomorphic quality and evokes associations with prehistoric birds. At times, the video appears to be taken from the point of view of a bird frantically attempting to flee the confines of the building.

As Cole describes his work, "By implementing a context that is more experiential than static, I want to question our viewing boundaries, discerning the fun house for what it really is: the blurred line between an implied reality and what constitutes our own sense of truth."[1]

LJD

[1] Artist's statement, January 1, 2002, curatorial files, North Carolina Museum of Art.

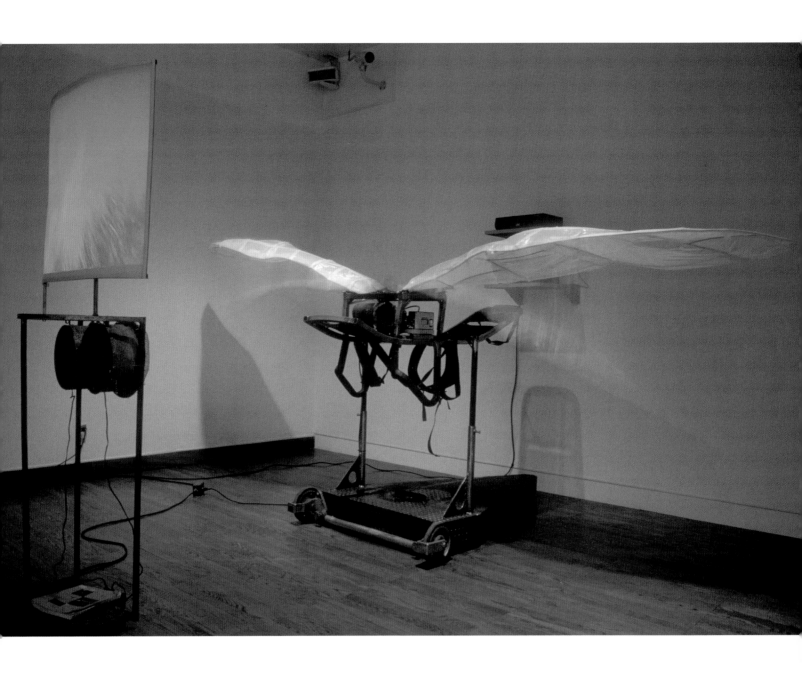

Flight, 2001, revised 2003
Kinetic installation activated by motion sensor
Flight mechanism: wings of plastic over steel armature, camera-dolly wheel base, cradle made from backpack frame and reassembled institutional chairs, and recycled ceramic wheel motor

Screen assembly: double-sided matte drafting vellum screen and fans from chicken coop, with old flight manual on shelf
Projector and DVD player
Approximately 6 x 20 x 15 ft. (1.8 x 6 x 4.5 m)
Collection of the artist

Lewis deSoto

AMERICAN, BORN 1954; LIVES SAN FRANCISCO AND NEW YORK

Repose consists of a wood and aluminum airplane, leaning against the wall, suspended in a nosedive into the floor. The aircraft is surrounded by a blue velvet curtain that swirls into a puddle on the floor around the nose of the plane (the curtain can be arranged differently each time the work is shown). This poetic work is simultaneously meditative and tragic. The plane can be seen as merely resting against the wall, but it could also be caught in that eerie moment of stillness before the final impact. The dark blue velvet imbues the work with a melancholy air and the plane, obviously headed for disaster, signals a sense of loss. On close inspection, one can see that the cross section of a woman's silhouette has been cut into the horizontal aluminum panels that make up the fuselage of the airplane. With the insertion of the female form, the aircraft becomes an evocative surrogate object, a symbol of human suffering, perhaps a memorial to a life or love lost.

LJD

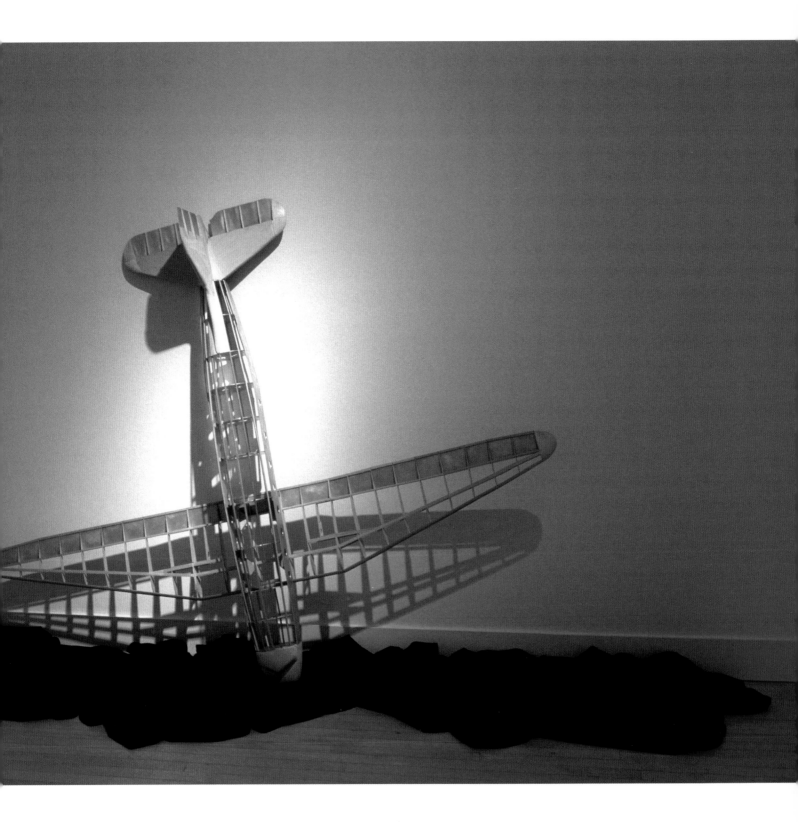

Repose, 1996
Wall-supported wood and aluminum skeleton housing
aluminum panels, with velvet curtain pooling on floor
underneath base, 10 ft. 9 in. x 6 ft. 9 in. x 4 ft. 2 in.
(3.3 x 2.1 x 1.3 m)
Courtesy Bill Maynes Gallery, New York

Eugenio Dittborn CHILEAN, BORN 1943; LIVES SANTIAGO

During the 1870–71 Siege of Paris, embattled Parisians communicated beyond enemy lines using airmail. Aboard two hot air balloons owned by the photographer Nadar, vital correspondence, supplies, and even endangered political figures were shuttled in and out of the

city unimpeded. The Chilean artist Eugenio Dittborn's *Airmail Paintings* have, since the 1980s, similarly used airmail to convey subversively his politically charged artistic expressions beyond the confines of the oppressive militaristic regime formerly led by Augusto Pinochet. Folded one-sixteenth their original size to fit into mailing envelopes, Dittborn's paintings travel the world freely, stopping briefly at museums and galleries as part of an endless global itinerary. Dittborn's works are thus records of the freedom that air travel enables.

Curvas de Fantasía, composed of pictographs that suggest the passage of time and death, echoes the frustration of living under a violent dictatorship, even as its travels literally inscribe spatial and chronological

liberation from Chile. Having traveled from Chile to Australia, Europe, and the United States, the inexpensive and humble wrapping paper, with its folds and signs of wear, belies its global reach and its status as "high" art.

Likewise, *El Crusoe* transgresses borders of both geography and artistic production. Borrowing its title from Daniel Defoe's 1719 account of the famed castaway Alexander Selkirk, who stranded himself on an island four hundred miles west of Santiago, Dittborn illustrates Crusoe's confrontation with cannibalism. Dittborn's painting thus pointedly criticizes intolerance to cultural difference, while also drawing parallels between the artist, his country, and their shared isolation.

LMA

El Crusoe, 1999–2001
Airmail Painting No. 127
Tincture, sateen, embroidery, stitching, and photo-silkscreen on 2 sections of cotton duck fabric, 82½ x 110½ (209.6 x 280.7)
Courtesy Alexander and Bonin, New York

Curvas de Fantasía, 1985
Airmail Painting No. 31
Paint, feathers, string, and photo-silkscreen on Kraft wrapping paper, 82½ x 60 (209.6 x 152.4)
Courtesy Alexander and Bonin, New York

Las Curvas de Fantasía

This sign

has a particular value

This sign

has a particular value

because it permits

the precise

ascertainment of time

This sign

has a particular value

because it permits

the precise

ascertainment of time

spent by the corpse

in the water.

PINTURAS AEROPOSTALES DE DITTBORN
AIRMAIL PAINTINGS BY DITTBORN

Art Domantay

AMERICAN, BORN THE PHILIPPINES, 1965; LIVES BROOKLYN, NEW YORK

Art Domantay's *Balsa Wood Airplane: The Land That Time Forgot* is an enlarged replica of a toy airplane expanded from twelve inches in length to approximately sixteen feet. The artist takes an everyday and familiar object and alters it to make the viewer look more closely, examining both childhood and adult dreams of flight. Just as in the toy model version, the operating instructions and the decorative details, including a silhouette of the pilot, are painted in red on the plane's various parts. There is even an oversized rubber band stretched from the back of the plane to the propeller, readying the *Sky Streak* for takeoff. Like a gigantic cartoon caricature or a childhood fantasy come to life, the exaggerated scale of this whimsical sculpture turns the adult viewer into a child again.

As Domantay has described his work, "When we see something familiar and recognize the function it has in our everyday life, it then becomes forgotten because many times familiarity equals insensitivity. . . . [My works] intentionally try to break that familiarity [and] walk that thin thread between make-believe and reality."[1]

LJD

[1] Art Domantay, quoted in press release, "Temporary Residents," Public Art Fund, New York, September 18, 2001, 1.

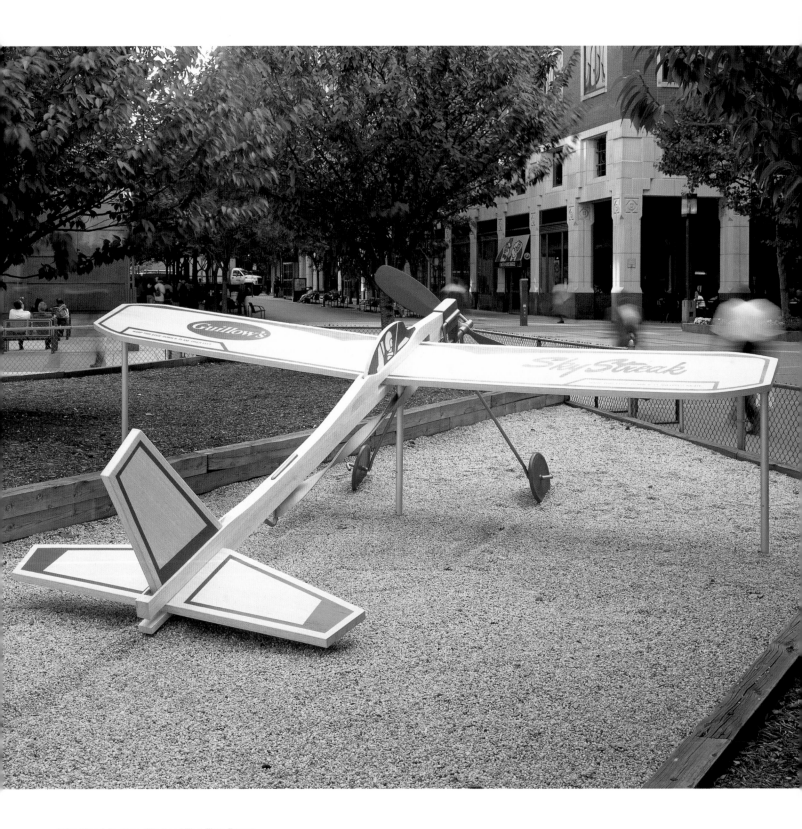

Balsa Wood Airplane: The Land That Time Forgot,
2001
Steel substructure with balsa wood sheath, rubber
band, aluminum wheels, and propeller unit, on
Museum grounds, 5 x 14 x 16 ft. (1.5 x 4.3 x 4.9 m)
Collection of the artist; Commissioned by the Public
Art Fund, New York, for *Temporary Residents*, 2001–2

Chris Drury BRITISH, BORN SRI LANKA, 1948; LIVES EAST SUSSEX, ENGLAND

Chris Drury creates both temporary and permanent sculptures in the landscape that are intimately intertwined with the natural world. A recent series of works, *Cloud Chambers*, are shelters made of stone, turf, or wood. The chambers have an ageless, primal quality, often appearing to be ancient ruins or natural formations, and tend to blend with their surroundings. Each shelter operates as an oversized camera obscura or pinhole camera, with a small aperture in the roof that projects an inverted image of the sky onto the floor of the chamber, an effect that seems to pull the sky down to the viewer and make the atmosphere tangible.

For the exhibition, Drury (with the assistance of the NCMA's Bill Hamlet) constructed an octagonal *Cloud Chamber* of stone, logs, and turf in the woods of the Museum Park. Inside the chamber, an image of the sky appears on the floor. On a clear day, one might see a perfect circle of blue sky and

green treetops; at other times, a mass of white clouds swirling across the sky might be captured for a brief moment by the lens of the chamber. The interior is a still, meditative space, its darkness pierced only by the luminous reflection of the sky. Inside the chamber,

one's perspective of the world is turned upside down and reversed. Instead of looking up at the sky—the earthbound view of the world—one sees the sky pulled down to Earth, and one looks down on it from above.

LJD

OPPOSITE interior, showing camera obscura image projected on wall and floor

Cloud Chamber for the Trees and Sky, 2003
Stone, wood, and turf structure built on Museum grounds, approximately 12 ft. (diam.) (3.7 m)
North Carolina Museum of Art; Commissioned with funds from the North Carolina Art Society (Robert F. Phifer Bequest)

Donald Evans

AMERICAN, 1945–1977; LIVED AMSTERDAM

Eugenio Dittborn is not the only artist whose works in *Defying Gravity* have a connection with postage stamps. As opposed to Dittborn's pragmatic use of airmail as art shipper, Donald Evans established postal systems that exist only on paper; the borders he transcends are those of reality. The artist made up forty-two countries and issued postage stamps for them. The period feel of these tiny, delicately nuanced watercolors helps separate them from the present. Sometimes Evans "used" the stamps on a postcard, all of which became a collage. Most often, he presented the stamps as any philatelist would, lined up on black backgrounds. He even indicated the perforations.

The stamps, like real countries' stamps in size and image, feature native flora and fauna, characteristic scenery and products—and airplanes and dirigibles. Also included here is a sheet of windmills. The windmill is not as odd a presence in an exhibition about airplanes as it might at first appear. Like airplanes, it takes advantage of the wind, and it is an antecedent of the helicopter.

Stamps establish an unlikely link between Donald Evans and Andy Warhol. The pop artist painted not only soap boxes and soup cans but also stamps. Warhol's 1962 canvases are made up entirely of sheets of seven-cent United States airmail stamps, each with an emblematic jet beside a stylized 7.[1] Warhol pointedly makes his stamps mimic the government's standard issue. Evans, on the other hand, persuasively conjures an escapist fantasy. HP

[1] The *Airmail Stamps* series, as well as another work relating to aviation, the better-known airplane crash painting *129 Die in Jet*, are reproduced, respectively, in *The Andy Warhol Catalogue Raisonné: Paintings and Sculpture, 1961–1963* (New York: Phaidon Press, 2002), cat. nos. 110–24, 199.

Aquarelles, Song-Ting, 1930. Timbres pour la poste aérienne: Dirigibles. (Watercolors, Song-Ting, 1930. Airpost stamps: Dirigibles.), 1975, Watercolor on paper, framed 12 x 9 (30.5 x 22.9) Mr. and Mrs. Eldon C. Mayer Jr.

Reproduction larger than original

Nadorp, 1953. Windmills., 1975
Watercolor and rubber stamp on paper, framed 12 x 9
(30.5 x 22.9)
Collection Bill Katz, New York

*Nadorp, Airpost of 1919 and 1921
on souvenir postcard.*, 1974
Watercolor on paper collaged to postcard,
3³/₄ x 5¹/₂ (9.6 x 14)
Collection of Hugh J. Freund

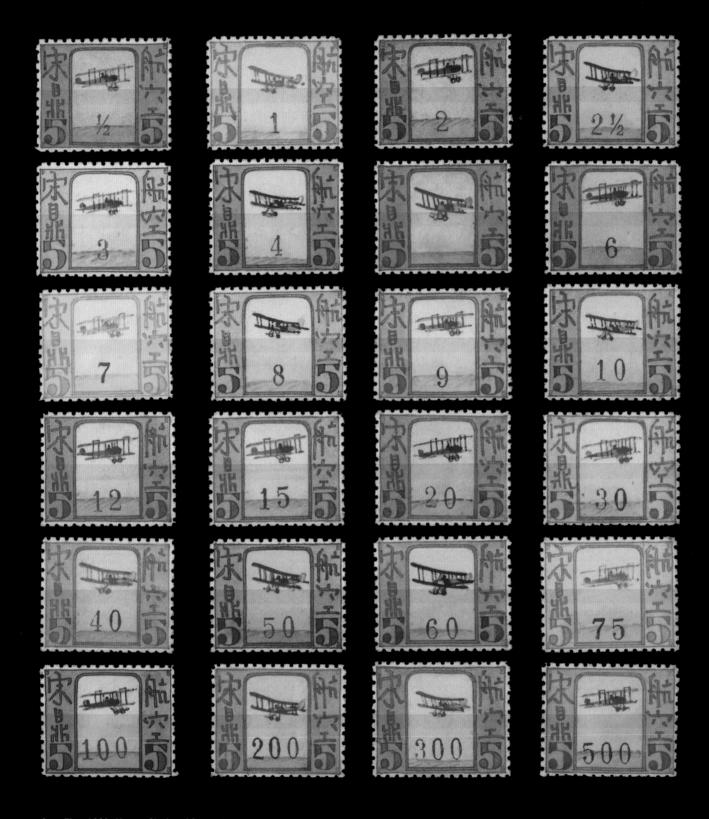

***Sung Ting, 1928. Airpost. Shades of five cent
values surcharged in black.***, 1975
Watercolor on paper, framed 12 x 9 (30.5 x 22.9)
Emanuel Gerard, New York

Not in exhibition

Heide Fasnacht AMERICAN, BORN 1951; LIVES NEW YORK

For the last few years, Heide Fasnacht's work has focused on capturing forces of energy, dramatic actions frozen in midstream or, more often, in midexplosion. Her "stop-action" sculptures and drawings depict sneezes, bombs, volcanoes, and geysers: various man-made and natural eruptions, demolitions, implosions, and explosions. Her works present violent catastrophes that often combine a sense of awe, and sometimes humor, with an acknowledgment of devastation and disaster.

Exploding Plane, made of carved Styrofoam and Neoprene that has been forced through wire mesh and then painted a metallic silver, is based on special effects disaster scenes from movies. Suspended between the floor and ceiling by an intricate webbing of guy wires, the plane is formed of shattered fragments and recognizable objects, including tiny suitcases, an airplane wing, nose, and tail. It is a spectacular visual image of a tragic event that portrays the dematerialization of a solid object and the materialization of an invisible force of energy.

Fasnacht's works have a sense of ordered chaos and barely restrained energy in their documentation of imminent implosion, maximum speed, final impact, and disintegration. As described by Lilly Wei in *Energy Inside*, "Willing to confront the catastrophic, Fasnacht sees in the horror of destructive events not only a terrible beauty but also redemption, reclamation, a clearing away after the apocalypse that regenerates and ameliorates. She cites disasters such as Hiroshima, where many people paused and looked back while they were running away from the explosion, terrified and in great peril, yet transfixed by its utterly compelling, unholy beauty."[1]

LJD

[1] Lilly Wei, "Systems of Energy, Dreams of Sculpture," in *Energy Inside*, exh. cat. (Grinnell, Iowa: Faulconer Gallery, Grinnell College, 2001), 12.

Exploding Plane, 2000
Suspended maquette; carved and polychromed
Styrofoam and shot Neoprene over metal armature,
approximately 10 x 10 x 10 ft. (3.04 x 3.04 x 3.04 m)
Courtesy Kent Gallery, New York

Peter Fischli and David Weiss

SWISS, BORN 1952 AND 1946; LIVE ZURICH

Like the Wright brothers, the Swiss artists Peter Fischli and David Weiss work well as a team, sometimes employing the Wrights' trial-and-error methodology. The best-known example of this strategy in action is their film *The Way Things Go* (*Der Lauf der Dinge*). Tires, bottles, balloons, chairs, and other familiar objects roll and teeter, burn and fizzle, explode and collapse, never allowing a break in the chain reaction. It is good fun—and seems akin to the playful spirit that moved the young Wilbur Wright. As the elder brother, he made up stories for Orville, all of which ended, "and then the boiler bust."[1] The film also equates the artistic and the mechanical, blurring distinctions between disciplines. This boundary-defying approach has a certifiable presence in *Defying Gravity*.

Fischli and Weiss's works, often characterized by purposeful mediocrity, center on the theme of anonymity. Twice in their career—the artists have collaborated since 1979—they have chosen airports as the subject of a photographic series, a topic well suited to this theme, for in an airport everyone seems anonymous. The exhibition includes chromogenic prints from the more recent series. These scenes of planes at the jetway, taken from the terminal, have an artfulness (uncentered compositions, reflections on the plate-glass windows) that Fischli and Weiss usually avoid studiously. And the images rarely include human beings—a populous place ironically documented with people so anonymous they disappear from view. The plaster of the stewardess, as flight attendants were once called, was done about the time of the first airport series. The nondescript attendant serves as an appropriately blank greeter to the world photographed by Fischli and Weiss.

HP

[1] Recounted in Fred Howard, *Wilbur and Orville: A Biography of the Wright Brothers* (London: Robert Hale, 1987), 7.

Frankfurt (Condor)
Jane Holzer

3 works from *Airports* series, 2000
Each chromogenic print, 48 ¾ x 72 ¾
(123.8 x 184.9)

Untitled (Zurich, green line, #07)
Courtesy Matthew Marks Gallery, New York

Untitled (Zurich, Lufthansa, #10)
Courtesy Matthew Marks Gallery, New York

OPPOSITE
Stewardess, 1989
Plaster, 44½ x 10¼ x 7¼ (113 x 26 x 18.4)
Sammlung Hauser und Wirth, St. Gallen, Switzerland

Lawrence Gipe

AMERICAN, BORN 1962; LIVES LOS ANGELES

Lawrence Gipe appropriates Depression-era mass-media advertising and propaganda images to criticize twentieth-century American faith in industrial progress. As key symbols of what the publisher Henry Luce called "The American Century," transportation industry icons appear frequently in Gipe's work. Borrowing the theme Century of Progress from the 1933 Chicago World's Fair, Gipe's series of paintings *The Century of Progress Museum* combines images with text to question the relationship between industrialization and utopian progress. Gipe's *Panel No. 6* mimics a travel poster with its dynamic arrangement of streamlined ocean liner, locomotive, airplane, and looming automobile. Across the bottom of the canvas, an army of buses lines up, as if ready to whisk viewers directly "in[to] the future." The optimistic text, "All Your Hope Should Be in the Future," could have come verbatim from a vintage source, but seen from the perspective of contemporary viewers, its ironic plea becomes desperate, suggesting instead that there is no hope in the present.

Gipe's sublime *Insignificance* reminds viewers that it is difficult to overestimate the extent to which the transportation industry and, in particular, the ability to fly have expanded the limits of human consciousness. However, such discoveries have also threatened or destabilized entire systems of thought. Roaming the sky in a tiny biplane, Gipe's aviator parallels contemporary society, for whom technological progress offers the possibility of both liberation within nature and alienation from it.

LMA

OPPOSITE
"Panel No. 6 from The Century of Progress Museum (Propaganda Series)," 1992
Oil on panel, 72 x 48 (183 x 122)
The Speyer Family Collection, New York

OVERLEAF
Insignificance, 1998
Oil on panel, 36 x 72 (91.4 x 183)
Eric and Lisa Dortch

Jeffrey W. Goll AMERICAN, BORN 1953; LIVES DURHAM, NORTH CAROLINA

Known for sculptures made of found objects and recycled materials, Jeffrey W. Goll has created an installation of one hundred airplanes, one for each year of the Wright brothers' centennial. The airplanes march across the front lawn of the Museum like a ragtag army of weathered soldiers, an irregular armada of ancient ships, a flock of earthbound birds, a herd of ponderous beasts, or a child's treasure trove of homemade toys. The artist, who has described the work as "a fetish field or perhaps a junkyard or shrine," sees "the overall impact of the installation as that of a monument or an offering site to the gods of flight."[1] In part, the installation is inspired by the idea of "cargo cults," where in places like New Hebrides and Melanesia islanders believed that cargo planes, bringing goods and money, could be summoned to their island by magic rituals.

The one hundred planes are made of rough, crude materials, including scrap lumber, oilcans, fan motors, lawn mower parts, rubber wagon wheels, typewriter elements, books, gourds, toys, shoes, kitchen utensils, and musical instruments. With wingspans ranging from one foot to six feet, some of the planes are simple and minimalist in form, whereas others are highly decorated and embellished. Goll's fantastic winged assemblages combine nostalgic and whimsical associations with darker undertones that allude to wrecked and abandoned airplanes, in an installation that can be seen as a graveyard for grounded flying machines.

LJD

[1] Jeffrey W. Goll, e-mail correspondence with the author, September 9, 2002.

Memorial Field for a Disappointed Century, 2003
100 planes made from recycled materials and found objects, distributed on Museum grounds, with wingspans varying from 1 to 6 ft. (.3 x 1.8 m)
Collection of the artist

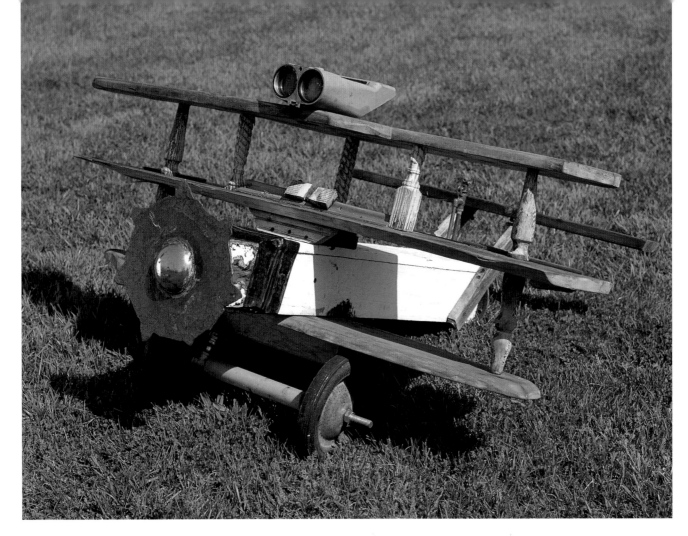

Planes, 1996
Oil on canvas, 59 x 59 (150 x 150)
Collection of the artist

Margot Gran

ISRAELI AND AMERICAN, BORN UNITED STATES; 1967, LIVES KIRYAT-ONO, ISRAEL

Born in the United States and a resident of Israel since she was ten, Margot Gran spent her early childhood on a boat with her family, sailing in the South Pacific and Indian Oceans. The experience—the confined space of their living quarters, awareness of the water's motion and power, the edenic islands—left its mark on her. Such memories have helped form the artist's desire to create images that combine movement, beauty, and danger.

These interrelated ideas find expression in *Planes*, a painting influenced by a still from a film documenting air maneuvers in 1945. The near abstraction of the bombers, smeared horizontals speeding by in formation, mercifully distances viewers from their threat; the hum of engine noise is evoked but faintly. Recognizing the war imagery, one is at the same time moved by the serene blue sky—and by Gran's poetic and self-assured skill with design, paint handling, and palette. Hard to see in reproduction, the orangish light of the underpaint comes through the prevailing blues, which, in their variety, yield nuanced complexity.

Inspired by the ongoing Middle East violence, *Planes* relates as much to peace as it does to war. The artist regards the sky in its quiet tranquillity, yet blemished by the blurs of the bombers, as representative of the calm before catastrophe; the painting's mood evokes the throbbing presence of imminent disaster that warps daily life in Gran's part of the world. For Gran, *Planes* describes inner conflict and the quest for concord and liberty: life can't go on like this; life must go on—with, always, the sky overhead bestowing a soaring sense of freedom.
HP

Andreas Gursky

GERMAN, BORN 1955; LIVES DÜSSELDORF

On first encountering one of Andreas Gursky's astonishing photographs, viewers often feel compelled to move ever closer—as if they're looking for something deep in the photographic space. Incredulously, they scan the massive image for its tiny treasures of detail, and for confirmation that what they are looking at is indeed only an image. With its high vantage point and expansive subject, Gursky's *Los Angeles* prompts its viewers to replicate the physical and optical experience of air travelers observing the ground from above, training their eyes on tiny details amid a staggeringly vast panorama.

Despite its breadth, this huge photograph, taken looking south from the Griffith Park Observatory, encompasses a fractional slice of the city.

Prior to aviation, such bird's-eye views existed only in the imagination of artists and cartographers—most individuals had neither the leisure nor the inclination to scale mountains just for the view. In the Western tradition, such

Los Angeles, 1999
Chromogenic print, framed 6 ft. 8 ¾ in. x
11 ft. 9 ¾ in. (205 x 360)
Warren and Victoria Miro Collection

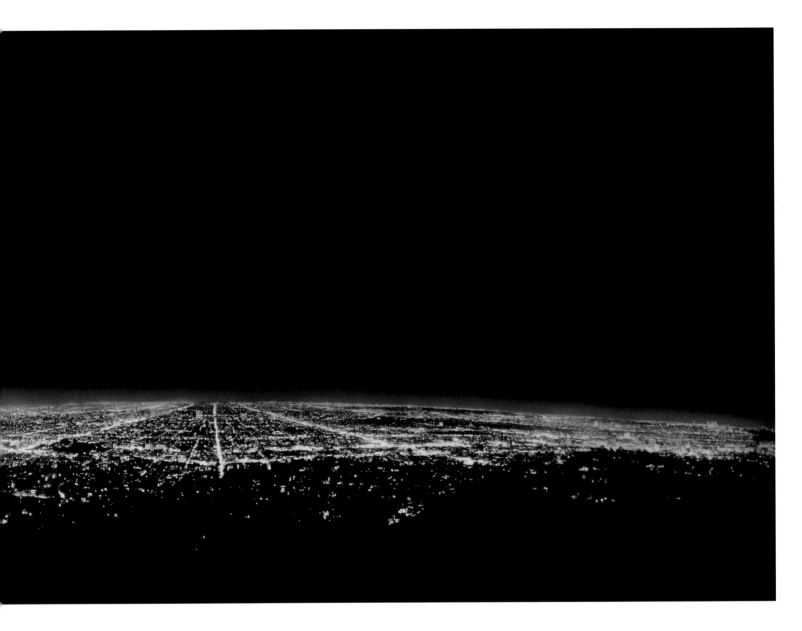

locales have been exclusive, reserved for deities. Now, although such commanding vistas appear regularly to contemporary air travelers, the high vantage point is still one of privilege. For many people, air travel is but a luxury; real estate with a view is notoriously expensive, and many of these sites are within the controlled grounds of private corporations and government institutions.

Like the airborne perspective it mimics, *Los Angeles* is a remarkable technical achievement. There is, however, a tense irony: a site devoted to observing the galaxies helps make visible the conditions on Earth.

LMA

Hoss Haley AMERICAN, BORN 1961; LIVES ASHEVILLE, NORTH CAROLINA

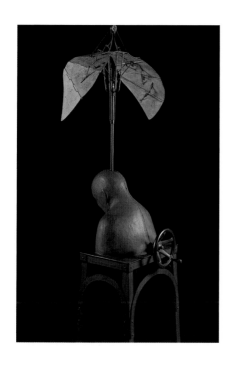

Hoss Haley's sculpture presents a disjunctive view of the myth of Icarus and the dream of flight. Titled *Daedalus*, it refers to Icarus's father and the inventor of the wings they used to escape from the labyrinth of King Minos. The work portrays a man from the chest up. His wings, mounted on a pole that rises out of his head and powered by a crank on his back, hover over him. Depicted in this manner, the wings become a metaphor or symbol for a dream of flight, rather than a true attempt at flight. The elaborate mechanized contraption that constitutes the armature for the wings brings to mind

Leonardo da Vinci's drawings and backyard inventors' flying machines. Slumped over, the man's posture alludes to a sense of defeat or failure, of a flight that never reached its destination, like that of Icarus when he flew too close to the sun.

LJD

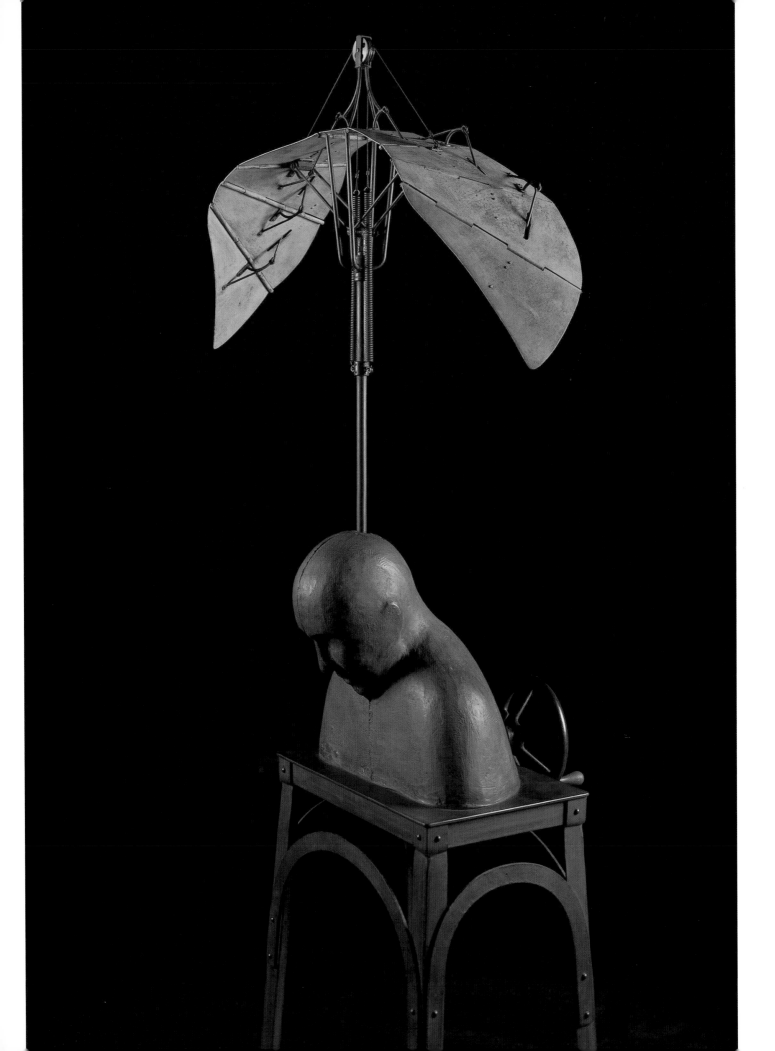

Kara Hammond AMERICAN, BORN 1963; LIVES BROOKLYN, NEW YORK

As a native North Carolinian and an avid cyclist, Kara Hammond confesses to more than a passing interest in the Wright brothers and their breakthrough invention. She recognizes them as true scientists, not just guys goofing around in their bicycle shop. An important lesson she has learned from them—the value of experiment and failure—is reflected in two drawings in the exhibition, *Lilienthal's Biplane Glider* and *1900 Wright Kite*. Otto Lilienthal, a German mechanical engineer and aeronautical pioneer, was the Wrights' hero. They benefited from *his* experiments and failures, particularly from his realization that the solution to maneuvering a plane had to come before that of power for takeoff.[1] Inspired by Lilienthal, the Wrights devised a flying machine that was more like a kite.

Not for transporting people, it was for testing controls. Hammond's delicate graphite drawings, based on vintage photographs, find the poetry in these rudimentary objects.

Hammond makes good use of her source material. In *Landing in L.A.*, a painting derived from a photograph, an expertly rendered Boeing 747 flies under a graceful swirl of clouds, whose upward curves echo a bird's flapping wings. The more expansive *30,000 feet*, an image Hammond saw on a transcontinental airplane trip, depicts the sky as an inhabitable space. Just as a traditional landscape gives the viewer a sense of a physical space, the clouds provide a similar image of solidity, in thin air.

HP

[1] Pat Shipman, *Taking Wing: "Archaeopteryx" and the Evolution of Bird Flight* (New York: Simon and Schuster, 1998), 66.

Landing in L.A., 1998
Oil on Masonite, 14½ x 16 (36.8 x 40.6)
Courtesy Joseph Rickards, New York

Lilienthal's Biplane Glider, 2002
Graphite on paper, 22 x 22 (55.9 x 55.9)
Collection of the artist

1900 Wright Kite, 2002
Graphite on paper, 22 x 22 (55.9 x 55.9)
Collection of the artist

30,000 feet, 2002
Oil on wood panel, 30 x 120 (76.2 x 304.8)
Collection of the artist

Ralph Helmick and Stuart Schechter

AMERICAN, BORN 1952 AND 1958; LIVE NEWTON, MASSACHUSETTS

Ralph Helmick and Stuart Schechter collaborate on large-scale works of art, which they describe as three-dimensional Pointillism, consisting of thousands of small, suspended sculptural elements that coalesce into large, composite forms. Collaborating on public art projects since the early 1990s, Helmick and Schechter bring together the talents of a trained sculptor and a former art professor with the skills of a portrait painter and former rocket scientist to create sculptural installations that combine art and technology to focus on elements of visual perception.

In conjunction with the exhibition, they were commissioned by the Museum to create a work of art with references to flight in both content and form. The new work is composed of nearly 1,400 subtly moving parts depicting more than a dozen species of butterflies that together form an image of a jetfighter. The steeply banking plane is caught in midflight, frozen in time yet filled with the fluttering movement of the individual butterflies. Suspended by cables from the ceiling, each Mylar butterfly is anchored by a small pewter weight. Floating behind the plane are contrails of brightly colored flowers.

In *Rabble*, an immensely heavy, inert, metallic, industrially manufactured machine is transformed into a porous, ephemeral, animated, buoyant, cloudlike construction of flickering, delicate, vibrantly hued natural forms—"a brilliant visual cacophony of 'natural' design."[1] This monumental sculpture, composed of a multitude of fragments, is inherently contradictory, visually complex, and yet immediately engaging and easy to read. A fantastic synthesis of man-made and natural flight, it is, in the artists' words, "a conversation between two kinds of rapture, natural and technological, with all the beauty and terror that each encompasses."[2]

LJD

[1] Ralph Helmick and Stuart Schechter, written proposal for North Carolina Museum of Art commission, May 14, 2002, curatorial files, North Carolina Museum of Art.

[2] Ralph Helmick and Stuart Schechter, e-mail correspondence with the author, May 7, 2003.

Digital rendering

Rabble, 2003
Airplane of Mylar butterflies suspended from stainless-
steel cables installed in ceiling and anchored by
pewter weights with contrails of flowers, approxi-
mately 10 x 15 x 44 ft. (3.1 x 4.6 x 13.4 m)
North Carolina Museum of Art; Commissioned with
funds from the North Carolina Art Society (Robert F.
Phifer Bequest)

PREVIOUS COMMISSION
Double Vision (DC-3), 2000
Cast metal and stainless steel, 28 x 13 x 12 ft.
(8.5 x 4 x 3.7 m)
American Airlines Arena, Miami, Florida;
Commissioned by Metro-Dade Art in Public Places
and the Miami Heat (see also p. 55)

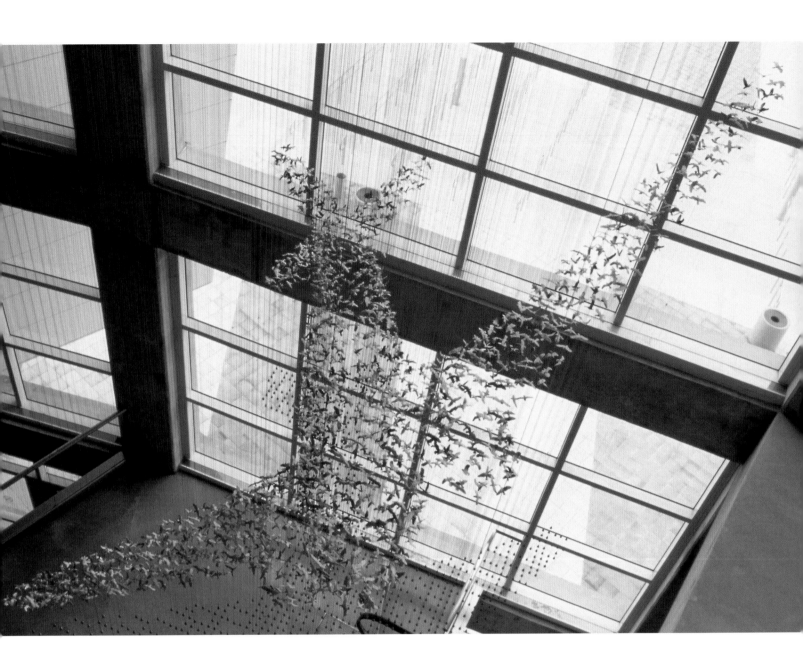

Yvonne Jacquette AMERICAN, BORN 1934; LIVES NEW YORK

For more than thirty years, Yvonne Jacquette's distinctive paintings have aptly illustrated Gertrude Stein's axiom: "One must not forget that the earth seen from an airplane is more splendid than the earth seen from an automobile."[1] Indeed, Jacquette's vibrant, large-scale aerial views evoke a sense of delight and intrigue that is nothing short of splendid, especially in shimmering nocturnal scenes like *Night Wing: Metropolitan Area Composite II*.

Representing a composite of the New York–Newark metropolitan area, this painting conveys the fascinating, yet often disorienting, view air travelers have: when flying low over a city, they strain to catch a glimpse of some landmark to which they might orient themselves. The altered perspective from above, at times obscured by clouds; the movement and noise of the aircraft, here evoked by the prominent wing; the shifting streams of automobile headlights; and the reflective glint of water combine to present something often unrecognizable to even the most experienced travelers. Entire regions, cities, neighborhoods, buildings, shopping centers, parks, harbors, and highways dissolve into a giant animated and twinkling toy train set that expands and challenges the perception of those who are willing to look.

Jacquette's palette and delicate, short brushstrokes echo impressionist and post-impressionist efforts to capture light in motion; her work hints at what Vincent van Gogh might have painted had he been able to take to the skies of his *Starry Night* (The Museum of Modern Art, New York) and gaze down on the village below. Jacquette's "splendid" works confirm Stein's related assertion, "the earth seen from an airplane is something else."

LMA

[1] Gertrude Stein, *Picasso* (Boston: Beacon Press, 1959), 49–50.

Night Wing: Metropolitan Area Composite II, 1993
Oil on canvas, 80¾ x 56¾ (205.1 x 144.1)
North Carolina Museum of Art; Purchased with funds from the North Carolina Art Society (Robert F. Phifer Bequest)

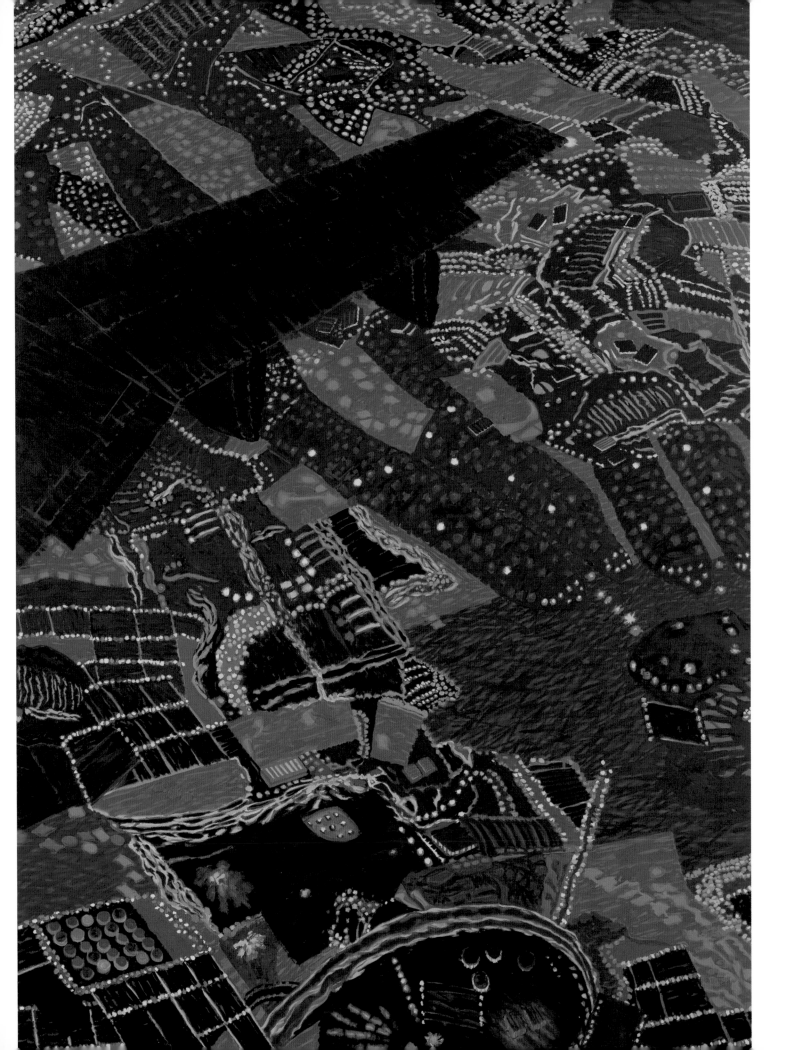

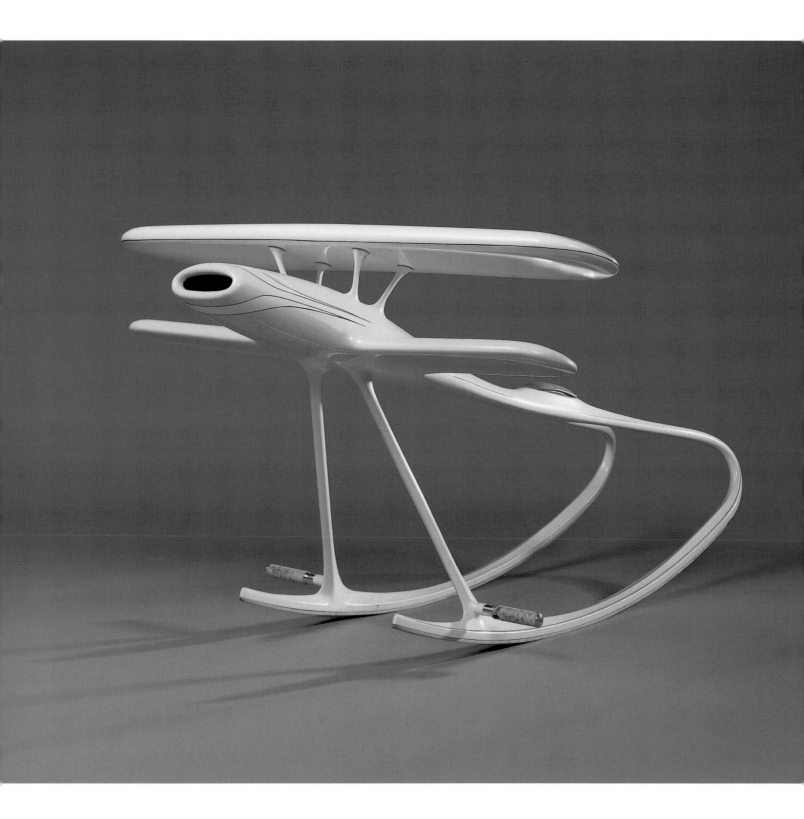

Give Me Wings, 1981
Painted biplane rocker
Composite construction over steel armature, with
lacquer finish and leather seat and footpegs, 36 x
36 x 60 (91.4 x 91.4 x 152.4)
Sonia and Isaac Luski

Marvin Jensen

AMERICAN, BORN 1945; LIVES PENLAND, NORTH CAROLINA

This pair of airplane-inspired child's rocking "horses" combine two interests of the North Carolina artist Marvin Jensen: creative furniture design and the elegant efficiency of aeronautical engineering. Although *Give Me Wings* gently and effortlessly rocks its "pilot" back and forth on its integrated "landing gear," it looks as if it can do much more. With a paint scheme that mimics the tiny yet powerful stunt planes and racers of sport aviation and a strong, flexible, yet lightweight composite laminate frame constructed with the same materials used in high-performance aircraft, *Give Me Wings* is no ordinary rocker.

As a child's toy, *Give Me Wings* also refers to the aspirations and dreams of growing up. The make-believe open-cockpit biplane, like the play horse, offers its young riders freedom to roam and explore to their hearts' content, feeling the rush of wind on their face and in their hair. *Give Me Wings* thus not only recalls a childhood imperative but also suggests how the joy of seeing children at play can send a parent, or anyone else, soaring as well.

Jensen's father, Norval, once owned a plane and happily pursued aerobatic flying and crop dusting, but with the birth of his sons he realized that he could afford neither the time nor the expense of aviation and gave it up to devote himself to his family. Jensen honors his father's selfless abandonment of his beloved airplane in the title of his second work, *Norval's Sacrifice*. LMA

Norval's Sacrifice, 2003
Painted monoplane rocker
Composite construction over steel armature, with polyurethane finish and leather seat and footpegs, 36 x 54 x 60 (91.4 x 137.1 x 152.4)
Collection of the artist

The work, a high-wing monoplane, was not completed at the time the catalogue went to press.

Simone Aaberg Kærn DANISH, BORN 1969; LIVES COPENHAGEN

A modern-day Amelia Earhart, Simone Aaberg Kærn is an "ace" in the best sense of the word: absolutely fearless and ready for adventure. One of her many exploits includes flying her plane across the United States to visit and make a documentary of the surviving, and largely unrecognized, female pilots of World War II. Since the early 1990s Kærn has built a large body of work around the subject of flight, including paintings, videos, installations, and performances. In her quirky video, *Royal Greenland*, one sees her flying through the air and over the water by flapping her arms and kicking her legs, unassisted in her pursuit of magically self-propelled flight.

Kærn expanded the range of her work when she got her pilot's license in the mid-1990s. For her recent project, *1001 Nights 2002*, Kærn left Denmark in September 2002 and flew in an antique Piper Colt to Kabul, Afghanistan, via Berlin, Sarajevo, Istanbul, and Tehran, to help realize an Afghani girl's dream of flying. A multimedia installation in the exhibition documents the

ABOVE the artist installing her Piper Colt (temporarily wingless), in a work for *Against All Evans*, 2nd International Biennial for Contemporary Art, Göteborg, Sweden, 2003

1001 Nights 2002, 2003
Multimedia installation, including statement co-authored by the artist and Magnus Bejmar, dimensions variable
Collection of the artist

TOP AND OVERLEAF images from *1001 Nights 2002*

several months-long journey. As she explains the project, "A 16 year old Afghan girl [has], from the ruins of Kabul, [sent] a wish to fly into the sky.—[The project] is about the freedom to dream and make wishes come true.—100 years ago the Wright brothers flew. Man took to the skies and in a month or two the first Afghan girl will take control of an aircraft and fly the skies of the country and take positive control of her life."[1] The months-long project is documented in *Defying Gravity* by an installation which includes a vivid statement, co-authored by the artist and Magnus Bejmar, detailing how Kærn and Faryal bravely defied the bureaucrats, the military, and tradition to reclaim the skies for everyone.

LJD

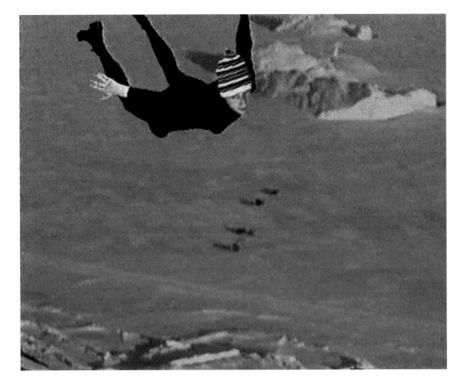

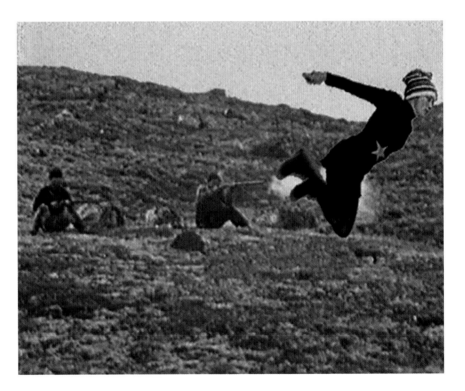

[1] Simone Aaberg Kærn, e-mail correspondence with Huston Paschal, August 11, 2002, and October 25, 2002.

Royal Greenland, 1995
Video with sound, 10-min. loop
Collection of the artist

ABOVE stills from *Royal Greenland*

Soo Kim AMERICAN, BORN KOREA 1969; LIVES LOS ANGELES

In Soo Kim's photographs, objects are distilled, decontextualized, and concentrated in starkly beautiful compositions. Kim's images of the underbellies of airplanes are disconcertingly close-up, cropped views that reveal the various underpinnings and apparatuses of planes—landing gear, wheels, flaps, and hatches. The vantage point of the photographs also exposes the markings and wear and tear inflicted on these giant airborne beasts, giving them a sense of vulnerability and fragility not normally associated with hulking metal machines. Cropping the view of the plane so closely that it fills the frame and cuts off some of its recognizable elements, such as the tail and nose, takes it out of context and abstracts its form, turning it into a composition of shadow and light, shape and line. The sky becomes a blank canvas or backdrop of pure color and light, and the spaces around and between objects take on form and substance.

LJD

OVERLEAF
North East, 2001
Chromogenic print, 30 x 40 (76.2 x 101.6)
Courtesy Sandroni.Rey, Venice, California

Atlantic, 2001
Chromogenic print, 30 x 40 (76.2 x 101.6)
Courtesy Sandroni.Rey, Venice, California

Rosemary Laing AUSTRALIAN, BORN 1959; LIVES SYDNEY

Rosemary Laing's exuberant images of a skydiving bride, suspended in the air in her billowing white dress, depict a moment frozen in time—the split second before the parachute opens, or the plane stalls. Immersed in flight (she lives and works under the flight path of the Sydney airport), Laing magically captures an elusive sensation of displacement from time and space and the movement of flight in still images.

Her monumental photographs present an expansive, boundless landscape and the exhilarating sense of freedom and defiance of gravity found in an airborne moment. Laing has described the *flight research* photographs as reflecting a moment of idealism and optimism, "an embodiment of the desire for a better state of existence in the world—unhindered and unfettered ✈

flight research #3, 1999
Chromogenic print, 46¹/₂ x 46¹/₂ (118 x 118)
Courtesy Gitte Weise Gallery, Sydney

flight research #4, 1999
Chromogenic print, 31½ x 48⅜ (80 x 123)
E. Fraser Collection, Melbourne

by the stymie of necessity and cultural condition."[1] The unaltered photographs document elaborately staged performances, orchestrated by Laing working with a stuntwoman in the Blue Mountains of Australia, west of Sydney. The images invite the viewer to suspend disbelief. One wonders where the bride's parachute is, or if she has discovered superhuman powers enabling her to fly unassisted, or perhaps she has decided to take a final leap in a dramatic, free-fall escape from the altar. In her antique-looking wedding gown, the bride hovers in the sky like a fluffy, lacy cloud in a panoramic landscape. Her stark white dress creates a dramatic silhouette against the brilliant blue sky. Caught in midflight, in a transitory moment between arrival and departure, she is depicted falling, floating, and diving toward the earth.

LJD

[1] Rosemary Laing, unpublished studio notes, 1998–2000.

flight research #5, 1999
Chromogenic print, 42 3/8 x 94 1/4 (107.6 x 239.4)
North Carolina Museum of Art; Purchased with funds from Charles Babcock and Dr. and Mrs. Lunsford Long, by exchange

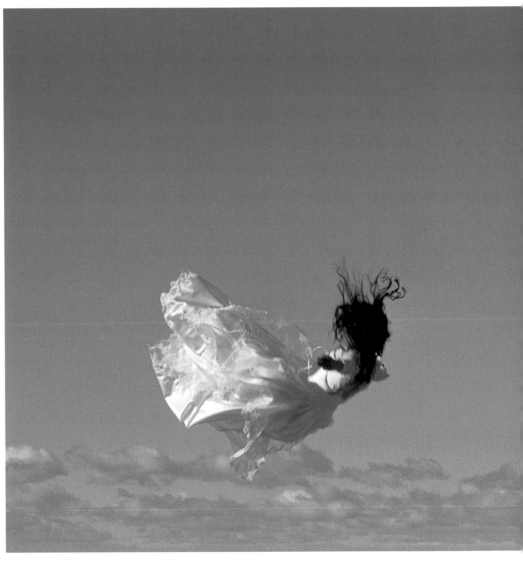

flight research #8, 1999
Chromogenic print, 23⅝ x 23⅝ (60 x 60)
Courtesy Gitte Weise Gallery, Sydney

Donald Lipski AMERICAN, BORN 1947; LIVES NEW YORK

Donald Lipski's sculpture is based on an assemblage technique in which the artist combines found materials collected from salvage yards, demolition sites, and other treasure troves to create new objects from often unrelated materials. *Broken Wings #3* and *Baby Z* mimic flight's ability to compel viewers to reorient their perspective, to reexamine objects that once were familiar, and to reconsider how an encounter with the unexpected can dramatically alter understanding.

Broken Wings is a series of works Lipski produced largely from materials gathered at the Bethpage, New York, salvage yard of Grumman Aero-space Corporation. *Broken Wings #3* recombines precisely made aviation industry detritus with crude, yet no less functional, buckets to create a new object that resembles a radial engine with propeller, or perhaps a devastating weapon of war that protrudes menacingly and incongruously from the gallery wall.

The infant-sized *Baby Z* improbably suggests a baby fighter pilot, swaddled for the stratosphere in a pressurized helmet (filled with an amniotic-like fluid) and a constricting "g-suit" to protect its body. The tiny womblike cockpit also suggests the encapsulated chimpanzees and dogs that were sent into Earth orbit during the early years of space exploration. The military implications of the materials, combined with the sculpture's title, are also eerie reminders of the similarly anthropomorphized "Little Boy" and "Fat Man" atomic bombs dropped on Japan in 1945. *Baby Z* illustrates how these weapons are always first and foremost a product of human hands.

LMA

Baby Z, 1987
Wall-hung sculpture composed of aviator's helmet and artillery shell shipping case with pressure cuff, clamp, water, and glass, 10 x 27 x 10 (25.4 x 68.9 x 25.4)
Victoria Vesna

Broken Wings #3, 1986
Wall-hung sculpture composed of pod housing, buckets, periscopes, and miscellaneous hardware from salvage yard of Grumman Aero-space Corporation of Long Island, 43 x 46 x 52 (109.2 x 116.8 x 132.1)
Collection of Phoenix Art Museum; Museum purchase with funds provided by the Men's Arts Council Sculpture Endowment

Vera Lutter GERMAN, BORN 1960; LIVES NEW YORK

Two artists in this exhibition about modern technology resort to the pre-modern camera obscura. The sculptor Chris Drury employs a pinhole camera in his *Cloud Chamber for the Trees and Sky*; Vera Lutter uses it in her photography. Think of this archaic imaging device as a darkened room with a small opening in one wall. Light from the outside passes through the opening, which acts as a lens. The image the lens "sees" is cast, inverted, on photosensitized paper covering the opposite wall. The developed image appears as a photographic negative (thus, reversed).

Lutter, whose themes include architecture and industry as well as transportation, makes a pinhole camera to suit each project. For the work on view, from the *Frankfurt Airport* series, she left a room-size container sitting on the visitors' terrace for hours, allowing the activity at a Lufthansa jetway to be imprinted on the photosensitized paper within. The long exposure time means that the catering vans, maintenance vehicles, and luggage dollies were recorded as blurs. The jumbo jet, a composite image of aircraft that docked and departed during the exposure, rests at the jetway, an uncanny, shadowy hulk vested with secret, disturbing powers.

This overwhelming triptych, a glowing, spellbinding specter, robes paradox with poetry. Lutter discovers the spiritual in a highly mechanized setting. A slight unease coexists with a curious calm. In *Vera Lutter: Light in Transit* Gertrud Sandqvist writes with sympathetic insight about the photographer's work, "The planes look like astral bodies, fuelled by pure light. . . . Lutter helps us to rediscover our capacity for attention, for contemplation. . . . [S]he takes us beyond the modern to the mystical, which retains its secret in the midst of life."[1]

HP

[1] Gertrud Sandqvist, "Astral Bodies Fuelled by Light," in *Vera Lutter: Light in Transit*, trans. Mike Garner (Berlin: Holzwarth Publications, 2002), 55–56.

Frankfurt Airport, V: April 19, 2001, 2001
Unique silver-gelatin print
3 panels, overall 82 x 168 (208.3 x 426.7)
Collection of the artist, courtesy Gagosian Gallery,
New York

Euan Macdonald

CANADIAN AND BRITISH, BORN SCOTLAND 1965; LIVES LOS ANGELES

Euan Macdonald's videos mark fleeting moments of everyday life, frequently revealing the grace of even mundane moments. The shadows cast by gently swaying palm trees or the arcing trail of an airliner tracking across a cloudless sky are, for Macdonald, opportunities to stop and rediscover one's experience of the external world. In *two planes*, viewers watch for several minutes as two airliners soar above an unseen landscape, moving gradually closer toward the camera. At first, only chirping crickets and an occasional bird interrupt the rushing sound of wind, as viewers perhaps imagine themselves in a meadow watching a pair of giant hawks or seagulls gliding above.

The sight of the paired airplanes is both natural and challenging, as their formation flight—an airborne ballet— suggests both a passionate pas de deux and an inorganic aviation mating ritual. While critics have suggested that the apparent coupling of Macdonald's *two planes* echoes the opening scene of Stanley Kubrick's 1964 film *Dr. Strangelove: or How I Learned to Stop Worrying and Love the Bomb*, in which a fuel tanker and a bomber suggestively join in midair, Macdonald attests that his planes more emphatically call into question viewers' perceptions. Seeing double, viewers are unaware that Macdonald's planes are only digitally spliced together—the original footage depicted a single plane. As the plane(s) approach, the engines become audible; this shift nudges viewers gradually from the surreal visual experience. Yet here is precisely where Macdonald's tape ends. Denied resolution, viewers return to the beginning of the cycle, to experience again the brief, mesmerizing passage of time, watching each loop more closely.
LMA

two planes, 1998
Digitally altered video, 3-min.-30-sec. loop
Collection of the artist

ABOVE AND OPPOSITE stills from *two planes*

para: space, flight #8

Jane D. Marsching

AMERICAN, BORN 1968; LIVES SOUTH BOSTON, MASSACHUSETTS

Installation view

Jane Marsching's photographic panorama, *para: space, flight*, envelops the viewer with historical and contemporary images of flight: star-filled skies, unidentified flying objects, science fiction stills, shooting beams of color and light, rockets, insects, the moon, and outer space, all starting from a jumping-off point inspired by the human desire to fly and the Wright brothers' first experimental flights.

As she describes her work, "The narrative starts with what it is like to be on earth and long to and ultimately try to fly. It ends with imagining what it is like to be in space and to be flying and looking around you. In between, the images address a historical to futuristic, science to science fiction, ordinary to fantastical, real to illusory line between physical and visual impossibilities and discoveries relating to the science, effort, and facts of flight."[1]

An interactive website, *para:// a database of wonders*, continues the narrative thread of the panorama with

[1] Jane D. Marsching, e-mail correspondence with the author, January 21, 2002.

para: space, flight #2

para: space, flight #10

a collection of ninety-nine images culled from the web, a virtual Wunderkammer, or cabinet of curiosities. Utilizing search engines and keyword assemblages, the viewer can temporarily reconfigure and reorder the data to create individual stories of and journeys into space and flight.

Marsching creates a transitory and shifting magical world of images, where the borders between fact and fiction start to blur, and the universal dreams and desires to fly and escape the confines of gravity are captured in photographic images veiled by illusion and representation.

LJD

para: space, flight, 2001
Installation composed of 12 archival ink-jet prints, 2 chromogenic prints, and laptop for satellite internet access to interactive website
Laptop on table, 36 x 44 (diam.) (96.5 x 111.8); overall dimensions variable
Collection of the artist

para:// a database of wonders
http://www.thesweepers.com/jane/para

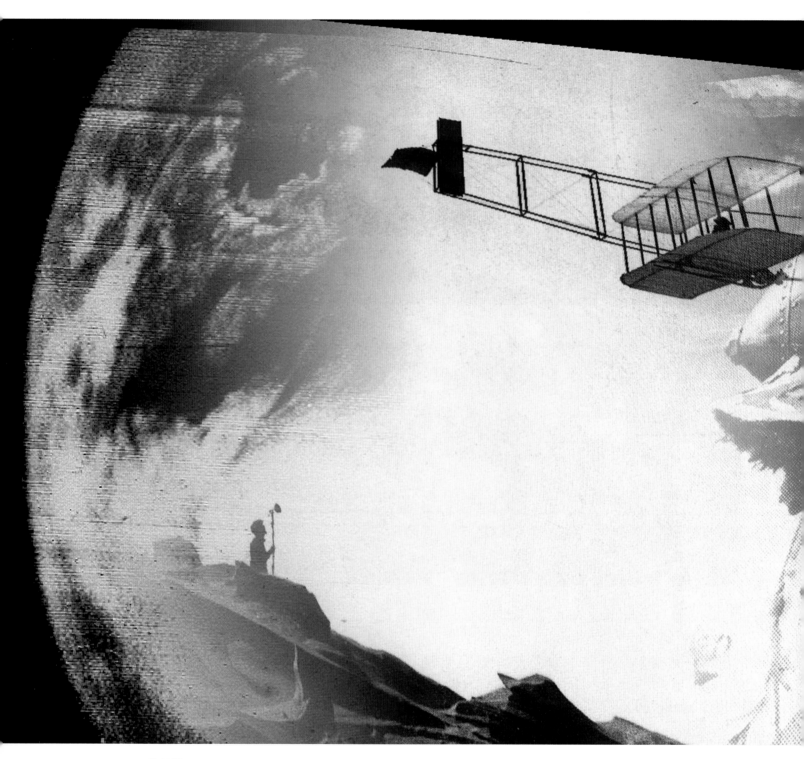

para: space, flight #1

12 archival ink-jet prints

Prints overall 1 ft. ¾ in. x 30 ft. 9½ in.

(32.4 x 9.4 m)

para: space, flight #1
12⅞ x 34¾ (32.8 x 88.3)

para: space, flight #2
12⅞ x 27¾ (32.8 x 70.5)

para: space, flight #3
12⅞ x 31 (32.8 x 78.7)

para: space, flight #4
12⅞ x 30 (32.8 x 76.2)

para: space, flight #5
12⅞ x 34¾ (32.8 x 88.3)

para: space, flight #6
12⅞ x 27¾ (32.8 x 70.5)

para: space, flight #7
12⁷⁄₈ x 34¼ (32.8 x 88.3)

para: space, flight #8
12⁷⁄₈ x 27¾ (32.8 x 70.5)

para: space, flight #9
12⁷⁄₈ x 31 (32.8 x 78.7)

para: space, flight #10
12⁷⁄₈ x 30 (32.8 x 76.2)

para: space, flight #11
12⁷⁄₈ x 34¾ (32.8 x 88.3)

para: space, flight #12
12⁷⁄₈ x 27¾ (32.8 x 70.5)

2 chromogenic prints

para: space, flight (11:11)
30 x 30 (76.2 x 76.2)

para: space, flight (Star Wars still)
40 x 30 (101.6 x 76.2)

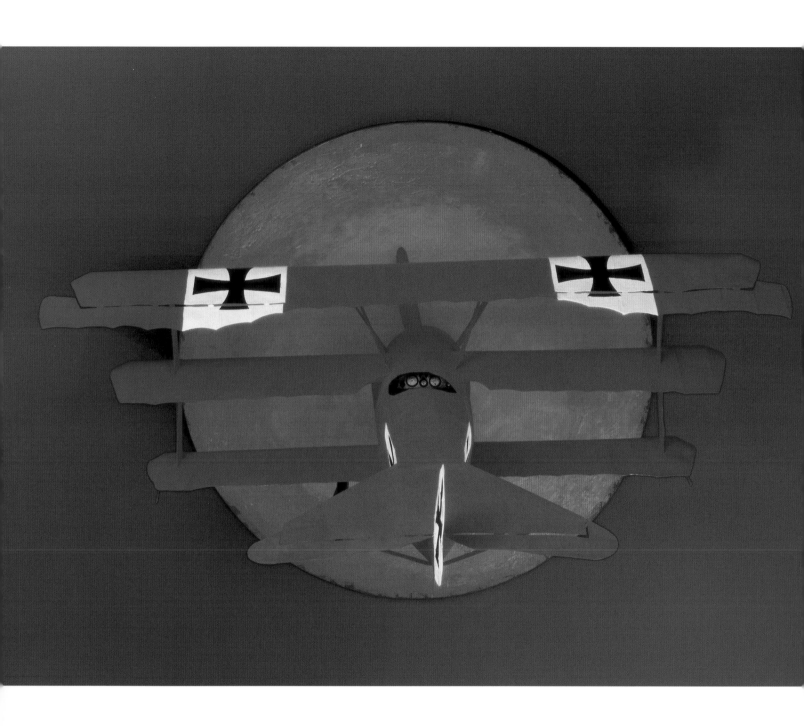

The Flight of Icarus, 1995
Oil and wax on circular canvas, with artist-built
and -painted wooden model plane attached,
45 (diam.) x 113 x 91 (114.3 x 287 x 231.1)
Collection of Timothy Egert, courtesy Baumgartner
Gallery, New York

Malcolm Morley

AMERICAN, BORN ENGLAND 1931; LIVES BROOKHAVEN, NEW YORK

Like Mark Tansey in *Picasso and Braque*, Malcolm Morley employs an airplane to address the flatness of the pictorial plane, poking holes in its inviolability with wit and ingenuity. In *The Flight of Icarus* Morley has attached a three-dimensional model of an antique biplane (which he made of paper and painted in watercolor) so it noses into the two-dimensional surface of his canvas.

In addition to confusing painting and sculpture, *The Flight of Icarus* blends autobiography and mythology, humor and pathos. Morley's adult fascination with model planes and ships can be traced to his model-building childhood. His choice here of a World War I German fighter plane links to memories of the German aircraft that destroyed the family's London house during the Blitz in World War II.

An interest in, perhaps even an identification with, Icarus also plays a role. The encaustic Morley paints with relates to the wax that Daedalus used in making wings, a medium that melted when Icarus flew too near the sun. The sun is suggested here by the large red circular canvas. Morley (who has taken flying lessons) courts the exhilaration felt by Icarus—and the Wright brothers—at being the first to fly. Artistically, he is a willing risk-taker.

If *The Flight of Icarus* reads like a pop-up book, then *Rat Tat Tat* is its cut-fold-and-paste counterpart. Morley, a virtuoso painter who can manipulate paint in any way he chooses, has copied at giant scale three vintage build-your-own-airplane cards onto an oversize canvas. The three-syllable title for the three-fighter-plane work calls up a simpler world, where "rat tat tat" means child's play and the enemy is easy to recognize.

HP

RAT
TAT
TAT
TAT
TAT

Fokker
DVIII

N 1895
120
6

NIEUPO

Machine Guns

Fuselage

wind screen

Tail

Cowling
Nose Plate

firewall

Engine

Tail Fin

prop & wheels

Landing Gear Plane

landing gear struts→

wing struts→

Upper Wing

BEND

FOLD

BEND

BEND

Machine Gun

Engine

bulkhead

Cowling

roll glue

Propel

wheel covers

Landing Gear

roll glue

Wheels

Upp

Marc Newson

AUSTRALIAN, BORN 1963; LIVES LONDON

The *Lockheed Lounge* helped launch the Australian Marc Newson's contemporary design career. His sleek, smart furniture, timepieces, home appliances, vehicles, and interior design are sought after. (Notably, commissions include the design of the cabin and cockpit of a Falcon 900B jet.) The curvaceous, amoeba-like form of the *Lockheed Lounge* successfully fulfills Newson's vision of creating "a fluid metallic form, like a giant blob of mercury" on which to sit.[1] At any second the mesmerized viewer expects to see the three drop-like feet release their tenuous grip on the Earth and disappear into the liquid body of the chair.

For all its evocative allusions to a futuristic space age, however, the *Lockheed Lounge* is also an emphatic, nostalgic throwback to the golden age of aviation (not to mention an offhand reference to Jacques-Louis David's 1800 portrait of Mme Récamier). During the 1930s and 1940s, aircraft manufacturers like Lockheed experimented with a variety of high-performance designs using aluminum, a malleable, lightweight, reflective, and widely available metal. Over the ensuing decades emerged an array of stunningly beautiful, streamlined, and innovative airplanes such as the Electra, P-38, and F-104. Each of these legendary Lockheed planes resonates in this work, with its cut and riveted aluminum-panel skin that uncannily suggests an organic, almost reptilian presence. The London-based Newson made his first hourglass-shaped lounge chair in a laborious process of hand-hammering each piece over a Fiberglas-molded body, in a process far removed from that of the mass-produced airplane. What the *Lockheed Lounge* does share with its prototypes is the promise to transport its passengers to another realm.

LMA

[1] Newson's concept is quoted in Sarah C. Nichols, *Aluminum by Design: Jewelry to Jets*, exh. cat. (Pittsburgh: Carnegie Museum of Art in association with Harry N. Abrams, 2000), 264.

Lockheed Lounge, 1986–88;
designed 1985 and manufactured by Pod
Riveted sheet aluminum over Fiberglas and rubber,
35 x 25 x 60 (88.9 x 63.5 x 152.4)
Carnegie Museum of Art, Pittsburgh;
Women's Committee Acquisition Fund

Phuong Nguyen AMERICAN, BORN VIETNAM 1968; LIVES BROOKLYN, NEW YORK

Born in Ho Chi Minh City in 1968, Phuong Nguyen left Saigon the day the city fell during the Vietnam War. He has created a haunting series of paintings that explore his memories of the war, memories that have been shaped and formed by the images he saw on television. With titles like *Interference II* and *RGB Static*, the slightly curved canvases echo the shape of television sets and depict images of war filtered through the screen of mass media. An overlay of "static" or repetitive patterns serves as a scrim to abstract the images below the surface, capturing and freezing fleeting moments in time.

At first, one only notices the hypnotically beautiful compositions and animated surfaces of these densely layered and labored oil and wax paintings. Eventually, one realizes that one is looking, not at an ocean filled with a teeming school of fish in varying shades of gray, blue, and black, but at a sky filled with ghost planes dropping a multitude of bombs. In another work, a swirling swarm of dragonflies transmogrifies into a fleet of threatening military helicopters.

As Nguyen describes his work, "my own recollections of the war are entangled with the collective memories created through television.—These television memories are combined with the reflections found on the glass of the screen and the surprising patterns created by interference. The paintings demonstrate how the television signal heightens the abstract quality of images, distorting and obscuring them much as memory itself does, thus inviting reinterpretation."[1]

LJD

[1] Phuong Nguyen, e-mail correspondence with the author, January 20, 2003.

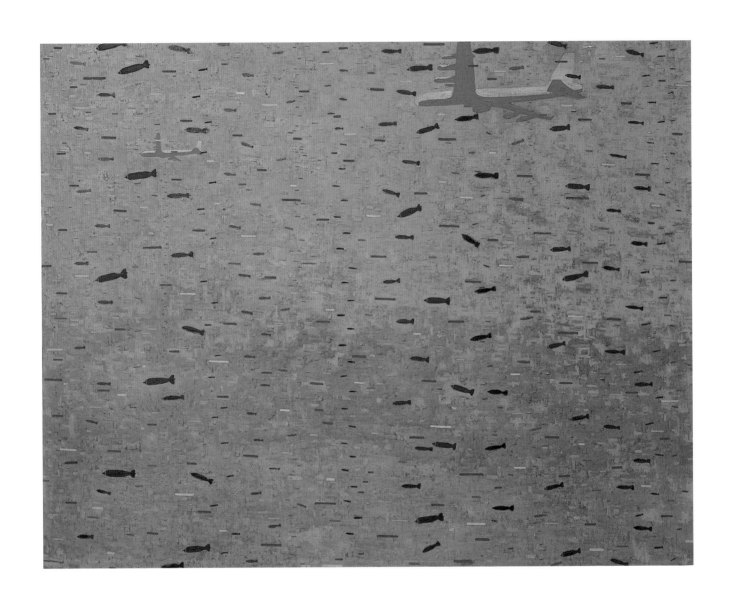

Interference II, 1999
Oil and wax on Masonite, 32³/₈ x 41¹/₂ x 5⁵/₈
(82.2 x 105.4 x 14.3)
Collection of the artist

Panamarenko

BELGIAN, BORN 1940; LIVES ANTWERP

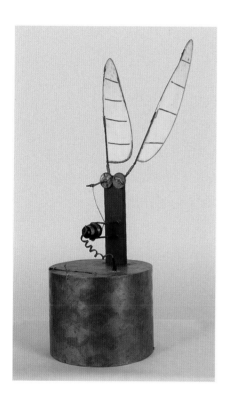

"Artist-technologist," rather than sculptor, is what Panamarenko prefers to be called,[1] and that hyphenated term aptly sums up this variously gifted man. Integrating art and technology, he has created a dazzling array of transports (from flying carpets to submarines), meant to sail through the buoyant mediums of air or water.

The apparatuses Panamarenko fabricates often appear uncomplicated, even improvised in their construction. But they are the result of research and engineering—and high hopes. Though Panamarenko intends each machine to work, he regards the whole process—invention, realization, experimentation and improvements, failure or success—as a thrilling adventure into the unknown. This adventure is →

Encarsia–Formosa, 1987
Coin-operated model flying apparatus made of copper, iron, and PVC, with motor and batteries, 15 x 5 (diam.) (38.1 x 12.7)
Ronald Feldman Fine Arts, New York

[1] Jon Thompson, "Panamarenko: Artist and Technologist," in *Panamarenko*, exh. cat. (London: Hayward Gallery, 2000), 15.

Raven's Variable Matrix, 2000
Artist-designed and -built airplane with body of polycar-
bonate, aluminum, steel, and felt; rubber wings; and
motor, wingspan approximately 17 ft. 7 in. (5.4 m)
Courtesy Mianko, Belgium

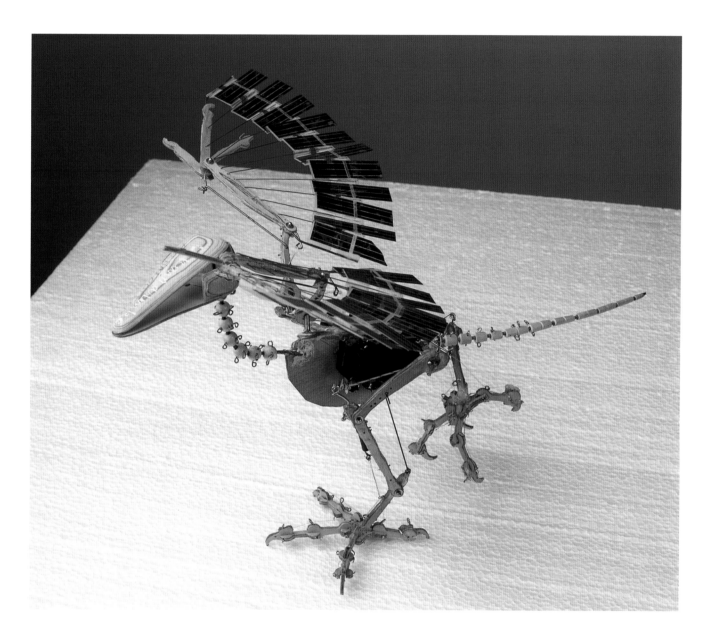

one he cannot resist embarking on, repeatedly.

Panamarenko's consuming pre-occupation is to defy gravity. It is no surprise, then, that he would be drawn to the earliest creatures who achieved this goal. Panamarenko has devoted a series to the oldest known animal that is generally accepted as a bird, the late Jurassic period archaeopteryx. Taking some liberties, he replicates these crow-size, reptilelike creatures.

Taking further liberties, Panamarenko tries to simulate the flight of a modern-age bird with *Raven's Variable Matrix*, a wing-beating, one-person, motorized aircraft with an implied homage to the Wright brothers in its bicycle

Archaeopterix IV, 1991
Wood, strings, electronic chips, and solar cells,
9 x 15⅜ x 15¾ (23 x 39 x 40)
Michel and Julie Espeel

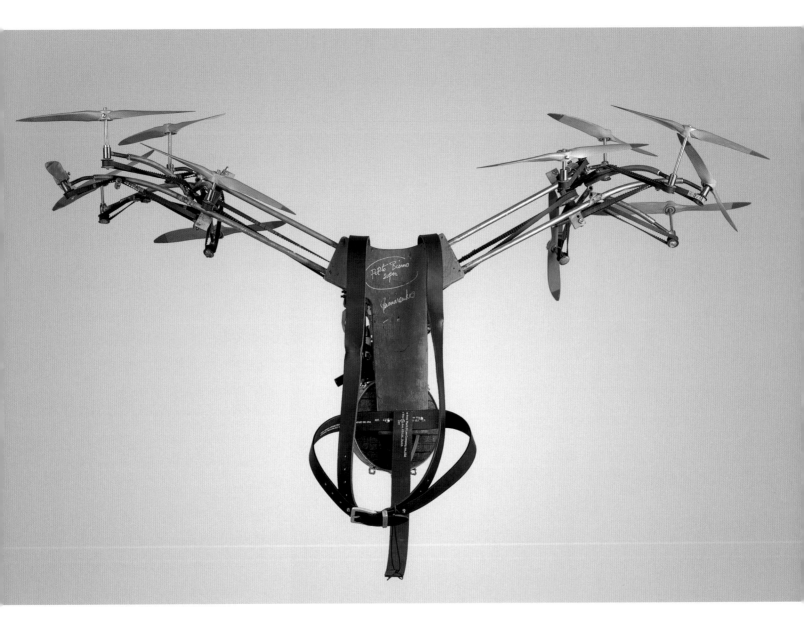

wheels.[2] Another wing-flapper, the tabletop model *Encarsia–Formosa* operates on battery power. To get a human being airborne remains central to Panamarenko's program. *Super Pepto Bismo*, once strapped on by a passenger-pilot, turns the person into a human helicopter, with whirring rotor blades that, with a bit of luck, will overcome unyielding gravity.

HP

[2] For the artist's discussion of the inspiration for this work, see *Panamarenko: For Clever Scholars, Astronomers, and Doctors* (Ghent: Ludion, 2001), unpaginated.

Super Pepto Bismo, 1996
Artist-designed and -built flying apparatus with 12 propellers and motor with electric ignition, 39 x 59 x 31¹/₂ (99 x 150 x 80)
Ministerie van de Vlaamse Gemeenschap, Brussels

Robert and Shana ParkeHarrison

AMERICAN, BORN 1968 AND 1964; LIVE WORCESTER, MASSACHUSETTS

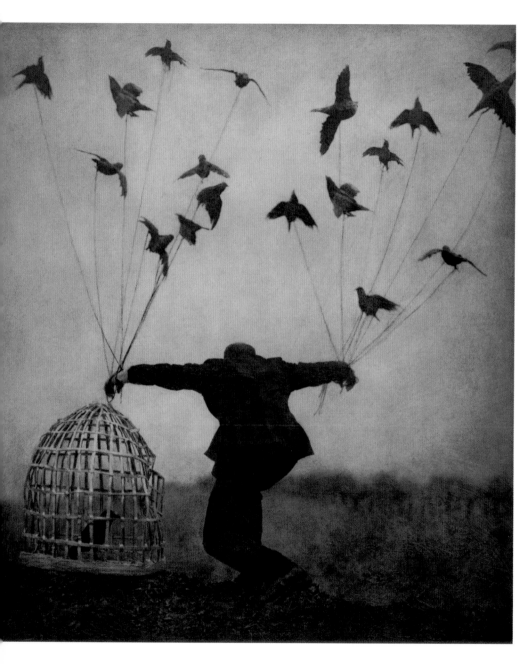

Flying Lesson, 1999
Waxed photogravure
Plate 20 x 18 (50.8 x 45.8)
Sheet 26½ x 23 (67.3 x 58.4)
Courtesy the artists and
Bonni Benrubi Gallery, New York

Working collaboratively, Robert and Shana ParkeHarrison produce richly textured photographs that are poignant allegories of modern existence. Portraying an "inventor, scientist, caretaker, and fool,"[1] Robert ParkeHarrison appears in these images as an Everyman, who labors diligently, yet futilely, with crude, antiquated tools, "to save or rejuvenate nature" in the face of human destruction of the planet.

Shana ParkeHarrison photographs her husband in character, and the resulting picture is then altered using various techniques. In *Flying Lesson* and *The Sower*, ParkeHarrison's character turns to flight as a way to increase the efficiency of his labor. In *Flying Lesson*, the devastating naïveté of attaching his body to a flock of birds suggests that mankind is no better off than the caged bird dangling from the artist's left hand. The intricate, overwrought contraption of *The Sower*, whose gears help disperse seeds from buckets while the artist plants them manually,

[1] Artists' statement, curatorial file, North Carolina Museum of Art.

offers a compelling reminder that mankind's attempts to control or harness nature are in this case no match for the simplicity of the wind.

With their lush, antiqued sepia tones, the ParkeHarrisons' photographs address not only a contemporary nostalgia for "simpler" times and technologies; they also suggest that even the most imaginative technological achievements are powerless against the loss of nature and the passage of time.

LMA

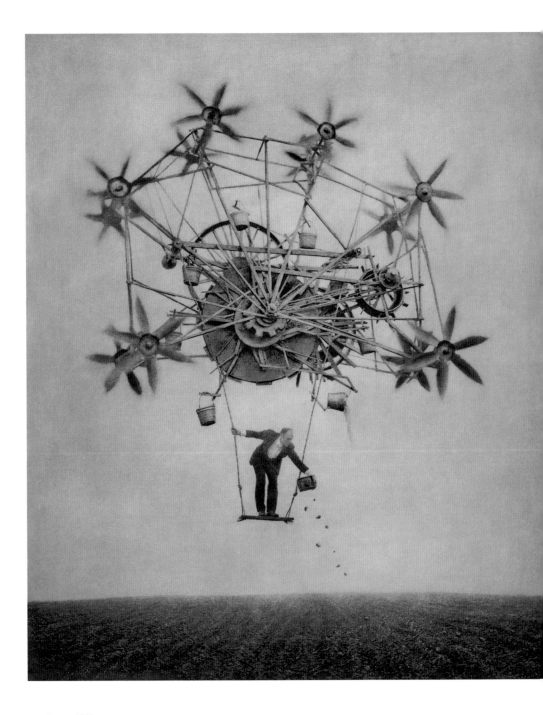

The Sower, 2002
Multicolor photogravure
Plate 18½ x 22 (47 x 55.8)
Sheet 24 x 27½ (61 x 69.8)
Courtesy the artists and
Bonni Benrubi Gallery, New York

Susan Rankaitis

AMERICAN, BORN 1949; LIVES CLAREMONT, CALIFORNIA

The opulent renderings of Susan Rankaitis exist somewhere between painting and photography, between art and science. Rankaitis experiments with photographic materials and methods to create singular, combined-media works. Moving between the darkroom and the studio, she uses multiple negatives and appropriated sources, adapting chemical and nonchemical processes, photographic and painting techniques. Her works are expansive; scale is important. The outcome, whose expressionist spontaneity disguises the fact that it has taken months to create, is neither wholly abstract nor wholly representational. These mysterious, dusky images alluding to the world's terrifying beauty belong to the tradition of the sublime.

Aeronautical imagery frequently appeared in the artist's work of the 1980s. Rankaitis took advantage of a drawback, her studio's proximity to Los Angeles International Airport. She used to spend hours lying on her back on the building's roof, photographing the planes as they flew by. The resulting negatives often provided a starting point for her. Rankaitis's specialized montage technique and bravura brush-work allow her to complicate the image—and the meaning—with veiled layers, both on the horizontal and the diagonal, of nose cones, cockpits, wings, landing gear, tails.

Technique and composition help Rankaitis achieve what is most important to her, complexity of content. The artist uses a multidisciplinary approach to reflect the dichotomous nature of technology—the airplane, sleekly elegant metallic sheath, holds the power to inspire hope and despair. Rankaitis movingly dramatizes the modern world's dilemma.

HP

OPPOSITE
Formattage, from Jargomatique Series, 1989–90
Combined media on photographic paper,
82¾ x 58¼ (210.2 x 148)
Courtesy the artist and Robert Mann Gallery, New York

OVERLEAF
L'avion, L'avion, 1983
Combined-media photographic monoprint,
56 x 84 (142.2 x 213.4)
Yarema Family Trust

Michael Richards

JAMAICAN-AMERICAN, BORN JAMAICA, WEST INDIES, 1963–2001; LIVED NEW YORK

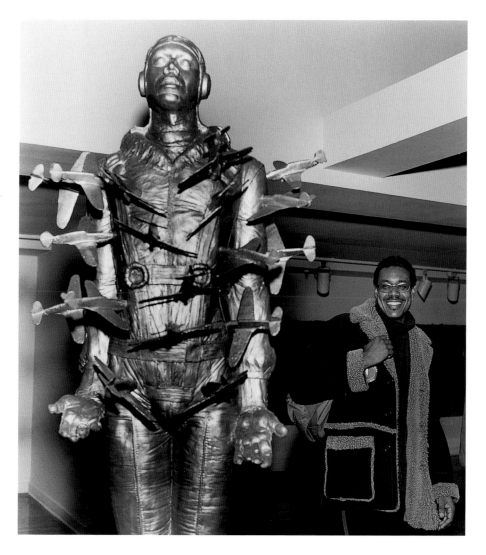

The late artist with *Tar Baby vs. St. Sebastian*, at
The Studio Museum in Harlem, New York, 1999
(for a full-length view of the sculpture, see p. 58)

For most of his career, Michael Richards devoted his work to sculptures and installations that paid tribute to the Tuskegee Airmen, a group of African American Air Force pilots during World War II, whose heroism and bravery were truly recognized only long after the war ended.

Winged consists of bronze casts of the artist's arms joined at the elbows to form one continuous arm with gracefully curved hands at either end. Suspended from the ceiling, the work sways with the air currents. The double arm forms both the shape of a wingspan and a tentative embrace. Cast feathers hanging beneath evoke thoughts of a flight arrested or only dreamed of but never fully realized.

Tar Baby vs. St. Sebastian, cast from the artist's body, is a gilded,

glowing figure of an airman wearing his helmet and uniform, mounted on a pole in a pose of supplication, his eyes gazing at something beyond the viewer, his body pierced with numerous small airplanes. The title of the work refers to both a Southern folktale of entrapment and a soldier who became a saint after he refused to deny his faith and was shot with arrows.

Richards was working in his studio, on the ninety-second floor of the World Trade Center, the night of September 10, 2001, and was still there early the next morning when the buildings fell. He did not survive the attack on September 11. The last piece he was known to have been working on was a sculpture depicting an airman riding a burning meteor, falling toward Earth. LJD

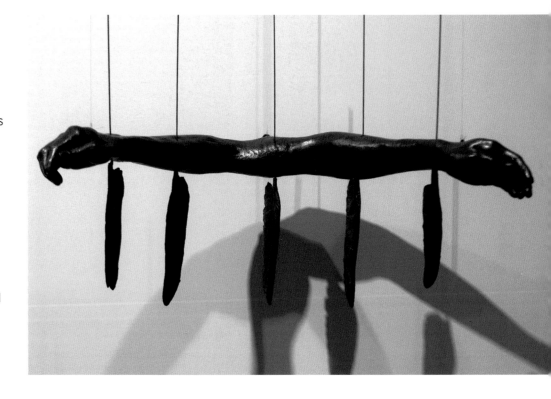

Winged, 1999
Bonded bronze and metal, 20 x 38 x 4
(50.8 x 96.5 x 10.2)
Courtesy Ambrosino Gallery, North Miami

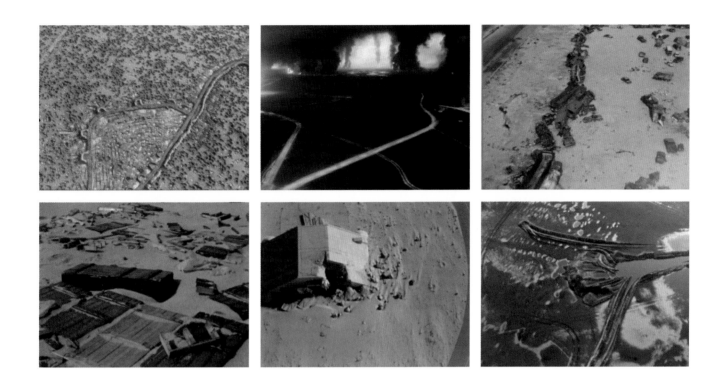

Sophie Ristelhueber FRENCH, BORN 1949; LIVES PARIS

Sophie Ristelhueber's installations explore destruction and regeneration, evident in her large-scale photographs of ruptured bodies, landscapes, cities, and other "details of the world."[1] Scars on skin and Earth become not only traces of history but also reminders of an ongoing process of transformation that ultimately affirms life, even amid terrible devastation.

In its entirety, *FAIT* consists of seventy-one photographs taken in Kuwait in October 1991, following the Gulf War; six representative images are included in this exhibition. Ristelhueber's work frequently draws her toward battle zones—she has also photographed the effects of war in Beirut, Bosnia, and, most recently, Afghanistan. The aerial view is crucial to helping Ristelhueber reveal compelling images: craters, trenches,

[1] *Sophie Ristelhueber: Details of the World*, text by Cheryl Brutvan, exh. cat. (Boston: MFA Publications, 2001).

FAIT, 1992
6 chromogenic prints from a series of 71, mounted on aluminum and framed, each 39³/₈ x 51¹/₈ x 2 (100 x 130 x 5.1), overall 78³/₄ x 153¹/₂ x 2 (200 x 390 x 5.1)
Albright-Knox Art Gallery, Buffalo, New York; George B. and Jenny R. Mathews Fund

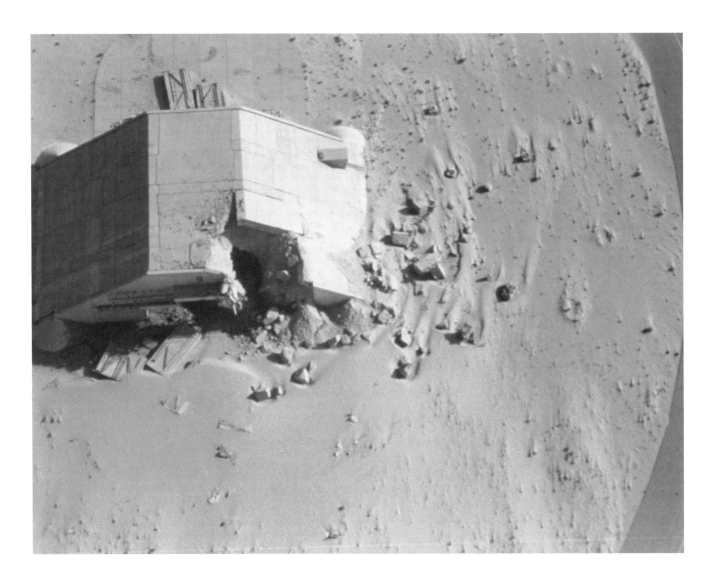

abandoned supplies, and bombed-out structures. Traveling over the Kuwaiti desert by air and by land, amid oil fires, land mines, wrecked aircraft, tanks, and convoys, Ristelhueber faced hostile environments to collect her photographs, which, absent human figures and eerily desolate, belie the circumstances of their acquisition.

Fait is a French word that means "fact" or "what has been done." Viewers of Ristelhueber's *FAIT* are thus doubly struck. They visually confront the chaotic remains of war from a detached aerial perspective that challenges them to look not just for the facts but for the overall impact on the Earth—this has been done. At the same time, viewers must reassemble these facts according to their own individual and cultural logic—*FAIT* is not just about what has been done; it is about the vital act of perception.

LMA

James Rosenquist

AMERICAN, BORN 1933; LIVES ARIPEKA, FLORIDA

In 1965 in New York the former bill-board painter and rising pop artist James Rosenquist unveiled his monumental *F-111*, an eighty-six-foot-long aluminum painting that wrapped around four walls of Leo Castelli Gallery's main room. Named for the controversial, overbudget, and overweight supersonic jet fighter then being designed for use in Vietnam, *F-111* became one of Pop art's most critical antiwar images. Since the 1960s Rosenquist's work has become more abstract, yet he continues to make use of flight-related imagery and themes in his large-scale paintings.

Voyager—Speed of Light reflects the artist's fascination with the altered visual and cognitive perspectives that space flight, virtual reality, and other forms of high speed visual and/or mental travel impose. In Rosenquist's fractured images, viewers experience mind-bending arrays of color in various shapes and sizes, arranged in patterns that suggest a quasi-geometric order.

However, any perceptible organizing principle is thwarted by the painting's insistent refusal to adhere to a machined or technological aesthetic. Rosenquist's work is always hand-painted, not only retaining a connection to the artist but appealing to the viewer's humanity as well.

The metallic reflectivity of the central conical forms echoes an airplane's nose or a jet engine intake and more generally betrays Rosenquist's affinity for the aluminum and other metals used in aircraft and spacecraft design. They also suggest the "speed of light" and the ensuing distortion and tunnel-like space that the "voyager"—at this moment, at least—can only imagine.
LMA

Voyager—Speed of Light, 2001
Oil on canvas, 90 x 144 (228.6 x 365.8)
Collection of the artist
© James Rosenquist/Licensed by VAGA, New York, NY

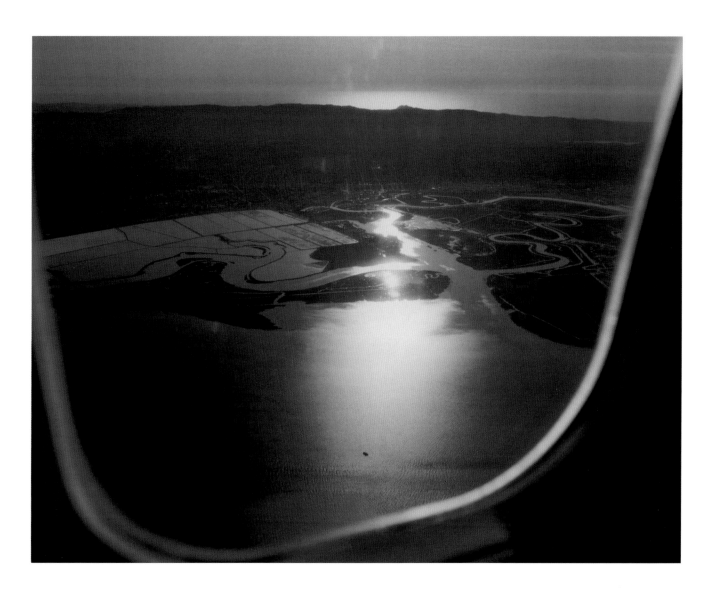

Leo Rubinfien

AMERICAN, BORN 1954; LIVES NEW YORK

Leo Rubinfien's photographs provide glimpses of life on a plane, moments in flight taken from the passenger's perspective. One sees the landscape framed by the elongated ovals of airplane windows, porthole views of the distant world below, either during take-off or while landing, leaving or approaching the countryside beneath the plane. Cropped by the plane windows and seen from high above, these urban

Approaching San Francisco, 1992
Chromogenic print, 20 x 24 (50.8 x 61)
Courtesy Robert Mann Gallery, New York

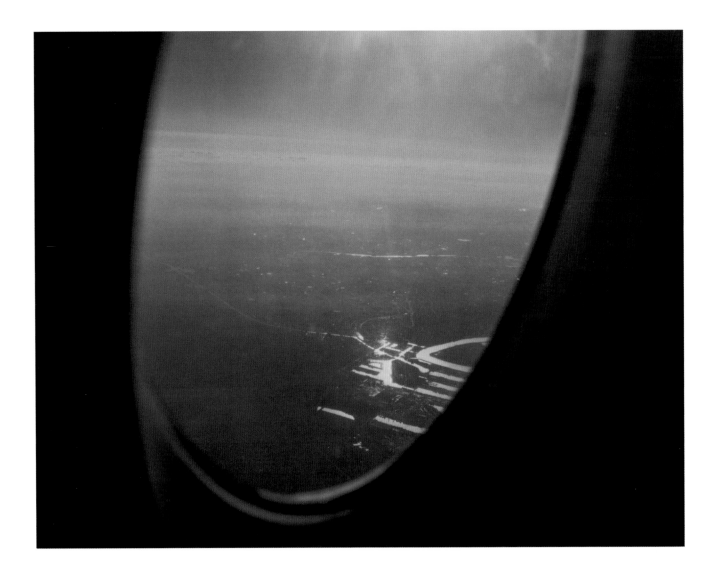

landscapes are transformed into glowing abstract patterns, tinted gold and pink by a rising or setting sun. The landscapes turn into a network of lines, plots, and grids, divided by roads and rivers, lakes and oceans, housing developments and farms.

When Rubinfien aims his camera inside the plane, the viewer becomes the voyeur of unwitting passengers caught in mundane moments of travel: a man peering over a seat to talk to the passenger behind him, or a young girl, leaning into the window, sleeping in the sunlight. As a secret spy, one can imagine their lives, speculate as to where they are going and what they are leaving behind. In Rubinfien's words, one can imagine "the human world that [the passenger] is rushing toward and fleeing from."[1]

His photographs capture a sense of suspended time, the kind of netherworld one travels in, especially on long flights, and the feeling that being in a plane is like being in a bubble or a cocoon, isolated from the world, outside real time. His photographs also portray a sense of alienation and loneliness that is part of traveling even when one is on a plane filled with people. LJD

Leaving Amsterdam, 1989
Chromogenic print, 20 x 24 (50.8 x 61)
Courtesy Robert Mann Gallery, New York

[1] Leo Rubinfien, *10 Takeoffs, 5 Landings*, exh. cat. (New York: Robert Mann Gallery, 1994), unpaginated.

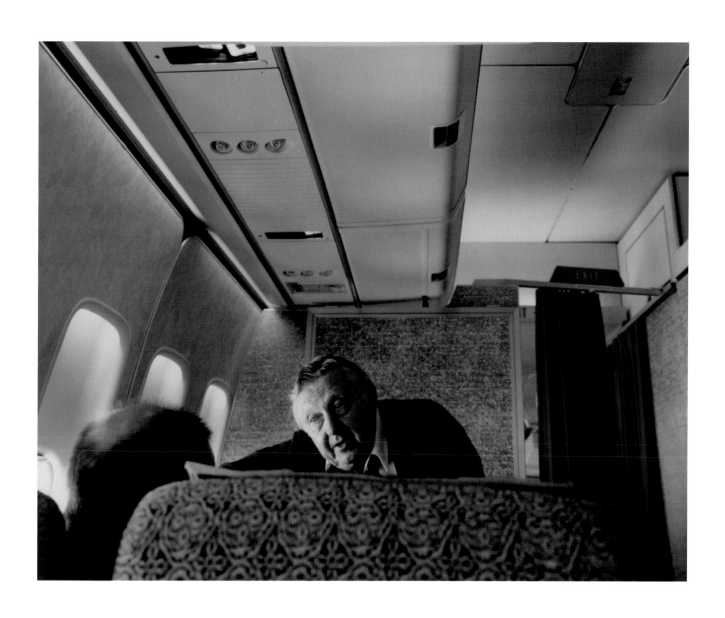

Over the Pacific On a Flight to Hong Kong, 1984
Chromogenic print mounted on aluminum, 30 x 40
(76.2 x 101.6)
Courtesy Robert Mann Gallery, New York

Santa Monica, Melrose, Beverly, La Brea, Fairfax, 1998
Acrylic on canvas, 60 x 112 (152.4 x 284.5)
Los Angeles County Museum of Art; Purchased with funds provided by Paul and Dorothy Toeppen, Alice and Nahum Lainer, Bettey and Brack Duker, Jo Ann and Julian Ganz, Jr., Susan and David Gersh, Ellyse and Stanley Grinstein, Terri and Michael Smooke, and others through 1999 Collector Committee and Modern and Contemporary Art Council

Ed Ruscha

AMERICAN, BORN 1937; LIVES VENICE, CALIFORNIA

People tend to associate the unclassifiable Ed Ruscha with this country's car culture—the world as seen through an automobile window. But Ruscha's travel theme is not restricted to roadside views. He has done a series—typified by *Mysteries*—of nightscapes with luxurious blue-black skies punctuated by grids of streetlights seen from above; the paintings generally have text painted across their centers. The overhead vantage point of *Mysteries* makes it plausible that an airplane might have been involved in its conception. However, like the Wayne Thiebaud landscape and the Andreas Gursky photograph in *Defying Gravity*, the point of view of *Mysteries* supports a premise of the exhibition, that the *idea* of flight has entered the collective consciousness and changed humans'

perspective on the world. As Ruscha's painting makes clear, a new perspective does not necessarily eliminate the unfathomable of life. (And who would wish it so?)

In *Santa Monica, Melrose, Beverly, La Brea, Fairfax* Ruscha enlarges a close-up of a Los Angeles street map (it should be noted that maps presume an aerial view), the painting's monochromatic graininess suggesting the city's notorious smog. One of a group the artist calls "metro plots," the diagrammatic work has a skewed, almost cinematic overhead perspective. It is as if a source for the painting were the view from a helicopter angling down for a closer look. (If that *were* the case, it would not be the first time Ruscha has used a helicopter. The photography for his 1967 classic artist's book, *Thirty-four Parking Lots in Los Angeles*, was taken from one.) From the polluted atmosphere of an asphalt megalopolis to the sublime secrets of the universe, Ruscha leaves viewers with a lucid and ludic message, as rewardingly mystifying as it is edifying.

HP

OVERLEAF
Mysteries, 1988
Oil and acrylic on canvas, 46 x 80 (116.8 x 203.2)
Collection of Samuel and Ronnie Heyman, New York

curious, empty charter-jet

helicopter and wiener dog

Michael A. Salter

AMERICAN, BORN 1967; LIVES RALEIGH, NORTH CAROLINA

Michael Salter's series of ink-jet prints based on digital drawings, *situations unknown, landscape series*, portrays a flattened, artificially colored, and mechanically produced view of the world. His stylized, simplified landscapes are bleak, uninhabited places, often with implications of violence, catastrophe, tragedy, and loss, but also with undercurrents of humor and whimsy.

**4 works from *situations unknown,
landscape series**, 2001–2
Each ink-jet print based on digital drawing, 15 x 15
(38.1 x 38.1)
Collection of the artist

lost baggage

pen, pad, plane

Employing a reductive visual language, these tiny vignettes, like stills from a cartoon, tell cryptic, enigmatic stories, all presented with an air of detachment. In one work, which is divided into an immense, unblemished blue sky and a thin strip of a black horizon line, the viewer sees the tail end of a white jet, fleeing the frame and leaving behind an open briefcase in a freefall from the back of the plane. In another work, a black helicopter tows a tiny dog through a flotilla of perfect white clouds. Infused with an air of finality and a melancholy atmosphere, an additional print in the series depicts a grounded plane with an open door in the foreground and a black horizon punctuated with smoke and fire in the background.

LJD

John Schabel AMERICAN, BORN 1957; LIVES NEW YORK

John Schabel's series of photographs depicting anonymous airline passengers effectively captures the curious blend of impersonal efficiency and poignant humanity that pervades the experience of contemporary commercial air travel. Like products on an assembly line, the planes carrying Schabel's subjects churn down the runway; and with the same regularity the individual passengers emerge, identically framed, from his camera and onto the gallery wall. Interestingly, it is precisely this mechanized process that lays bare the active, but often overlooked, emotional and intellectual relationship between human beings and flight.

Schabel's images confront the viewer with a diverse array of travelers, each of whom suggests a personal narrative singled out from the dozens, or perhaps hundreds, of others aboard the airplane. Clandestinely

Untitled (Passenger #1)

Untitled (Passenger #10)

4 works from *Untitled (Passenger)* series,
1994–97
Each toned gelatin-silver print,
23¼ x 19¼ (59.1 x 48.9)
Courtesy the artist and Paul Morris Gallery, New York

capturing his subjects from across the airport tarmac with a powerful tele-photo lens, Schabel later inspects his enlarged images to locate and reveal the nearly invisible, but no less memorable and moving, faces of those individuals, couples, and families sealed inside the fuselage. Whether depicting jaded business travelers in search of solitude and relaxation, or a wide-eyed youngster on her first airplane ride, or a pair of strangers sharing a conversation—perhaps for the first and only time in their lives—Schabel's photographs always seem to produce a narrative in the mind of the viewer.

Ultimately, these voyeuristic photographs of nameless travelers, packed like cattle on their way to unknown destinations, refer viewers reflexively back to themselves.

LMA

Untitled (Passenger #11)

Untitled (Passenger #12)

Roman Signer

SWISS, BORN 1938; LIVES ST. GALLEN, SWITZERLAND

Roman Signer calls his work "event sculptures"—actions that take place in carefully controlled circumstances for a specific duration of time. *Bed* (*Bett*) exemplifies Signer's often boyish approach to his art, which frequently makes use of toys, sporting equipment, homemade rockets, electrical currents, and weak explosions. In *Bed*, Signer himself appears asleep in a

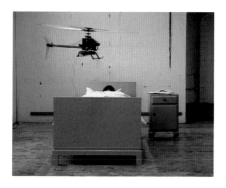

quasi-bedroom setting, his head barely visible as it emerges from beneath the bedcovers. As the curtains of this "boy's" window gently sway in the breeze, a large-scale model helicopter enters the scene and hovers above the artist in bed. With its transparent, ocular cockpit keeping a vigilant watch on

Signer, the helicopter darts back and forth cautiously, like a wary dragonfly, as it surveys the sleeping artist.

Bed evokes not only the flying dreams that come to many people during sleep but also the constant surveillance of helicopters, airplanes, and satellites that hover over the Earth, often unnoticed. The youthful delight Signer's *Bed* suggests is significant also for its notable parallel with a famous story from the Wright brothers' childhood. Although fully functional, practical helicopters were not mass produced until the 1930s, Wilbur and Orville Wright received a toy helicopter from their father in 1878. As legend has it, the boys, aged eleven and seven, respectively, were fascinated with the aircraft, made of cork, bamboo, and paper, its two rotors powered by a rubber band, and immediately set about building their own models. The Wright Flyer was only a quarter century away.

LMA

Bed (Bett), 1997
Video with sound, 4-min.-5-sec. loop
Carnegie Museum of Art, Pittsburgh; Milton Fine Fund

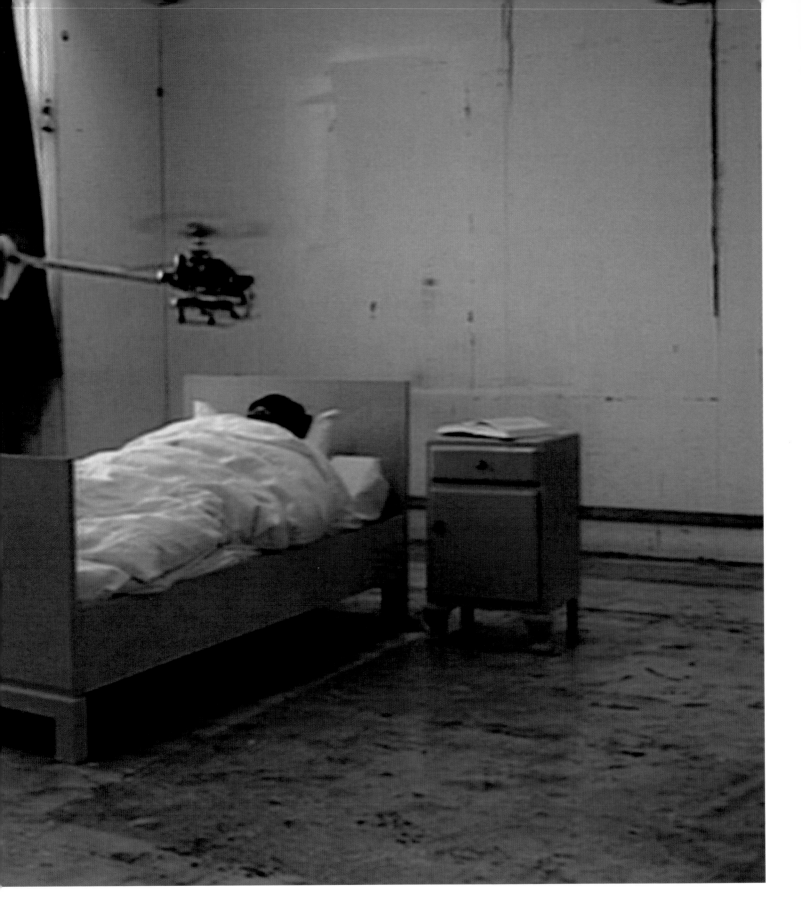

ABOVE AND OPPOSITE stills from *Bed (Bett)*

David Solow

AMERICAN, BORN 1961; LIVES ROUGEMONT, NORTH CAROLINA

David Solow's mixed-media installations often incorporate sculpture, video, sound, and photography to create multisensory experiences. For the exhibition, he will create a temporary installation, *runway*, that will be on view one night during the exhibition. His installation of luminaries will replicate an airplane runway across the grounds of the Museum with several hundred candles. The lights will sweep across the driveway up to the front entrance of the Museum and then continue across the lawn behind the Museum, up the hill, and through the pasture. This glowing, ephemeral landing strip or runway is based on a grid of nine perfectly straight lines, leading from point to point, "as the crow flies." Referencing runway lights and memorial candles, the luminaries signify both a point of departure and a moment of arrival. Solow's installation is a runway for the imagination—it cuts through the Museum and stretches across the horizon, disappearing beyond one's field of vision, in a seemingly endless line.

As the artist has described the installation, "The lights of the candles refer not only to memorials and the ephemeral but also to lightness in weight, to flight, to ethereality, to the intangible, to the poetry of light when flying into a large metropolis at night, or standing atop a tall building looking out over the city sparkling and glowing below. The landing strip connects to the ordered grid, the skyscraper, and the ability of humans to create through logic and imagination ways of lifting us off the ground to see that ground in a new way—changing our perspective."[1]

LJD

[1] David Solow, written proposal for installation of *runway* for the North Carolina Museum of Art, October 9, 2002, curatorial files, North Carolina Museum of Art.

runway, 2003
a. One-night installation composed of 100s of
candle luminaries arranged on Museum grounds
b. Digitally manipulated chromogenic print in galleries
(shown above), 20 x 16 (50.8 x 40.6)
Courtesy the artist and Kimberly Venardos &
Company, New York

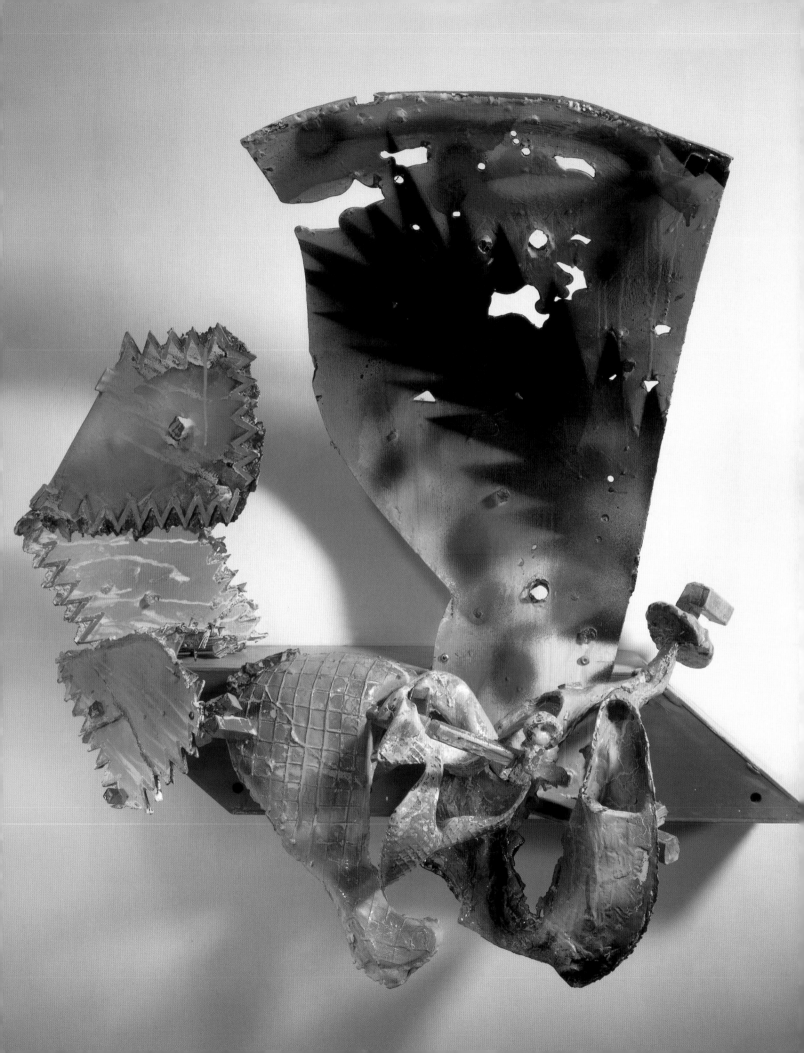

Frank Stella

AMERICAN, BORN 1936; LIVES NEW YORK

Since the late 1950s, Frank Stella has been one of the most highly regarded and innovative artists working in the United States. Defying the conventional boundaries of painting, which dictated the use of rectangular canvases, Stella's early works featured geometrically shaped canvases painted in monochromatic tones that looked more like machine-made products than hand-painted works of art. Helping to pave the way for a robust aesthetic of Minimalism and Post-Painterly Abstraction during the 1960s, Stella quickly began experimenting with a variety of colors and irregularly shaped canvases in an effort to continue challenging the discipline of painting. During the 1970s Stella's works began to take on even more pronounced sculptural qualities, as he added a third dimension to his wall-mounted paintings, which resembled brightly colored organic or liquid forms frozen in time.

Always rigorously theoretic, Stella's recent art is also less abstract. *News of the Day (Anecdote No. 9)* is part of a series of works inspired by the writings of the early-nineteenth-century German romantic author Heinrich von Kleist. Although *News of the Day* does not literally illustrate Kleist's anecdote "Tagesbegebenheit," its avian form and silhouetted leaves do suggest that essay's tragicomedic story about a man who accidentally gets struck by lightning while standing under a tree.

The materials of the cast aluminum sculptural painting recall those used in the aeronautical industry, and the work shares with the dreams of flight a desire to exist as if airborne, limited neither by the space it occupies nor by the imagination that perceives it.
LMA

News of the Day (Anecdote No. 9), 1999
Urethane epoxy enamel and spray paint on cast aluminum, 37 x 38½ x 17 (94 x 97.8 x 43.2)
Bernard Jacobson Gallery, London

Mark Tansey AMERICAN, BORN 1949; LIVES NEW YORK

People invariably laugh when presented with Mark Tansey's *Picasso and Braque*. And it is a funny scene. In a composition based on photographs of early aeronautical experiments, the painting shows Picasso as pilot of a flying cubist collage and his cubist co-conspirator Braque running alongside.[1] A violin as the Wright Flyer? Tansey makes it work.

Tansey, known for his monochromatic retellings of historical events, asks a lot of his viewers. The clues here can be pieced together to tell a story about the origins of modern art. Picasso and Braque liked to think of themselves as doing for art what the Wright brothers were doing for flight— bursting boundaries, revamping conventional ways of thinking and seeing. (A concrete example of a parallel: making collages involves improvising—and can be seen as analogous to the improvising with materials that the Wright brothers practiced.) The artists' use of collage shook up traditional notions of both the picture plane and acceptable media for a work of art; their cubist compositions showed objects from more angles than the human eye could see at any one moment. These radical innovations took shape in the heady atmosphere of the revolution the Wrights brought about. Tansey adroitly blends the two worlds, using a collage on a flat canvas to render an airplane in flight—the beginnings of modernity. Have art and technology been as magically integrated since the time of Orville and Wilbur, Picasso and Braque? HP

[1] Anne Goodyear's essay, "The Impact of Flight on Art in the Twentieth Century," in *Reconsidering a Century of Flight*, ed. Roger D. Launius and Janet R. Daly Bednarek (Chapel Hill: University of North Carolina Press, 2003), provides illuminating details about the two photographs from which *Picasso and Braque* derives: the indelible image of the Wright brothers' first flight taken by John Daniels (see p. 32) and a picture of A. M. Herring in an oscillating-wing glider designed by Octave Chanute, the latter providing the basic compositional elements of Tansey's painting.

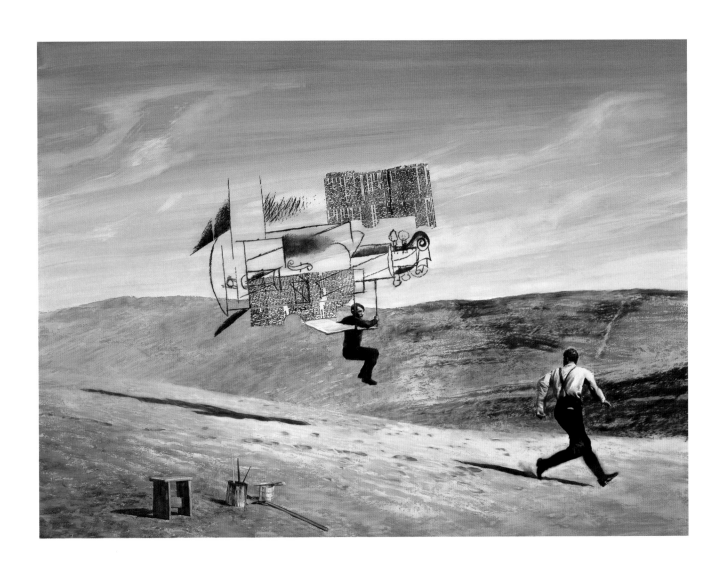

Picasso and Braque, 1992
Oil on canvas, 80 x 108 (203.2 x 274.3)
Los Angeles County Museum of Art;
Modern and Contemporary Art Council

Reservoir and Orchard, 2001
Acrylic and oil on canvas, 40 x 40 (101.6 x 101.6)
Courtesy Paul Thiebaud Gallery, San Francisco
© Wayne Thiebaud/Licensed by VAGA, New York, NY

Wayne Thiebaud AMERICAN, BORN 1920; LIVES SACRAMENTO, CALIFORNIA

Although they are always primarily formal exercises in composition, Wayne Thiebaud's recent paintings also reflect the artist's shift from his 1960s-era pop and photorealist work, with their carefully rendered replication of the physical world, to his current investigations into memories and places that exist only in the imagination.

Reservoir and Orchard and related works are meditations on the artist's childhood environment in Utah and California. That these images appear on canvas, and in the mind, as aerial views is not contingent on their being actually apprehended from aircraft. Instead, it is as if the aerial perspective that Thiebaud employs is analogous to the perspective of memory and distant time. Thiebaud renders the places of his youth as ever more abstracted and removed from the tangible. Thiebaud's compelling works thus evince a telling relationship between elevation and temporal distance. If he is right, viewers might wonder if indeed Einstein's theories of time and motion influence art in ways not previously considered. Is the view from above always already a view of the past?

LMA

Erik Wesselo

DUTCH, BORN 1964; LIVES ALKMAAR, THE NETHERLANDS, AND NEW YORK

Erik Wesselo describes his film *Düffel's Mill* (*Düffels Möll*) as a way for him to experience the Dutch landscape "from a different angle."[1] He achieves this new perspective on his native country by strapping himself to the blade of a windmill. (A windmill has also starred in a video by another artist in this exhibition, Roman Signer. Signer, however, attached his camera to the blade.) As the windmill rotates on its stationary base, this fan of the Wright brothers "flies" through the air, if on a circumscribed path. The five-minute film focuses on Wesselo. The camera, on a tripod among the cows grazing in the surrounding wetlands, follows every move of Wesselo's swoopy ride.

[1] Telephone conversation with the artist, November 13, 2001.

Düffel's Mill (Düffels Möll), 1997
16mm film, 5-min. loop
Collection of the artist,
courtesy Team Gallery, New York

It closes in on the artist and then pulls back, giving people a better look at Wesselo's advantaged view. The Dutch countryside, which has inspired so many artists through the centuries (painters like Jacob van Ruisdael, Vincent van Gogh, and Piet Mondrian, for instance), has found another devotee in Wesselo. (And in Donald Evans, whose reverence for this country's landscape is reflected in many of his stamps [see p. 97].)

The film may induce a queasiness akin to seasickness—or the giddiness felt during an amusement park ride. (It also might cause viewers to wonder how the "flight" compares with a trip on a helicopter, descendant of the windmill.) The dizzying circularity triggers carefree laughter as well as sober reflection. Wesselo depicts himself in an unending dilemma: he's both flying and confined, he's both moving and going nowhere—an unintended parable of the bind in which technology holds society.

HP

ABOVE AND OPPOSITE stills from *Düffel's Mill* (*Düffels Möll*)

Susan Rankaitis, *L'avion, L'avion,* large detail (see pp. 170–71)

Exhibition at a Glance

VITO ACCONCI
American, born 1940; lives Brooklyn, New York
Two Wings for One Wall and Person, 1979–81
Photoetching on 12 sheets of paper, printed in pink
Each sheet 16½ x 41 (41.9 x 104.1);
overall 53 x 268 (1.3 x 6.8 m)
Published by Crown Point Press, edition 10
Crown Point Press

DOUG AITKEN
American, born 1968;
lives Los Angeles and New York
Inflection, 1992
Video, 13-min. loop
Collection of the artist, courtesy 303 Gallery,
New York

ALIGHIERO BOETTI
Italian, 1940–1994; lived Rome
Skies at High Altitudes (*Cieli ad alta Quota*), 1982
Ballpoint pen on paper on canvas
3 panels, each 39 x 27 (100 x 68.5);
overall 39 x 81 (100 x 205.5)
Courtesy Gagosian Gallery, New York

JONATHAN BOROFSKY
American, born 1942;
lives Ogunquit, Maine
I Dreamed I Could Fly,
2000
1 figure suspended from
ceiling, from group of 6
Painted Fiberglas,
62 x 36 x 18 (157.5 x
91.4 x 45.7)
Museum of Fine Arts,
Boston; Museum
purchase with funds
donated by Hank and
Lois Foster

ROGER BROWN
American, 1941–1997; lived Chicago
Living near the Airport, 1990
Oil on canvas, 72 x 48 (183 x 122)
Private collection

BILL AND MARY BUCHEN
American, born 1949 and 1948; live New York
Flight Wind Reeds, 2003
5 aluminum and stainless steel elements
with brass bells, on Museum grounds,
each approximately 25 x 25 ft. (7.6 x 7.6 m)
North Carolina Museum of Art; Commissioned
with funds from the North Carolina Art Society
(Robert F. Phifer Bequest)

CHRIS BURDEN
American, born 1946; lives Topanga, California
Airplane Factory Drawing, 1998
Drawing #1 of 5
Graphite on paper, 19 x 24 (48.2 x 61)
Collection of the artist

CHRIS BURDEN
American, born 1946; lives Topanga, California
Airplane Factory Drawing, 1998
Drawing #2 of 5
Graphite on paper, 19 x 24 (48.2 x 61)
Collection of the artist

CHRIS BURDEN
American, born 1946; lives Topanga, California
Airplane Factory Drawing, 1998
Drawing #3 of 5
Graphite on paper, 19 x 24 (48.2 x 61)
Collection of the artist

CHRIS BURDEN
American, born 1946; lives Topanga, California
Airplane Factory Drawing, 1998
Drawing #4 of 5
Graphite on paper, 19 x 24 (48.2 x 61)
Collection of the artist

CHRIS BURDEN
American, born 1946; lives Topanga, California
Airplane Factory Drawing, 1998
Drawing #5 of 5
Graphite on paper, 18¾ x 24 (47.6 x 61)
Gilbert and Lila Silverman, Detroit

VIJA CELMINS
American, born Latvia, 1938; lives New York
Concentric Bearings B, 1984
2-color aquatint, drypoint, and mezzotint on paper
Left plate 5 x 4⅜ (12.7 x 11.1); right plate 4¹¹⁄₁₆ x
3¹¹⁄₁₆ (11.9 x 9.4); sheet 17 ⅜ x 14 ½ (44.1 x 36.8)
Mount Holyoke College Art Museum, South Hadley,
Massachusetts; Gift of Renée Conforte McKee
(Class of 1962)

VIJA CELMINS
American, born Latvia, 1938; lives New York
Holding onto the Surface, 1982
Graphite on acrylic ground on paper, 17 x 15
(43.2 x 38.1)
Collection Renée and David McKee, New York

VIJA CELMINS
American, born Latvia, 1938; lives New York
Strata, 1983
1-color mezzotint from 25 individual copperplates
mounted on single aluminum plate on
Arches Cover paper
Plate 23½ x 29¼ (59.7 x 74.3);
sheet 29½ x 35¼ (74.9 x 89.5)
Collection of the Orlando Museum of Art;
Gift of Council of 101

ALBERT CHONG
American, born Jamaica, West Indies, 1958;
lives Boulder, Colorado
Winged Evocations, 1998–2003
Kinetic installation activated by motion sensor,
approximately 25 x 25 ft. (7.6 x 7.6 m)
Collection of the artist

BRENT COLE
American, born 1968;
lives Burnsville, North Carolina
Flight, 2001, revised 2003
Kinetic installation activated by motion sensor
Approximately 6 x 20 x 15 ft. (1.8 x 6 x 4.5 m)
Collection of the artist

LEWIS DESOTO
American, born 1954; lives San Francisco
and New York
Repose, 1996
Wall-supported wood and aluminum skeleton
housing aluminum panels, with velvet curtain,
10 ft. 9 in. x 6 ft. 9 in. x 4 ft. 2 in.
(3.3 x 2.1 x 1.3 m)
Courtesy Bill Maynes Gallery, New York

EUGENIO DITTBORN
Chilean, born 1943; lives Santiago
El Crusoe, 1999–2001
Airmail Painting No. 127
Tincture, sateen, embroidery, stitching, and
photo-silkscreen on 2 sections of cotton duck
fabric, 82$\frac{1}{2}$ x 110$\frac{1}{2}$ (209.6 x 280.7)
Courtesy Alexander and Bonin, New York

EUGENIO DITTBORN
Chilean, born 1943;
lives Santiago
Curvas de Fantasía,
1985
Airmail Painting No. 31
Paint, feathers, string,
and photo-silkscreen
on Kraft wrapping
paper, 82$\frac{1}{2}$ x 60
(209.6 x 152.4)
Courtesy Alexander
and Bonin, New York

ART DOMANTAY
American, born the Philippines, 1965;
lives Brooklyn, New York
Balsa Wood Airplane: The Land That Time Forgot,
2001
Steel with balsa wood sheath, 5 x 14 x 16 ft.
(1.5 x 4.3 x 4.9 m)
Collection of the artist; Commissioned by
the Public Art Fund, New York, for *Temporary
Residents*, 2001–2

CHRIS DRURY
British, born Sri Lanka, 1948;
lives East Sussex, England
Cloud Chamber for the Trees and Sky, 2003
Stone, wood, and turf structure built on Museum
grounds, approximately 12 ft. (diam.) (3.7 m)
North Carolina Museum of Art; Commissioned with
funds from the North Carolina Art Society (Robert
F. Phifer Bequest)

DONALD EVANS
American, 1945–1977;
lived Amsterdam
*Aquarelles, Song-Ting, 1930.
Timbres pour la poste aérienne:
Dirigibles. (Watercolors, Song-
Ting, 1930. Airpost stamps:
Dirigibles.),* 1975
Watercolor on paper, framed
12 x 9 (30.5 x 22.9)
Mr. and Mrs. Eldon C. Mayer Jr.

DONALD EVANS
American, 1945–1977; lived Amsterdam
*Nadorp, Airpost of 1919 and 1921 on souvenir
postcard.,* 1974
Watercolor on paper collaged to postcard,
3$\frac{3}{4}$ x 5$\frac{1}{2}$ (9.6 x 14)
Collection of Hugh J. Freund

DONALD EVANS
American, 1945–1977; lived Amsterdam
Nadorp, 1953. Windmills., 1975
Watercolor and rubber stamp on paper,
framed 12 x 9 (30.5 x 22.9)
Collection Bill Katz, New York

DONALD EVANS
American, 1945–1977; lived Amsterdam
Sung Ting, 1928. Airpost. Shades of five cent
values surcharged in black., 1975
Watercolor on paper, framed 12 x 9 (30.5 x 22.9)
Emanuel Gerard, New York
Not in exhibition

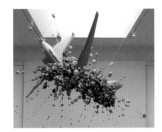

HEIDE FASNACHT
American, born 1951; lives New York
Exploding Plane, 2000
Suspended maquette, approximately 10 x 10 x
10 ft. (3.04 x 3.04 x 3.04 m)
Courtesy Kent Gallery, New York

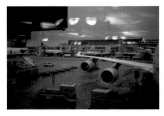

PETER FISCHLI AND DAVID WEISS
Swiss, born 1952 and 1946; live Zurich
Frankfurt (Condor), from *Airports*, 2000
Chromogenic print, 48³/₄ x 72³/₄
(123.8 x 184.9)
Jane Holzer

PETER FISCHLI AND DAVID WEISS
Swiss, born 1952 and 1946; live Zurich
Untitled (Zurich, green line, #07), from
Airports, 2000
Chromogenic print, 48³/₄ x 72³/₄
(123.8 x 184.9)
Courtesy Matthew Marks Gallery, New York

PETER FISCHLI AND DAVID WEISS
Swiss, born 1952 and 1946; live Zurich
Untitled (Zurich, Lufthansa, #10), from
Airports, 2000
Chromogenic print, 48³/₄ x 72³/₄
(123.8 x 184.9)
Courtesy Matthew Marks Gallery, New York

PETER FISCHLI AND DAVID WEISS
Swiss, born 1952 and 1946; live Zurich
Stewardess, 1989
Plaster, 44¹/₂ x 10¹/₄ x 7¹/₄ (113 x 26 x 18.4)
Sammlung Hauser und Wirth, St. Gallen,
Switzerland

LAWRENCE GIPE
American, born 1962; lives Los Angeles
Insignificance, 1998
Oil on panel, 36 x 72 (91.4 x 183)
Eric and Lisa Dortch

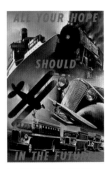

LAWRENCE GIPE
American, born 1962; lives Los Angeles
"Panel No. 6 from The Century of Progress
Museum (Propaganda Series)," 1992
Oil on panel, 72 x 48 (183 x 122)
The Speyer Family Collection, New York

JEFFREY W. GOLL
American, born 1953;
lives Durham, North Carolina
Memorial Field for a Disappointed Century, 2003
100 planes made from recycled materials,
distributed on Museum grounds, with wingspans
varying from 1 to 6 ft. (.3 x 1.8 m)
Collection of the artist

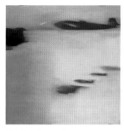

MARGOT GRAN
Israeli and American, born United States 1967;
lives Kiryat-Ono, Israel
Planes, 1996
Oil on canvas, 59 x 59 (150 x 150)
Collection of the artist

ANDREAS GURSKY
German, born 1955; lives Düsseldorf
Los Angeles, 1999
Chromogenic print, framed 6 ft. 8¾ in. x
11 ft. 9¾ in. (205 x 360)
Warren and Victoria Miro Collection

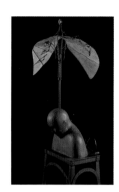

HOSS HALEY
American, born 1961;
lives Asheville, North
Carolina
Daedalus, 2000
Cast iron and steel,
97 x 60 x 28 (246.4 x
152.4 x 71.1)
Collection of the artist

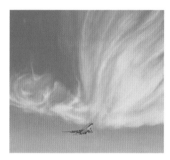

KARA HAMMOND
American, born 1963; lives Brooklyn, New York
Landing in L.A., 1998
Oil on Masonite, 14½ x 16 (36.8 x 40.6)
Courtesy Joseph Rickards, New York

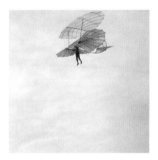

KARA HAMMOND
American, born 1963; lives Brooklyn, New York
Lilienthal's Biplane Glider, 2002
Graphite on paper, 22 x 22 (55.9 x 55.9)
Collection of the artist

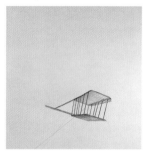

KARA HAMMOND
American, born 1963; lives Brooklyn, New York
1900 Wright Kite, 2002
Graphite on paper, 22 x 22 (55.9 x 55.9)
Collection of the artist

KARA HAMMOND
American, born 1963; lives Brooklyn, New York
30,000 feet, 2002
Oil on wood panel, 30 x 120 (76.2 x 304.8)
Collection of the artist

**RALPH HELMICK AND
STUART SCHECHTER**
American, born 1952 and 1958;
live Newton, Massachusetts
Rabble, 2003
Airplane of Mylar butterflies
suspended from stainless-steel cables installed in
ceiling and anchored by pewter weights with con-
trails of flowers, approximately 10 x 15 x 44 ft.
(3.1 x 4.6 x 13.4 m)
North Carolina Museum of Art; Commissioned with
funds from the North Carolina Art Society (Robert
F. Phifer Bequest)

YVONNE JACQUETTE
American, born 1934;
lives New York
Night Wing: Metropolitan Area Composite II, 1993
Oil on canvas, 80¾ x 56¾ (205.1 x 144.1)
North Carolina Museum of Art; Purchased with funds from the North Carolina Art Society (Robert F. Phifer Bequest)

MARVIN JENSEN
American, born 1945;
lives Penland, North Carolina
Give Me Wings, 1981
Painted biplane rocker,
36 x 36 x 60 (91.4 x 91.4 x 152.4)
Sonia and Isaac Luski

MARVIN JENSEN
American, born 1945;
lives Penland, North Carolina
Norval's Sacrifice, 2003
Painted monoplane rocker,
36 x 54 x 60 (91.4 x 137.1 x 152.4)
Collection of the artist

The work, a high-wing monoplane, was not completed at the time the catalogue went to press.

SIMONE AABERG KÆRN
Danish, born 1969; lives Copenhagen
1001 Nights 2002, 2003
Multimedia installation including statement co-authored by the artist and Magnus Bejmar, dimensions variable
Collection of the artist

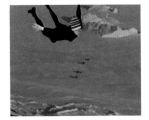

SIMONE AABERG KÆRN
Danish, born 1969; lives Copenhagen
Royal Greenland, 1995
Video with sound, 10-min. loop
Collection of the artist

SOO KIM
American, born Korea 1969; lives Los Angeles
Atlantic, 2001
Chromogenic print, 30 x 40 (76.2 x 101.6)
Courtesy Sandroni.Rey, Venice, California

SOO KIM
American, born Korea 1969; lives Los Angeles
North East, 2001
Chromogenic print, 30 x 40 (76.2 x 101.6)
Courtesy Sandroni.Rey, Venice, California

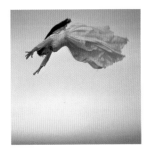

ROSEMARY LAING
Australian, born 1959; lives Sydney
flight research #3, 1999
Chromogenic print, 46½ x 46½ (118 x 118)
Courtesy Gitte Weise Gallery, Sydney

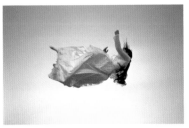

ROSEMARY LAING
Australian, born 1959; lives Sydney
flight research #4, 1999
Chromogenic print, 31½ x 48⅜ (80 x 123)
E. Fraser Collection, Melbourne

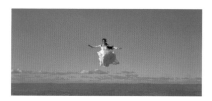

ROSEMARY LAING
Australian, born 1959; lives Sydney
flight research #5, 1999
Chromogenic print, 42³/₈ x 94¹/₄
(107.6 x 239.4)
North Carolina Museum of Art; Purchased with
funds from Charles Babcock and Dr. and Mrs.
Lunsford Long, by exchange

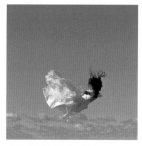

ROSEMARY LAING
Australian, born 1959; lives Sydney
flight research #8, 1999
Chromogenic print, 23⁵/₈ x 23⁵/₈ (60 x 60)
Courtesy Gitte Weise Gallery, Sydney

DONALD LIPSKI
American, born 1947; lives New York
Baby Z, 1987
Wall-hung sculpture composed of aviator's helmet
and artillery shell shipping case with pressure
cuff, clamp, water, and glass, 10 x 27 x 10
(25.4 x 68.9 x 25.4)
Victoria Vesna

**DONALD
LIPSKI**
American,
born 1947;
lives New York
Broken Wings #3,
1986
Wall-hung sculpture
composed of miscellaneous objects from salvage
yard of Grumman Aero-space Corporation of Long
Island, 43 x 46 x 52 (109.2 x 116.8 x 132.1)
Collection of Phoenix Art Museum; Museum
purchase with funds provided by the Men's Arts
Council Sculpture Endowment

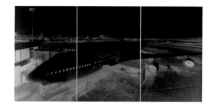

VERA LUTTER
German, born 1960; lives New York
Frankfurt Airport, V: April 19, 2001, 2001
Unique silver-gelatin print
3 panels, overall 82 x 168 (208.3 x 426.7)
Collection of the artist, courtesy Gagosian Gallery,
New York

EUAN MACDONALD
Canadian and British, born Scotland 1965;
lives Los Angeles
two planes, 1998
Digitally altered video, 3-min.-30-sec. loop
Collection of the artist

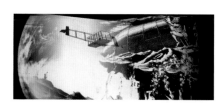

JANE D. MARSCHING
American, born 1968;
lives South Boston, Massachusetts
para: space, flight, 2001
para:// a database of wonders
http://www.thesweepers.com/jane/para
Installation composed of 12 archival ink-jet prints,
2 chromogenic prints, and laptop for satellite
internet access to interactive website, overall
dimensions variable
Collection of the artist

MALCOLM MORLEY
American, born England 1931;
lives Brookhaven, New York
The Flight of Icarus, 1995
Oil and wax on circular canvas, with artist-built
and -painted wooden model plane attached,
45 (diam.) x 113 x 91 (114.3 x 287 x 231.1)
Collection of Timothy Egert, courtesy
Baumgartner Gallery, New York

MALCOLM MORLEY
American, born England 1931;
lives Brookhaven, New York
Rat Tat Tat, 2001
Oil on linen, 7 ft. 10 in. x 16 ft. 5 in. (2.4 x 5 m)
Courtesy Sperone Westwater, New York

MARC NEWSON
Australian, born 1963; lives London
Lockheed Lounge, 1986–88; designed 1985 and
manufactured by Pod
Riveted sheet aluminum over Fiberglas and rubber,
35 x 25 x 60 (88.9 x 63.5 x 152.4)
Carnegie Museum of Art, Pittsburgh;
Women's Committee Acquisition Fund

PHUONG NGUYEN
American, born Vietnam 1968;
lives Brooklyn, New York
Interference II, 1999
Oil and wax on Masonite, $32^{3}/_8$ x $41^{1}/_2$ x $5^{5}/_8$
(82.2 x 105.4 x 14.3)
Collection of the artist

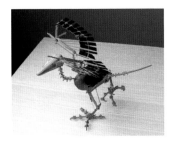

PANAMARENKO
Belgian, born 1940; lives Antwerp
Archaeopterix IV, 1991
Wood, strings, electronic chips, and solar cells,
9 x $15^{3}/_8$ x $15^{3}/_4$ (23 x 39 x 40)
Michel and Julie Espeel

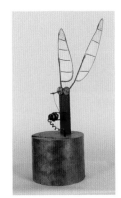

PANAMARENKO
Belgian, born 1940;
lives Antwerp
Encarsia–Formosa,
1987
Coin-operated model
flying apparatus,
15 x 5 (diam.)
(38.1 x 12.7)
Ronald Feldman
Fine Arts, New York

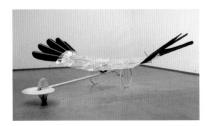

PANAMARENKO
Belgian, born 1940; lives Antwerp
Raven's Variable Matrix, 2000
Artist-designed and -built airplane with motor,
wingspan approximately 17 ft. 7 in. (5.4 m)
Courtesy Mianko, Belgium

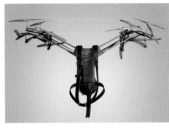

PANAMARENKO
Belgian, born 1940; lives Antwerp
Super Pepto Bismo, 1996
Artist-designed and -built flying apparatus with
12 propellers and motor with electric ignition,
39 x 59 x $31^{1}/_2$ (99 x 150 x 80)
Ministerie van de Vlaamse Gemeenschap, Brussels

ROBERT AND SHANA PARKEHARRISON
American, born 1968 and 1964;
live Worcester, Massachusetts
Flying Lesson, 1999
Waxed photogravure
Plate 20 x 18 (50.8 x 45.8);
sheet $26^{1}/_2$ x 23 (67.3 x 58.4)
Courtesy the artists and Bonni Benrubi Gallery,
New York

ROBERT AND SHANA PARKEHARRISON
American, born 1968 and 1964;
live Worcester, Massachusetts
The Sower, 2002
Multicolor photogravure
Plate $18^{1}/_2$ x 22 (47 x 55.8);
sheet 24 x $27^{1}/_2$ (61 x 69.8)
Courtesy the artists and Bonni Benrubi Gallery,
New York

SUSAN RANKAITIS
American, born 1949; lives Claremont, California
L'avion, L'avion, 1983
Combined-media photographic monoprint,
56 x 84 (142.2 x 213.4)
Yarema Family Trust

SUSAN RANKAITIS
American, born 1949;
lives Claremont,
California
Formattage, from
Jargomatique Series,
1989–90
Combined media on
photographic paper,
82³/₄ x 58¹/₄
(210.2 x 148)
Courtesy the artist and
Robert Mann Gallery,
New York

**MICHAEL
RICHARDS**
Jamaican-American,
born Jamaica, West
Indies, 1963–2001;
lived New York
*Tar Baby vs. St.
Sebastian*, 1999
Resin and steel, 81 x
30 x 19 (205.7 x 76.2
x 48.2)
Location unknown

MICHAEL RICHARDS
Jamaican-American, born Jamaica, West Indies,
1963–2001; lived New York
Winged, 1999
Bonded bronze and metal,
20 x 38 x 4 (50.8 x 96.5 x 10.2)
Courtesy Ambrosino Gallery, North Miami

SOPHIE RISTELHUEBER
French, born 1949; lives Paris
FAIT, 1992
6 chromogenic prints from a series of 71,
mounted on aluminum and framed, each
39³/₈ x 51¹/₈ x 2 (100 x 130 x 5.1),
overall 78³/₄ x 153¹/₂ x 2 (200 x 390 x 5.1)
Albright-Knox Art Gallery, Buffalo, New York;
George B. and Jenny R. Mathews Fund

JAMES ROSENQUIST
American, born 1933; lives Aripeka, Florida
Voyager—Speed of Light, 2001
Oil on canvas, 90 x 144 (228.6 x 365.8)
Collection of the artist
© James Rosenquist/Licensed by VAGA,
New York, NY

LEO RUBINFIEN
American, born 1954; lives New York
Approaching San Francisco, 1992
Chromogenic print, 20 x 24 (50.8 x 61)
Courtesy Robert Mann Gallery, New York

LEO RUBINFIEN
American, born 1954; lives New York
Leaving Amsterdam, 1989
Chromogenic print, 20 x 24 (50.8 x 61)
Courtesy Robert Mann Gallery, New York

LEO RUBINFIEN
American, born 1954; lives New York
Over the Pacific On a Flight to Hong Kong, 1984
Chromogenic print mounted on aluminum,
30 x 40 (76.2 x 101.6)
Courtesy Robert Mann Gallery, New York

LEO RUBINFIEN
American, born 1954; lives New York
Over the Pacific On a Flight to San Francisco, 1986
Chromogenic print mounted on aluminum,
30 x 40 (76.2 x 101.6)
Courtesy Robert Mann Gallery, New York

ED RUSCHA
American, born 1937; lives Venice, California
Mysteries, 1988
Oil and acrylic on canvas, 46 x 80 (116.8 x 203.2)
Collection of Samuel and Ronnie Heyman,
New York

ED RUSCHA
American, born 1937; lives Venice, California
Santa Monica, Melrose, Beverly, La Brea, Fairfax,
1998
Acrylic on canvas, 60 x 112 (152.4 x 284.5)
Los Angeles County Museum of Art; Purchased
with funds from various contributors (see p. 182)
through 1999 Collector Committee and Modern
and Contemporary Art Council

MICHAEL A. SALTER
American, born 1967; lives Raleigh, North Carolina
curious, empty charter-jet, from
situations unknown, landscape series, 2001–2
Ink-jet print based on digital drawing,
15 x 15 (38.1 x 38.1)
Collection of the artist

MICHAEL A. SALTER
American, born 1967; lives Raleigh, North Carolina
helicopter and wiener dog, from
situations unknown, landscape series, 2001–2
Ink-jet print based on digital drawing,
15 x 15 (38.1 x 38.1)
Collection of the artist

MICHAEL A. SALTER
American, born 1967; lives Raleigh, North Carolina
lost baggage, from *situations unknown, landscape
series*, 2001–2
Ink-jet print based on digital drawing,
15 x 15 (38.1 x 38.1)
Collection of the artist

MICHAEL A. SALTER
American, born 1967; lives Raleigh, North Carolina
pen, pad, plane, from
situations unknown, landscape series, 2001–2
Ink-jet print based on digital drawing,
15 x 15 (38.1 x 38.1)
Collection of the artist

JOHN SCHABEL
American, born 1957; lives New York
Untitled (Passenger #1), 1994–97
Toned gelatin-silver print, 23¼ x 19¼
(59.1 x 48.9)
Courtesy the artist and Paul Morris Gallery,
New York

JOHN SCHABEL
American, born 1957; lives New York
Untitled (Passenger #10), 1994–97
Toned gelatin-silver print, 23¼ x 19¼
(59.1 x 48.9)
Courtesy the artist and Paul Morris Gallery,
New York

JOHN SCHABEL
American, born 1957; lives New York
Untitled (Passenger #11), 1994–97
Toned gelatin-silver print, 23¼ x 19¼
(59.1 x 48.9)
Courtesy the artist and Paul Morris Gallery,
New York

DAVID SOLOW
American, born 1961; lives
Rougemont, North Carolina
runway, 2003
a. One-night installation
composed of candle lumi-
naries on Museum grounds
b. Digitally manipulated
chromogenic print
in galleries, 20 x 16
(50.8 x 40.6)
Courtesy the artist and
Kimberly Venardos &
Company, New York

WAYNE THIEBAUD
American, born 1920; lives Sacramento, California
Reservoir and Orchard, 2001
Acrylic and oil on canvas, 40 x 40 (101.6 x 101.6)
Courtesy Paul Thiebaud Gallery, San Fransisco
© Wayne Thiebaud/Licensed by VAGA, New York,
NY

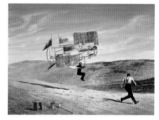

JOHN SCHABEL
American, born 1957; lives New York
Untitled (Passenger #12), 1994–97
Toned gelatin-silver print, 23¼ x 19¼
(59.1 x 48.9)
Courtesy the artist and Paul Morris Gallery,
New York

FRANK STELLA
American, born 1936;
lives New York
*News of the Day
(Anecdote No. 9)*,
1999
Urethane epoxy
enamel and spray
paint on cast
aluminum,
37 x 38½ x 17
(94 x 97.8 x 43.2)
Bernard Jacobson
Gallery, London

ERIK WESSELO
Dutch, born 1964; lives Alkmaar, the Netherlands,
and New York
Düffel's Mill (Düffels Möll), 1997
16mm film, 5-min. loop
Collection of the artist, courtesy Team Gallery,
New York

ROMAN SIGNER
Swiss, born 1938; lives St. Gallen, Switzerland
Bed (Bett), 1997
Video with sound, 4-min.-5-sec. loop
Carnegie Museum of Art, Pittsburgh;
Milton Fine Fund

MARK TANSEY
American, born 1949; lives New York
Picasso and Braque, 1992
Oil on canvas, 80 x 108 (203.2 x 274.3)
Los Angeles County Museum of Art;
Modern and Contemporary Art Council

Index

Photography Credits

In most cases photographs were supplied by the institutions or custodians cited in the captions. Further photography credits are given here. For certain documentary photographs reproduced in this volume, the Museum was unable to trace the copyright holders. We would appreciate notification of such information for acknowledgment in future editions.

Goodyear, *Chronology of Aviation and Art*
P. 3, Delaunay: © Photothèque des musées de la ville de Paris. Photograph by Joffre
P. 4, Carrà: © Scala/Art Resource, NY. © Artists Rights Society (ARS), New York/SIAE, Rome
P. 5, Malevich: Digital image © 2003 The Museum of Modern Art, New York
P. 6, Calder: Courtesy Vance Jordan Fine Art, NY; © 2003 Estate of Alexander Calder/Artists Rights Society (ARS), New York
P. 7, Tatlin: Photograph by Per-Anders Allsten
P. 7, Gorky: Digital image © 2003 The Museum of Modern Art, New York
P. 11, Lichtenstein: Photograph by Joseph Szaszfai, Yale University Art Gallery, New Haven, CT
P. 12, O'Keeffe: © 2003 The Georgia O'Keeffe Foundation/Artists Rights Society (ARS), New York
P. 13, Spero: Courtesy Galerie Lelong, New York. Photograph by David Reynolds

Wohl, *Messengers of a Vaster Life*
Figs. 1, 2: From Wohl, *A Passion for Wings: Aviation and the Western Imagination, 1908–1918*, pp. 4 and 32, from *Livre d'or de la conquête de l'air* (1909)
Fig. 3: From Wohl, *A Passion for Wings: Aviation and the Western Imagination, 1908–1918*, p. 96
Fig. 4: From Wohl, *A Passion for Wings: Aviation and the Western Imagination, 1908–1918*, p. 115, from Mario Cobianchi, *Pioneri dell'aviazione in Italia*, plate ix
Fig. 5: © Réunion des Musées Nationaux/Art Resource, NY. Photograph by C. Jean, Musée de l'Orangerie, Paris
Fig. 6: Öffentliche Kunstsammlung Basel. Photograph by Martin Bühler
Fig. 7: From Wohl, *A Passion for Wings: Aviation and the Western Imagination, 1908–1918*, facing p. 1 (hardback edition only), from *L'Illustration*
Figs. 8, 9: From *Futurism in Flight: "Aeropittura" Paintings and Sculptures of Man's Conquest of Space (1913–1945)* (Rome: De Luca Edizioni d'Arte, c. 1990), plates 140 and 66
Fig. 10: The Movie Channel
Fig. 11: Courtesy Academy of Motion Picture Arts and Sciences

**Goodyear, *The Legacy of Kitty Hawk:*
*A Century of Flight in Art***
Fig. 1: Library of Congress, Prints & Photographs Division
Fig. 2: © 2003 Estate of Pablo Picasso/Artists Rights Society (ARS), New York
Fig. 3: Digital image © 2003 The Museum of Modern Art, New York
Fig. 4: Digital image, courtesy Universal Limited Art Editions (ULAE)
Fig. 5: © 2003 Richard Serra/Artists Rights Society (ARS), New York. Photograph by Thomas Loonan © 1991
Fig. 6: © 2003 Board of Trustees, National Gallery of Art, Washington. Photograph by Philip A. Charles

Paschal, *The Possibility of Impossibility*
Fig. 5: © 2003 Artists Rights Society (ARS), New York/VISCOPY, Sydney

Dougherty, *Defying Gravity*
Fig. 1: Courtesy the artist
Figs. 2, 3: Photographs by Clements/Howcroft, Boston
Fig. 6: From *Passages: Contemporary Art in Transition* (New York: The Studio Museum in Harlem, 1999), p. 61
Fig. 7: Digital image, courtesy the artist and Gitte Weise Gallery, Sydney, and Galerie Lelong, New York. © 2003 Artists Rights Society (ARS), New York/VISCOPY, Sydney

Catalogue of the Exhibition
P. 70, Borofsky: © 2003, Museum of Fine Arts, Boston
P. 73, Brown: Photograph by Mike Jensen
Pp. 74–75, Buchens: Karen Malinofski and Christopher Ciccone, NCMA
P. 79, Burden, Drawing #5: Courtesy the artist
P. 82, Celmins: Courtesy McKee Gallery, New York. Photograph by Michael Korol, New York
P. 83, Celmins: © Raymond Martinot
Pp. 84–85, Chong: Allen Memorial Art Museum, Oberlin College, Oberlin, Ohio, 1998
Pp. 90–91, Dittborn: Photographs by Orcutt & Van Der Putten
P. 93, Domantay: Tom Powel Imaging
Pp. 94–95, Drury: Karen Malinofski and Christopher Ciccone, NCMA
Pp. 96–99, Evans: Courtesy Estate of the artist and Tibor de Nagy Gallery, New York
Pp. 100–101, Fasnacht: Faulconer Gallery, Grinnell College, Grinnell, Iowa, 2001. Photographs by Daniel Strong
Pp. 103–4, Fischli and Weiss: Digital images, courtesy Matthew Marks Gallery, New York

Pp. 107–9, Gipe: Courtesy Joseph Helman Gallery, New York
Pp. 110–11, Goll: Karen Malinofski and Christopher Ciccone, NCMA
P. 112, Gran: Photograph by Avraham Hay
Pp. 114–15, Gursky: © 2003 Monika Sprüth Gallery, Cologne/Artists Rights Society (ARS), New York/VG Bild-Kunst, Bonn
Pp. 116–17, Haley: Photographs by Pat Connell, Warner Photography, Inc.
Pp. 120–23, Hammond: Photographs by Christopher Burke
Pp. 126–27, Helmick and Schechter: Photographs by Clements/Howcroft, Boston
P. 129, Jacquette: Photograph by Bill Gage, NCMA
P. 130, Jensen: Photograph by Ken Pitts Studio
Pp. 140–43, Laing: Courtesy Gitte Weise Gallery, Sydney, and Galerie Lelong, New York. © 2003 Artists Rights Society (ARS), New York/VISCOPY, Sydney
P. 144, Lipski: Photograph by Karl Frederick Haendel
P. 145, Lipski: Photographs by Craig Smith
Pp. 148–49, Macdonald: Digital images, courtesy Cohan Leslie and Browne, New York, and Jack Hanley Gallery, San Francisco
P. 154, Morley: Courtesy Sperone Westwater, New York
P. 162, Panamarenko: Photograph by Zindman/Fremont
Pp. 162–63, Panamarenko: Courtesy Ronny Van de Velde, Antwerp
P. 164, Panamarenko: Courtesy Deweer Art Gallery, Otegem, Belgium. Photograph by Gerald van Rafelghem
P. 165, Panamarenko: Courtesy Ronny Van de Velde, Antwerp
Pp. 170–71, Rankaitis: Courtesy the artist
P. 172, Richards: Courtesy The Studio Museum in Harlem, New York. Photograph (large detail) by Frank Stewart
P. 173, Richards: Photograph by Andrea Mohin/*The New York Times*
Pp. 176–77, Rosenquist: Courtesy Gagosian Gallery, New York
Pp. 182, 184–85, Ruscha: Courtesy the artist. Photographs by Paul Ruscha
Pp. 190–91, Signer: Courtesy the artist and Galerie Hauser & Wirth, Zurich. Video stills by Aleksandra Signer
Pp. 193, Solow: Photograph by Christopher Ciccone, NCMA; digital imaging by Cameron Thorp
P. 194, Stella: © Art Resource, NY

Exhibition at a Glance
See *Catalogue of the Exhibition*